NIKON D3300

THE EXPANDED GUIDE

NIKON D3300

THE EXPANDED GUIDE

Jon Sparks

AMMONITE
PRESS

First published 2014 by
Ammonite Press
an imprint of AE Publications Ltd
166 High Street, Lewes, East Sussex, BN7 1XU, UK

Text © AE Publications Ltd, 2014
Images © Jon Sparks, 2014 (unless otherwise specified)
Copyright © in the Work AE Publications Ltd, 2014

ISBN 978-1-78145-104-3

British Library Cataloging in Publication Data: A catalog
record of this book is available from the British Library.

Editor: Rob Yarham
Series Editor: Richard Wiles
Design: Belkys Smock

Typefaces: Giacomo
Color reproduction by GMC Reprographics
Printed in China

《 PAGE 2
Light and agile, the Nikon
D3300 is a fine travel camera.
*35mm, 1/160 sec., f/16,
ISO 200.*

» CONTENTS

1 OVERVIEW

The D3300 is Nikon's latest entry-level digital single-lens reflex camera (DSLR). It is designed to marry the versatility and image quality of an SLR with the simplicity and ease of handling of the best digital compacts.

» EVOLUTION OF THE NIKON D3300

Nikon has always valued continuity as well as innovation; for instance, it has retained its tried and tested F lens-mount (originally introduced in 1959). This means it's possible to use many—though not all—classic Nikon lenses with the D3300. Care is needed and some camera functions (e.g. autofocus) may be lost (see Chapter 7, *page 181*).

Nikon's first digital SLR was the 1.3 megapixel E2s. It had no rear screen and images could only be viewed by connecting to an external device. A far

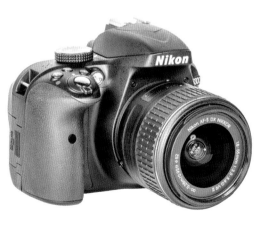

more practical introduction was the 2.7 megapixel D1, in 1999. Probably the most influential digital camera ever launched, the D1 was the first digital SLR to approach the flexibility and ease of handling of 35mm SLRs. Its sensor adopted the DX format (see page 9), subsequently used in every Nikon DSLR until the "full-frame" (FX) D3 in 2008. Nikon now has parallel ranges of DX and FX format cameras.

In 2004, Nikon introduced their first "enthusiast" DSLR, the six-megapixel D70. Its direct descendants were the D80 (2006) and then the D90 (2008), but by then the range had diversified further, with a new "entry-level" series beginning with the D40 (2006); this was followed by the D60 (2008) and then by the D3000, D3100, and D3200.

Meanwhile, the D90 was one of Nikon's most significant launches; a range of new features was overshadowed by one headline-grabber as it became the first DSLR capable of shooting video. The D90 remained on sale (and indeed is still listed today) even as many of its innovations were incorporated into the D5000 (2009), which added a fold-out LCD screen.

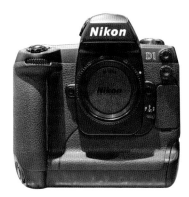

NIKON D1 (1999) ☆
The D1 was a revolutionary camera, making digital photography a practical, everyday proposition for thousands of professionals, not to mention amateur "early adopters".

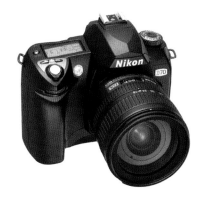

NIKON D70 (2004) ☆
The D70 was the camera which first persuaded a host of enthusiasts and not a few professionals (including the author) to take the plunge into digital photography.

NIKON D90 (2008) ☆
The D90 had many new features, but one of these grabbed all the headlines as it became the first DSLR capable of shooting video.

NIKON D3000 (2009) ☆
Apart from the introduction of Guide Mode, the D3000 was not radically different from the D60 which preceded it.

The shift from D60 to D3000 was less radical than the big change in model numbers suggests. Its biggest innovation was Guide mode. It had no Live View and could not shoot movies; both of these omissions were rectified in 2010 when the D3100 appeared. The D3200 upped the pixel count from 14 to 24 (arguably a mixed blessing) but otherwise made fairly minor changes, and the D3300 continues to refine the product line.

REFLECTION ⌄
I shot this image in NEF (RAW) format, which helped save detail in the foreground shadows without sacrificing the vivid colors of the sunlit ridge. *24mm, 1/40 sec., f/11, ISO 400.*

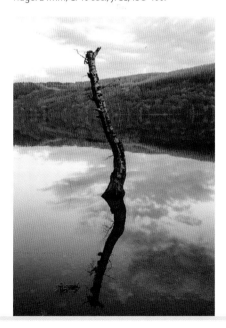

» ABOUT THE NIKON D3300

At first glance, the D3300 may look like a modest upgrade to the D3200, but there are some significant changes under the surface. The camera is almost exactly the same size as its predecessor, but significantly lighter.

The D3300 has a 24-megapixel sensor. The pixel count may be the same as the D3200, but there's a major difference as the D3300 has dispensed with an "anti-aliasing" filter in front of its sensor. The first Nikon to do away with the AA filter was the esoteric D800E, but the D7100 and then the D5300 soon followed. The effect of this should be to make images even sharper, and results do seem to bear this out—but improvements will only show up with good lenses and good technique. The D3300 also incorporates the latest EXPEED 4 image processing system.

The other significant innovation is not so much the D3300 itself as the lens which accompanies it. The collapsible 18–55mm F3.5–5.6 VR II kit lens makes the camera/lens combo smaller and lighter, but still delivers good optical performance.

Like all Nikon SLRs the D3300 is part of a vast system of lenses, accessories, and software. *The Expanded Guide* to the Nikon D3300 will guide you through all aspects of the camera's operation, and its relation to the system as a whole.

» NIKON DX-FORMAT SENSOR

DX-format sensors, measuring approximately 23.5 x 15.5mm (with slight variations), were used in every Nikon DSLR from the D1 onward, until the arrival of "full-frame" FX-format cameras with the D3 in 2008. The sensors in these models are approximately 36 x 24mm. Since then, FX and DX cameras have co-existed in Nikon's range.

The number of pixels on the DX sensor has risen from 2.7 million on the D1 to around 24 million across the current range. Early models used CCD sensors but today CMOS (Complementary Metal Oxide Semiconductor) sensors are used in all of Nikon's DSLRs.

The DX format dictates a 1.5x magnification factor, relative to the same lenses used on 35mm and FX cameras. The D3300's CMOS sensor measures 23.2 x 15.4 mm, making it fractionally smaller than most earlier models, though there's no real significance in this. Its 24 million pixels produce images at a native size of 6000 x 4000 pixels, making them suitable for demanding large prints and book and magazine reproduction; dispensing with an anti-aliasing (optical low-pass) filter helps sharpness still further.

ARCHES ⌄
The D3300 can deliver very polished results.
50mm, 1/80 sec., f/5.6, ISO 400.

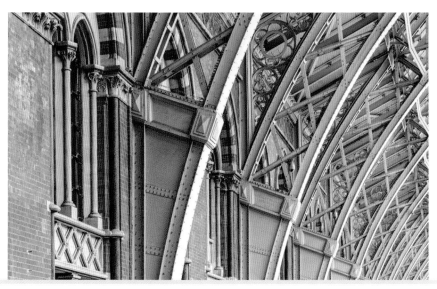

» MAIN FEATURES

Sensor

24 effective megapixel DX-format RGB CMOS sensor measuring 23.5 x 15.6mm and producing maximum image size of 6000 x 4000 pixels; self-cleaning function. No optical low-pass (anti-aliasing) filter.

Image processor

EXPEED 4 image processing system.

Focus

11-point autofocus system, supported by Nikon Scene Recognition System, which tracks subjects by shape, position and color. Three focus modes: (S) Single-servo AF; (C) Continuous-servo AF; and (M) Manual focus. Three AF-area modes: Single-area AF; Dynamic-area AF with option of 3D tracking; and Auto-area AF. Rapid focus point selection and focus lock.

ISO

ISO range between 100 and 12,800, with extension (Hi) up to 25,600. Exposure compensation between −5 Ev and +5 Ev; exposure lock and exposure bracketing facility.

Exposure modes

Two fully auto modes: auto; auto (flash off). Six Scene modes: 🏃 Portrait; 🏔 Landscape; 👧 Child; 🏃 Sports; 🌷 Close up; 🌃 Night portrait. 13 Effects modes: 🌙 Night Vision; 🎨 Color Sketch; 🏠 Miniature Effect; 🖌 Selective Color; 🏞 Silhouette; 🎹 High key; **Lo** Low key; 📷 Toy camera effect; 🖥 HDR painting; **VI** Super Vivid; **POP** Pop; 🖼 Photo Illustration; ⬜ Easy panorama. Four user-controlled modes: (P) Programmed auto with flexible program; (A) Aperture-priority auto; (S) Shutter-priority auto; (M) Manual.

Shutter

Shutter speeds from 1/4000 sec. to 30 sec., plus Bulb, Time. Maximum continuous frame advance of 5fps. Quiet mode, self-timer, remote control, and mirror-up modes.

Viewfinder

Pentamirror Viewfinder with 95% coverage and 0.82x magnification.

LCD monitor

Fixed 3"/75mm, 921k-dot TFT LCD display with 100% frame coverage.

Movie mode

Movie capture in .MOV format (Motion-JPEG compression) with image size (pixels) of: 1920 x 1280; 1280 x 720; 640 x 424.

Buffer

Buffer capacity allows up to 100 frames (JPEG fine, large) to be captured in a continuous burst at 5fps, approximately 8 RAW files.

Built-in flash

Pop-up flash (manually activated) with Guide Number of 12 (m) or 39 (ft) at ISO 100 supports i-TTL balanced fill-flash for DSLR (when matrix or center-weighted metering is selected) and Standard i-TTL flash for DSLR (when spot metering is selected). Up to 10 flash-sync modes (dependent on exposure mode in use): auto; auto + red-eye reduction; auto slow sync; auto slow sync + red-eye reduction; fill-flash; slow sync; rear-curtain sync; rear-curtain slow sync; red-eye reduction; slow sync + red-eye reduction. Flash compensation from −3 to +1 Ev.

File formats

The D3300 supports NEF (RAW) (12-bit) and JPEG (Fine/Normal/Basic) file formats plus .MOV movie format.

Storage

Secure Digital (SD) card slot; accepts SDHC and SDXC cards.

System back-up

Compatible with around 60 current and many non-current Nikkor lenses (functionality varies with older lenses); SB-series flashguns; Wireless Remote Control ML-L3 and WR-R10; ME-1 stereo microphone; Wireless Mobile Adapter WU-1a; and many more Nikon system accessories.

Connectivity

Connectors for external microphone, USB/AV, HDMI, Nikon remote cords/wireless controllers, WiFi, and GPS adapters.

Software

Supplied with Nikon View NX2 (incorporates Nikon Transfer 2, Nikon Movie Editor); compatible with Nikon Capture NX2 and many third-party imaging applications.

1 » FULL FEATURES AND CAMERA LAYOUT

FRONT OF CAMERA

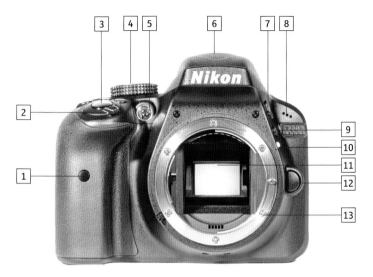

1 Infrared receiver (front)	**7** Flash/
2 Power switch	Flash mode/
3 Shutter-release button	Flash compensation button
4 Mode Dial	**8** Microphone
5 AF-assist illuminator/	**9** Fn button
Self-timer/	**10** Mounting mark
Red-eye reduction lamp	**11** Mirror
6 Built-in flash	**12** Lens release button
	13 Lens mount

BACK OF CAMERA

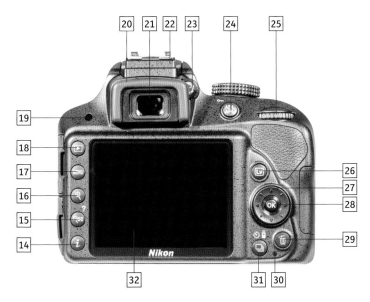

14 Information edit button	24 AE-L/AF-L/Protect button
15 Thumbnail/playback zoom out/ Help button	25 Command Dial
	26 Live View/Movie button
16 Playback zoom in button	27 Multi-selector
17 MENU button	28 OK button
18 Playback button	29 Delete button
19 Infrared receiver (rear)	30 Memory card access lamp
20 Eyecup	31 Release mode/ Self-timer/ Remote control button
21 Viewfinder eyepiece	
22 Accessory hotshoe cover	
23 Diopter adjustment dial	32 LCD monitor

1 » FULL FEATURES AND CAMERA LAYOUT

TOP OF CAMERA

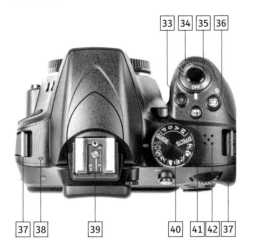

LEFT SIDE

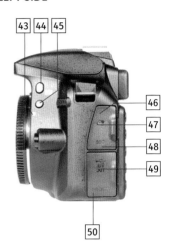

33	Movie-record button
34	Power switch
35	Shutter-release button
36	Exposure compensation/ Aperture adjustment/ Flash compensation button
37	Camera strap mount
38	Focal plane mark
39	Accessory hotshoe
40	Mode Dial
41	INFO button
42	Speaker

43	Mounting mark
44	Flash/ Flash mode/ Flash compensation button
45	Fn button
46	Connector cover
47	Accessory terminal
48	External microphone connector
49	USB and AV connector
50	HDMI mini-pin connector

BOTTOM OF CAMERA

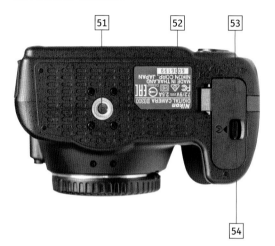

RIGHT SIDE

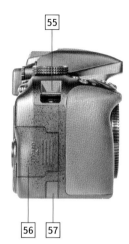

51 Tripod socket (¼in)
52 Camera serial number
53 Battery compartment
54 Battery compartment release lever

55 Camera strap mount
56 Memory card slot cover
57 Power connector cover for optional power connector

1 » VIEWFINDER DISPLAY

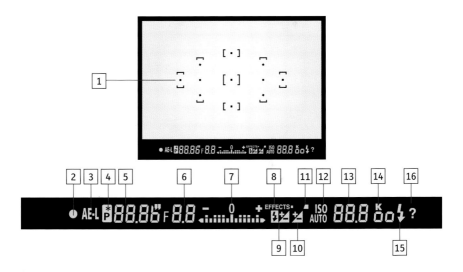

1	Focus points	11	Battery indicator
2	Focus indicator	12	Auto ISO sensitivity indicator
3	AE lock indicator	13	Number of exposures remaining/
4	Flexible program indicator		Number of exposures remaining in buffer/
5	Shutter speed		white balance recording indicator/
6	Aperture		exposure compensation value/
7	Exposure indicator/ Exposure compensation display/ Electronic rangefinder		flash compensation value/ ISO sensitivity
8	Special effects mode indicator	14	K (when over 1,000 exposures remain)
9	Flash compensation indicator	15	Flash-ready indicator
10	Exposure compensation indicator	16	Warning indicator

» INFORMATION DISPLAY (GRAPHIC FORMAT)

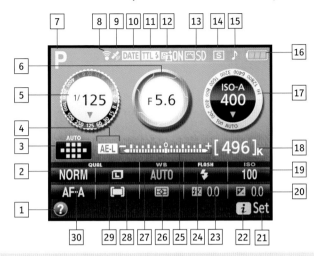

1	Help icon	15	Beep indicator
2	Image quality	16	Battery indicator
3	Auto-area AF/3D-tracking/focus point indicator	17	ISO sensitivity
4	Autoexposure lock indicator	18	No. of exposures remaining (K for >1000)
5	Shutter speed	19	Auto ISO
6	Aperture (f-number)	20	Exposure compensation indicator
7	Shooting mode	21	Set
8	Eye-Fi connection indicator	22	Information
9	Satellite signal indicator	23	Flash compensation indicator
10	Print date indicator	24	Flash mode
11	Flash control indicator/Flash compensation indicator	25	Exposure indicator
12	Active D-Lighting	26	Metering mode
13	Picture Control	27	White balance
14	Release mode	28	Focus mode
		29	Image size
		30	Focus mode indicator

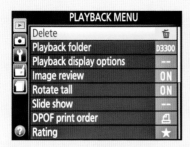

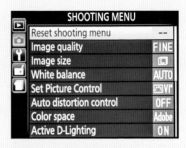

Playback menu
› Delete
› Playback folder
› Playback display options
› Image review
› Rotate tall
› Slide show
› DPOF Print order
› Rating
› Select to send to smart device

Shooting menu
› Reset shooting menu
› Image quality
› Image size
› White balance
› Set Picture Control
› Auto distortion control
› Color space
› Active D-Lighting
› Noise reduction
› ISO sensitivity settings
› AF-area mode
› Built-in AF-assist illuminator
› Metering
› Flash cntrl for built-in flash
› Movie settings

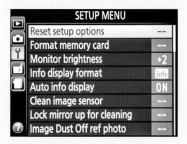

Setup menu

- › Reset setup options
- › Format memory card
- › Monitor brightness
- › Info display format
- › Auto info display
- › Clean image sensor
- › Lock mirror up for cleaning
- › Image Dust Off ref photo
- › Flicker reduction
- › Time zone and date
- › Language
- › Auto image rotation
- › Image comment
- › Auto off timers

- › Self-timer
- › Remote on duration
- › Beep
- › Rangefinder
- › File number sequence
- › Buttons
- › Slot empty release lock
- › Print date
- › Accessory terminal
- › Video mode
- › HDMI
- › Wireless mobile adapter
- › Eye-Fi upload
- › Firmware version

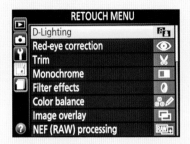

Retouch menu
> D-Lighting
> Red-eye correction
> Trim
> Monochrome
> Filter effects
> Color balance
> Image overlay
> NEF (RAW) processing
> Resize
> Quick retouch
> Straighten
> Distortion control
> Fisheye
> Color outline
> Photo illustration
> Color sketch
> Perspective control
> Miniature effect
> Selective color
> Edit movie
> Side-by-side comparison

Recent Settings menu

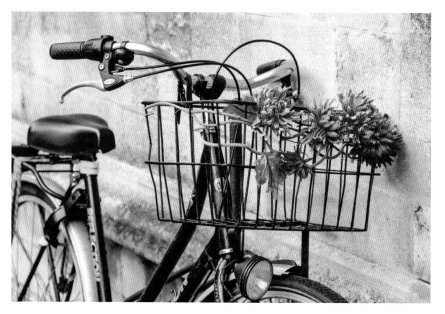

BASKET OF FLOWERS ⌃
Seen by chance, this may have been a spur-of-
the-moment shot, but it still repaid the extra
few seconds required for thoughtful exposure
and framing. *86mm, 1/40 sec., f/6.3, ISO 200.*

2 FUNCTIONS

For all its promises of simplicity, the Nikon D3300 still sports over a dozen control buttons, a Mode Dial, a Command Dial and a Multi-selector, so it may appear complex and daunting to users familiar with digital compacts or 35mm SLRs. In fact the D3300 is genuinely and thoughtfully designed to be as simple to use as any "point-and-shoot" camera.

Taking the D40 as the origin of this line of cameras, the D3300 is the sixth iteration. Nikon also has a particularly strong reputation for its interface and ergonomics, so if they can't get it right, who can? Of course, you don't have to use all those buttons—not right away, anyway. The D3300 can be as simple to use as any "point-and-shoot" camera, while delivering far superior image quality. It will be set to

its Full Auto mode when you first unpack it, and at any time you can revert to Full Auto operation by setting the Mode Dial to the ⚙ position. You can also quickly reset all other camera settings (*see pages 111 and 113*).

However, the D3300 offers much greater creative control than most compact cameras. Its design allows you to make a gradual transition from leaving everything to the camera to taking full control of its key functions.

Leaving the camera at default settings misses out on much of its imaging power, and the intention of this chapter is to provide a step-by-step introduction to its

most important features and functions. Even in a much longer book it would be impossible to fully explore every last detail, so we'll concentrate on the aspects which will be relevant to the majority of photographers.

> **❓ RECENT SETTINGS**
>
> An ordered list of the most recently used menu items. Use for quick access to frequently used items.

Tip

The printed manual supplied with the camera is a cut-down version: a more comprehensive Nikon Reference Manual *is provided on CD, and can also be downloaded from Nikon websites.*

ON-SCREEN HELP ⌃

The camera also provides on-screen help during shooting and when using the menus. When a question-mark appears at bottom left, you can press 🔍 to bring up information relating to the item currently selected on the screen. You can't access Help during playback as the button then has a different function.

FAMILIARIZATION «

When you unpack a new camera, it's tempting to start shooting right away—and taking pictures is the best way to learn. However, it still makes sense to peruse this book first, to ensure you don't miss out on new features and functions. *180mm, 1/250 sec., f/5.6, ISO 200.*

2 » CAMERA PREPARATION

Some basic operations, like charging the battery and inserting a memory card, are essential before you can use the camera. When first switched on, the camera will also prompt you to set language, time, date, and time zone: see under Setup menu in Chapter 3 (*page 115*).

› Attaching the strap

To attach the supplied strap, ensure the padded side faces inwards (so the maker's name faces out). Attach either end to the appropriate eyelet, located at top left and right sides of the camera. Loosen the strap where it runs through the buckle, then pass the end of the strap through the eyelet and back through the buckle. Bring the end of the strap back through the buckle, under the first length of strap already threaded (see photo). Repeat on the other side. Adjust the length as required, but ensure a good "tail" (minimum 2in. or 5cm) extends beyond each buckle for security. Tighten the strap to seat it snugly within the buckle.

ATTACHING THE STRAP ⌃
The strap is shown fully tightened on the left, threaded but not yet tightened on the right.

Note:
This method is not the same as that shown in the *Nikon User's Manual*, but is both more secure and neater.

› Adjusting for eyesight

DIOPTER ADJUSTMENT DIAL ☆

The D3300 offers dioptric adjustment, between −1.7 and +0.5 m⁻¹, to allow for individual variations in eyesight. Make sure this is optimized for your eyesight (with glasses or contact lenses if you normally use them). The diopter adjustment dial is by the top right corner of the Viewfinder. With the camera switched on, rotate the dial until the Viewfinder readouts appear sharpest (it's best to use the readouts rather than the Viewfinder image as they aren't affected by changes in focus).

Unless your eyesight changes, you should only need to do this once. Supplementary Viewfinder lenses are available if this adjustment proves insufficient.

› Mounting lenses

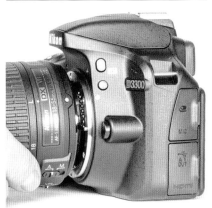

MOUNTING A LENS ☆

The ability to use a wide range of lenses (see Chapter 7, *page 180*) is one of the great advantages of a digital SLR.

Switch the camera off before changing lenses. Remove the camera body cap or the lens, if already mounted. To remove a lens, press the lens release button and turn the lens clockwise (looking at the front of the camera).

To mount a lens, remove the rear lens cap and align the index mark on the lens (white dot) with the one on the camera body; insert the lens gently into the camera and turn it anti-clockwise until it clicks home. Do not use force; if the lens is correctly aligned it will mount smoothly.

With older lenses which have an aperture ring, rotate this to minimum aperture (e.g. f/22) before using them on the D3300.

Warning!

Take care when changing lenses, especially in crowded surroundings or other awkward situations; dropping the lens or the camera is definitely to be avoided! Take extra care in dusty environments and beware wind that could introduce dust or sand while the camera's interior is exposed. Replace lens/body caps as soon as possible. Avoid touching the electrical contacts on lens and camera body, as dirty contacts can cause a malfunction.

See Chapter 7 (*page 180*) for information on compatible lenses. The *Nikon Reference Manual* also has extensive detail.

› Inserting and removing memory cards

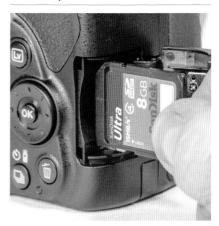

INSERTING A MEMORY CARD ⌃

The D3300 stores images on Secure Digital (SD) cards, including SDHC and SDXC cards. A memory card is essential in order to save images, but is not normally supplied with the camera. *See page 210* for more about memory cards.

1) Switch off the camera. Check that the access lamp on the camera back (below the Multi-selector) is off.

2) Slide the card slot cover (right side of the camera) to the rear. It will spring open.

3) To remove a memory card, press the card gently into its slot; it will spring out slightly, allowing you to remove it.

4) Insert a card with its label facing the rear and the terminals along the card edge facing into the slot. The "cut-off" corner of the card will be at the top. Gently push the card into the slot until it clicks home. The green access lamp will light briefly.

5) Close the card slot cover.

› Formatting a memory card

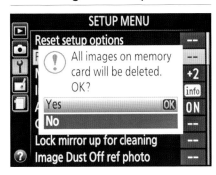

FORMATTING A MEMORY CARD ⌃

You'll need to format new memory cards, or ones that have been used in another camera, before using them with the D3300. Formatting is also the most efficient way to erase images from a card so you can reuse it—but first make sure images have been saved elsewhere!

To format a memory card
1) Press **MENU** and then select the Setup menu from the symbols at left of the screen.

2) Select **Format memory card** and press (OK).

3) Select **Yes** and press (OK).

› Battery

INSERTING THE BATTERY ⌃

Inserting and removing the battery

Turn the camera upside down and locate the battery compartment, below the handgrip. Release the latch to open the compartment. Insert the battery, contacts first, with the face that says "Nikon" facing away from the lens. Use the battery to nudge the gold-colored latch aside, then slide the battery gently in until the latch clicks home. Close the battery compartment cover, checking that it is secure.

To remove the battery, switch off the camera, and open the compartment cover. Press the gold latch to release the battery and pull it gently out of the compartment.

Charging the battery

Use the supplied MH-24 charger to charge the battery. Remove the battery terminal cover (if attached) and insert the battery into the charger with the maker's name uppermost and terminals facing the contacts on the charger. Press the battery gently but firmly into position. Plug the charger into a mains outlet. The charge lamp blinks while the battery is charging, then shines steadily when charging is complete. A completely flat battery will take around 90 minutes to recharge fully.

Battery life

Under standard test conditions (CIPA) the D3300 should deliver around 700 shots before the battery needs recharging; however, this can vary widely depending on how you use the camera. If you hardly use the LCD screen—i.e. rarely changing settings or reviewing your shots—you may achieve several times this number. On the other hand, heavy screen use, such as extensive Live View shooting, can drastically reduce it, as can heavy use of the built-in flash. Shooting movies is particularly draining.

Battery life may also be significantly shorter if you're shooting in temperatures below 0°C (see Chapter 8, *page 214*).

The battery icon in the Information Display shows roughly how much charge remains. The icon blinks when the battery is exhausted, and a low battery warning also appears in the Viewfinder.

For information on alternative power sources, see Chapter 8 (*page 208*).

› Switching the camera on

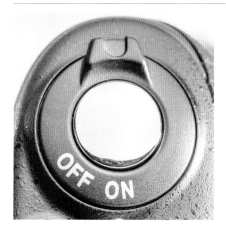

THE LENS RETRACTED AND EXTENDED ☆

At present, this is the only retractable-barrel lens that is available for the D3300 (this may change in future). With any other current lens fitted, all you need to do is turn on the camera's power switch.

POWER SWITCH AND SHUTTER-RELEASE BUTTON ☆

The power switch surrounds the shutter-release button. It has two self-explanatory settings, OFF and ON.

If you're using the retractable Nikkor AF-S DX 18–55mm f/3.5–5.6G VR II lens, commonly supplied with the camera, you'll also need to extend the lens barrel before you can take pictures. Press and hold the button on the lens barrel and rotate the zoom ring to extend the lens. (You can do things like playing back images or accessing the menus with the barrel retracted, but you can't shoot photos or video.)

> ### Tip
>
> *Unlike many compacts and some other cameras, the D3300 does not power down automatically after a set period. It's probably a good idea to turn it off if it's going to be unused for a day or more, but when you're out and about you can leave it switched on; this means it will always be ready to shoot.*

With strap, lens, battery, and memory card on board, the D3300 is ready to shoot. At the outset it will be set to its basic Auto mode (*see page 38*). The D3300 will happily shoot indefinitely like this, but as soon as you want to change any settings, review or playback your shots, use Live View or shoot movies, you'll need to use the screen and its Information Display (see below).

As you begin to explore a wider range of options, the key controls are the Mode Dial, Command Dial, and Multi-selector, and then the release mode button. However, in Auto and Scene modes it is perfectly possible (though not necessarily recommended) to shoot with virtually no recourse to any of these.

› Operating the shutter

The shutter-release button operates in two stages. Pressing it lightly, until you feel initial resistance, activates the metering and focus functions. Half-pressure also clears the Information Display, menus, or image playback, making the D3300 instantly ready to shoot. Press the button more firmly (but still smoothly) to take the picture.

› Information Display

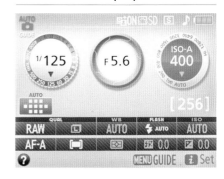

THE INFORMATION DISPLAY—　　　　❯❯
GRAPHIC FORMAT

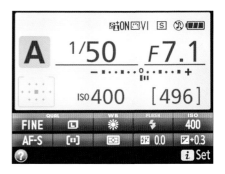

THE INFORMATION DISPLAY—　　　　❯❯
CLASSIC FORMAT

The Information Display is central to using the Nikon D3300. To activate it, do any of these:

—Half-press and release the shutter-release button (if you maintain pressure

the Information Display will not appear)

—Press **INFO** on top of the camera

—Press ◀**⬛**▶ on the rear of the camera.

This brings up a display showing the selected Exposure mode, the aperture, and shutter speed, and a range of other detail. This screen can be displayed in a choice of two formats. Graphic format, which is active by default, uses icons and pictures to illustrate the effect of various settings. Alternatively, Classic format presents the information in a more traditional, mostly numerical, way. The color scheme can also be changed. These options are chosen through the Setup menu (*see page 114*).

> ### Tip
>
> *Like all LCD screens, the D3300's can be hard to see clearly in bright sunlight. Screen shades are available which help to get around this problem (*see page 209*).*

› Active Information Display

Half-pressing the shutter release, or pressing **INFO**, brings up a passive Information Display, i.e. it displays many settings but does not allow you to change them. To make changes possible, press ◀**⬛**▶

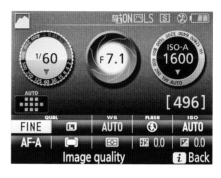

THE ACTIVE INFORMATION DISPLAY ⌃ WITH IMAGE QUALITY HIGHLIGHTED

while the initial display is visible. You can also press ◀**⬛**▶ when the screen is blank to go straight to the Active Information Display.

The lower panel on the screen is highlighted and you can use the Multi-selector to move through the various settings. To make changes, press ⓞⓚ, and the range of options for that setting appears. Use the Multi-selector to move through these options; when the one you want is highlighted, press ⓞⓚ again to select it.

> ### Note:
> We've coined the term "Active Information Display," but it is not used in Nikon's own manual.

› Mode Dial

› Command Dial

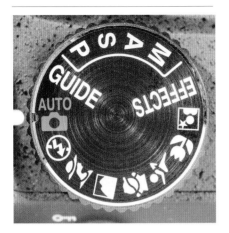

THE MODE DIAL ⌃

The mode setting, chosen from this dial, determines whether the camera operates entirely automatically or requires some level of input from you. It has 14 positions, split into five groups: Full Auto modes, User-control modes, Scene modes, Effects, and Guide. For a full run-down of these see under Exposure modes (*page 36*).

Warning!

The Mode Dial does not have a lock. It is firmly click-stopped, so accidental shifts are rare, but they can occur.

THE COMMAND DIAL ⌃

The Command Dial falls naturally under the right thumb when the camera is in shooting position. In the User-control modes it is a fundamental control.

Operating the Command Dial

The dial's function is flexible, varying according to the operating mode at the time. In Shutter-priority (S) or Manual (M) mode, rotating the Command Dial selects the shutter speed. In Aperture-priority (A) mode it selects the aperture. In Program (P) mode it engages flexible program, changing the combination of shutter speed and aperture. For descriptions of these modes *see page 60*.

The Command Dial is also used to select from among the Effects modes when the Mode Dial is set to EFFECTS. When shooting in Full Auto modes, the Command Dial has no direct effect.

› Multi-selector

THE MULTI-SELECTOR ⌃

The other principal control is the Multi-selector. Its main use when shooting pictures is to select and change settings in the Active Information Display, moving up, left, right, or down. The (OK) button at its center is used to confirm settings. The Multi-selector is also used for navigating through the menus, and through images on playback: these uses will be covered in the relevant sections.

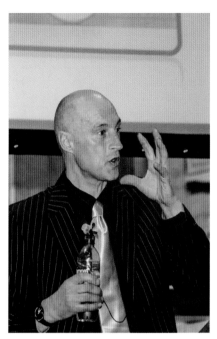

ATTACHING THE STRAP ⌃
The D3300's release modes (see next page) include a Quiet shutter mode. It's ideal for minimizing disturbance (I had both speaker and audience to consider here) but it does delay the camera's response slightly, and I had to try to anticipate expressions and gestures. *125mm, 1/40 sec., f/5.6, ISO 3200, flash.*

› Release mode

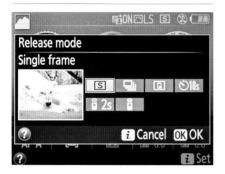

SETTING RELEASE MODE ⌃

"Release mode" may seem an obscure term. It determines whether the camera takes a single picture or shoots continuously. It can also allow you to delay the shot or trigger the camera remotely.

1) Press 🖳 to bring up a list of options (see the table below).

2) Release 🖳; until you do so, you can't do anything with the options.

3) Highlight the desired option and press ⊛ to make it active. The chosen release mode is shown in the Information Display. Six possible release modes can be selected in this way.

› Buffer

Images are initially held in the camera's internal memory ("buffer") before being written to the memory card, although this usually happens so quickly you won't notice. The maximum number of images that can be recorded in a continuous burst depends upon file quality, release mode, memory card speed, and how much buffer space is available. The figure for the number of burst frames possible at current settings is shown in the Viewfinder at bottom right when the shutter-release button is half-depressed. e.g. **[r05]**.

If **(0)** appears, the buffer is full, and no more shots will be taken until enough data has been transferred to the memory card to free up space in the buffer. This normally happens almost instantaneously, but if you're shooting in 🖳 Continuous mode you may notice a slow-down or a break in the rhythm of the shutter. On rare occasions you may have to lift your finger from the shutter-release button and re-press to resume shooting.

RELEASE MODE OPTIONS

Setting	Description
S Single	The camera takes a single shot each time the shutter release is fully depressed.
� Continuous	The camera fires continuously as long as the shutter release is fully depressed. The maximum frame rate is 5 frames per second (fps).
Q Quiet shutter release	Similar to Single Frame, but mirror remains up and shutter does not re-cock until shutter-release button is released, making operation quieter (but by no means silent).
☉ Self-timer	The shutter is released a set interval after the release button is depressed. Can be used to minimize camera shake and for self-portraits. The default interval is 10 sec., but 2 sec., 5 sec., or 20 sec. can be set using the Setup menu (page 116). Up to nine shots can be taken for each release. Camera resets to S after each release.
☐☉ Delayed remote	Requires the optional ML-L3 remote control; shutter fires approximately 2 sec. after remote is tripped. Camera resets to S if remote is not used within a certain time (set in the Setup menu, page 116).
☐ Quick response remote	Requires the optional ML-L3 remote control; shutter fires immediately when remote is tripped. Camera resets to S if remote is not used within a certain time (set in the Setup menu, page 116).

You can select Release modes no matter what Exposure mode is active, but whenever you switch to any Auto, Scene, or Effects mode, the camera reverts to the default Release mode for that Exposure mode (usually S).

2 » EXPOSURE MODES

The choice of Exposure mode makes a significant difference to the amount of control you can—or can't—exercise. Exposure modes are selected from the Mode Dial. The D3300 has a very wide choice of exposure modes, but they fall conveniently into three main groups: Full Auto modes, Scene modes, and User-control modes. There's also an EFFECTS position on the Mode Dial for more extreme or wacky results.

In Full Auto and Scene modes the majority of settings are controlled by the camera. These go beyond basic shooting settings (ISO, shutter speed, and aperture) to include options such as release mode, whether or not flash can be used, and how the camera processes the shot. The main difference is that Full Auto modes use compromise settings to cover most eventualities while Scene mode settings are tailored to particular shooting situations.

User-control modes, by contrast, give you complete freedom to control virtually every setting on the camera.

Note:
Guide mode is also selected from the Mode Dial but is not in itself an Exposure mode; instead it helps you make an appropriate selection from the available Exposure modes. For more on Guide mode *see page 52.*

Mode group	Exposure mode	
Full Auto modes	Auto	Leave all decisions about
	Auto (flash off)	settings to the camera.
Scene modes	Portrait	Choose the Scene mode
(Directly selectable	Landscape	to suit the subject and the
on Mode Dial)	Child	camera then employs
	Sports	appropriate settings.
	Close-up	
	Night portrait	
Special Effects	Night Vision	Use for more extreme
(Set the Mode Dial	Color Sketch	pictorial effects.
to EFFECTS and use	Toy Camera Effect	
Information Display/	Miniature Effect	
Command Dial)	Selective Color	
	Silhouette	
	High key	
	Low key	
	HDR Painting	
	Super Vivid	
	Pop	
	Photo Illustration	
	Easy panorama	
User-control modes	P Program	Allow control over the full
	S Shutter-priority	range of camera settings.
	A Aperture-priority	
	M Manual	

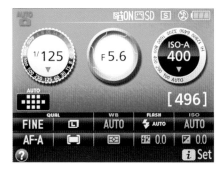

AUTO MODE ⌃

Nikon calls these "point-and-shoot" modes, which is probably a fair reflection of the way they're likely to be used. They work pretty well, most of the time; you'll hardly ever get a shot that doesn't "come out" at all, but you will sometimes find that the results aren't exactly what you were

aiming for. After all, in these modes the camera, not you, decides what kind of picture you are taking and how it should look.

> ### Tip
>
> *Even in "point-and-shoot" modes, thinking about what you're doing can make a big difference to the results you'll get. You still have to decide what to point the camera at and when to shoot—and these are pretty significant decisions!*

There's only one difference between these two modes. In 📷 Auto mode the built-in flash will pop up automatically if the camera determines light levels are too low, and can only be turned off via the Active Information Display (*see page 31*). (If a separate accessory flashgun is attached and switched on, this overrides the built-in unit.)

In 🚫 Auto (flash off) mode the flash stays off no matter what. This is useful whenever flash is banned or would be

FULL AUTO MODE «
Auto mode is ideal when shots need to be grabbed quickly. *135mm, 1/250 sec., f/7.1, ISO 125.*

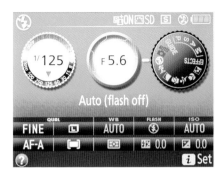

AUTO (FLASH OFF) MODE ⌃

intrusive, or when you just want to discover
what the D3300 can do in low light—if
you're trading up from a compact, the
image quality in low light may amaze you.

› Exposure warnings

In all modes, if the camera detects that
light levels are too low—or, more rarely,
too high—for an acceptable exposure,
warnings will be displayed. The Viewfinder
display blinks, and in the Information
Display you'll see a flashing question mark
and a warning message.

The camera will still take pictures, but
results may be unsatisfactory; for instance,
if it's too dark, shots may be underexposed
or subject to camera shake. However, the
warning can still appear even when the
camera is on a tripod, when camera shake
should not be an issue.

**AUTO (FLASH »
OFF) MODE**
Auto (flash off)
mode is useful
when flash is
banned, or when it
might be disruptive
or annoying, or
where it would
destroy a mood.
*40mm, 1/40 sec.,
f/5.6, ISO 800.*

›› SCENE MODES

Scene modes are designed to tailor camera settings to specific subjects and conditions. Seasoned photographers may disdain them, as they take many decisions out of your hands. However, even the most experienced may occasionally find them handy as a quick way to set the camera for shooting a particular kind of image.

If you're less experienced, you will find that Scene modes are a good way to discover how differently the camera can interpret the same scene or subject. This makes them a great stepping stone to the full range of options offered by the D3300. The first step is to understand how the various Scene modes work and to be aware of the difference they can make in your images: an obvious way to do this is to shoot the same subject using different modes.

Scene modes control basic shooting parameters such as how the camera focuses and how it sets shutter speed and aperture. They also determine how the image is processed by the camera (assuming you are shooting JPEG images, *see page 80*). For instance, Nikon Picture Controls (*page 98*) are predetermined. In 🎭 Portrait mode, for example, the camera applies a Portrait Picture Control, which aims for subtle, natural color rendition and is particularly kind to skin tones. Most Scene modes also employ Auto White Balance (*see page 82*), but in a few cases the white balance setting is predetermined to suit specific subjects.

› 🎭 Portrait

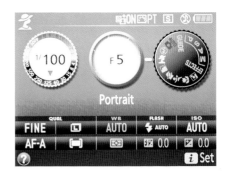

In Portrait mode the camera sets a relatively wide aperture to reduce depth of field (*page 65*), helping subjects stand out from their background. The camera also selects the focus point automatically, using Face Detection, although you can select other focusing options.

The flash automatically pops up if the camera determines light levels are too low, but can (and often should) be turned off via the Active Information Display. Attaching a separate flashgun will override the built-in-flash—and usually improves results dramatically (*see page 143*).

PORTRAIT MODE «

Portrait mode restricts depth of field. *55mm, 1/100 sec., f/5.6, ISO 800.*

camera to set a long shutter speed so an image of the background can register. A tripod or other solid camera support is recommended. The built-in flash operates automatically; results may be less harsh than regular Portrait mode but a flashgun will improve results. JPEG processing is based on a Portrait Picture Control.

NIGHT PORTRAIT MODE ⌄

This blends ambient lighting with on-board flash. *50mm, 1/30 sec., f/5.6, ISO 800mm.*

› ◪ Night portrait

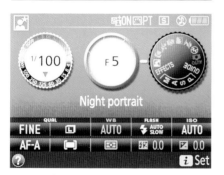

In most respects Night portrait mode is similar to regular Portrait mode, but when the ambient light is low it allows the

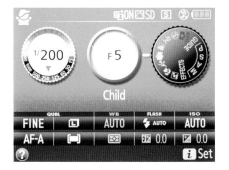

Child mode when shooting adults too, particularly if they are active rather than sitting still; it works well for "candid" shots rather than posed ones. If you want to be really unobtrusive, be sure to turn the flash off. It is probably also the best of the available Scene modes for pictures of pets. (If your subjects are very active, Sports mode might be a better bet.)

Child mode is broadly similar to Portrait mode, but one obvious difference is that the camera tends to set higher shutter speeds, no doubt because children are less likely than adults to sit still when required. JPEG processing is based on a Standard Picture Control rather than Portrait, which should give results that are more vivid overall but still give pleasing skin tones. The flash activates automatically, but of course its limitations are just as noticeable as in 👹 Portrait. It can be turned off via the Active Information Display. There's absolutely no reason why you can't use

CHILD MODE »
Child mode suits active subjects and candid shots, not just images of children. *50mm, 1/100 sec., f/7.1, ISO 400.*

› ▲ Landscape

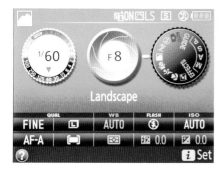

In Landscape mode, the camera sets a small aperture, aiming to maximize depth of field (*page 65*). The camera also selects the focus point(s) automatically, but you can override this choice if you wish. Small apertures mean that shutter speeds can be on the slow side, so a tripod is often advisable. A Landscape Picture Control is applied (when shooting JPEG images) to deliver vibrant colors. The built-in flash remains off; if you want to use fill-in flash (*see page 134*) to brighten the foreground, use an accessory flashgun or switch to another mode such as Aperture-priority.

LANDSCAPE MODE ⩔
Landscape mode should ensure vibrant colors and good depth of field. *22mm, 1/160 sec., f/13, ISO 500.*

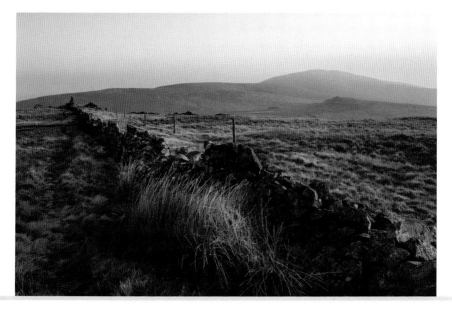

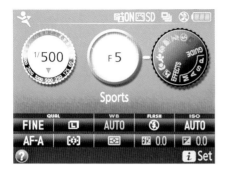

flash or mixed lighting (*see page 134*) you'll have to use a different mode (perhaps ✖, but the really obvious choice is shutter-priority: *see page 62*).

Alternatively, fit a separate flashgun. (Sports photographers use flash a lot!) A Standard Picture Control is applied.

Sports mode is suitable for shooting a range of fast-moving subjects, not just sporting events. It's a logical choice for a lot of wildlife photography, for example.

The camera seeks to set a fast shutter speed to freeze the movement. This is a reasonable approach to shooting action, but it isn't the only way to tackle it—*see page 63* for more on this.

Using fast shutter speeds usually implies using a wide aperture and therefore shallow depth of field. The camera initially selects the central focus point (this initial selection can be overridden) and if it detects subject movement will track it using the remaining focus points. The flash remains off, so if you'd like some fill-in

SPORTS MODE **»**
Sports mode is intended for rapid action.
200mm, 1/1000 sec., f/7.1, ISO 800.

› 🌷 Close-up

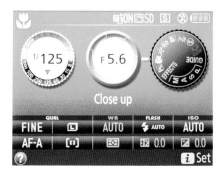

Close-up mode is of course intended for shooting at really close range. The camera sets a medium to small aperture to improve depth of field. This means shutter speeds can be low, so a tripod is often advisable to avoid camera shake. The built-in flash will activate automatically in low light, but it is generally a poor choice for close-up shots (*see page 156*): a separate accessory flashgun is a far better bet. You can also turn the flash off via the Active Information Display.

The camera automatically selects the central focus point, but this can be overridden very simply, using the Multi-selector. This is a good thing, as focus is particularly critical in close-up shooting and the key part of the subject will certainly not always be in the center of the frame. A Standard Picture Control is applied.

CLOSE-UP »
MODE
Close-up mode is versatile but it's often best to turn the flash off.
100mm macro, 1/250 sec., f/5.6, ISO 200, tripod.

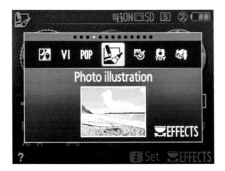

EFFECTS: CHOOSING ON SCREEN ⌃

Special Effects modes are Scene modes taken to extremes, producing various striking or fun effects through a combination of shooting settings and image processing. They always produce JPEG images: if you have Image Quality set to RAW, the camera will create a JPEG image (Fine quality) instead. Some of these effects can also be applied to existing images through the Retouch menu.

In most of these modes, the built-in flash does not operate; a separate flash can be used but will often undermine the effect.

Effects modes can be used in Live View and (with the exception of ☐ Easy panorama) in Movie mode. This (usually) gives a preview of the effect, which is helpful. For some modes, like 🖌 Selective Color, Live View is essential. In 🖼 Photo Illustration, 🖌 Color Sketch,

🎲 Toy Camera Effect, and 🖼 Miniature Effect, shooting in Live View/movie allows you some control over the effect (press ⊛ to see options).

To use Special Effects modes
1) Set the Mode Dial to EFFECTS.

2) Rotate the Command Dial to select the required mode, referring to the Information Display.

3) In Live View, press ⊛ to reveal shooting/processing options, if the current mode offers any. Choose from the options and press ⊛ again to continue.

The following modes are available:

🖼 Night Vision
Uses extreme high ISO settings (maximum Hi 4 or ISO 102,400); produces monochrome images. Autofocus is

> *Tip*
>
> *Night Vision does allow handheld shooting in remarkably low light— but it's mono-only, and quality is compromised. Using a normal Exposure mode and a tripod is usually a better bet.*

 NIGHT VISION ☆

available only in Live View/movie shooting, and not always then, as autofocus does demand a minimum light level. Manual focus may be required. No options (except that exposure compensation is available); built-in flash not available.

VI Super Vivid

A fairly self-explanatory name: boosts image saturation and contrast, well beyond even what you can achieve with a Viivid Picture Control. Images have an exaggerated quality and look anything but natural. It appears that this mode achieves its result mainly by making deep colors even deeper, which can easily make images appear simply dark and

underexposed, rather than vivid and punchy; it probably works best when most of the colors in the subject are neither very dark nor very light.

There are no options to fine-tune the image but you can preview the results in Live View.

VI SUPER VIVID ☆

POP Pop

Also boosts saturation, but isn't as heavy on the contrast as Super Vivid. Still, expect images to look distinctly "larger than life".

There are no options to fine-tune the image but you can preview the results in Live View.

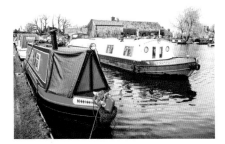

POP POP ⌃

Photo Illustration

This simplifies colors and adds dark outlines where there are clear borders in the image. Press (OK) in Live View to access options for **Thickness**, which controls the thickness of these outlines.

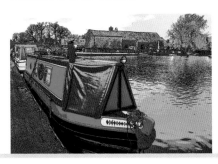

Color Sketch

Turns a photo into something resembling a colored pencil drawing. Movies can be recorded; the *Nikon Reference Manual* says they play back like a slide show or series of stills but I haven't found this to be true. The built-in flash is available (but not when recording movies).

Press (OK) in Live View to access options for **Vividness** and **Outlines**.

COLOR SKETCH ⌃

Toy Camera Effect

Your Nikon D3300 is a high-quality camera which can shoot fabulous quality images, but you can also force it to mimic the effect of shooting with plastic-lensed "toy" cameras (or applying popular Instagram filters) by creating a color cast and strong vignetting. This may well count as abuse of

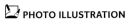

PHOTO ILLUSTRATION ≪

🔋 TOY CAMERA ⌃

a fine camera, but there's no actual law against it. The built-in flash is available.

Press (OK) in Live View to access options for **Vividness** and **Vignetting**.

📹 Miniature Effect

Mimics the recent fad for shooting images with extremely small and localized depth of field (*see page 65*), making real landscapes or city views look like miniature models. The built-in flash is not available. When used for movie shooting, clips play back at high speed. Live View options: Use the Multi-selector to adjust the in-focus zone—you can make it wide or narrow and make it run horizontally or vertically.

🖋 Selective Color

Select particular color(s); other hues are rendered in monochrome. Colors can only be selected in Live View. This selection remains active if you then exit Live View and take shots using the Viewfinder, but the Viewfinder does not preview the effect (*see page 128*). The built-in flash is not available.

Using Selective Color

1) Turn the Command Dial to enter Selective Color mode.

2) Press the Lv button to enter Live View.

3) Press (OK). The center focus area appears as a white outline. This area is fixed at the center of the frame so, to pick up the color you want, aim the camera appropriately.

4) When the desired color is under the focus point, press ▲. You can now make this selection more or less sensitive using ▲ and ▼. The sensitivity range is from 1 to 5; lower numbers mean the camera only picks up a narrow range of similar colors; higher numbers means it picks up a broader color range.

📹 MINIATURE EFFECT ⌄

5) If you want to select another color, turn the Command Dial to highlight another "swatch" and repeat step 4. You can do this again to select a third color.

6) When satisfied with the effect as shown in Live View, frame the shot as you want it and press the shutter release to capture the image. You can also press ⊙ to start shooting a movie.

Selective Color can be quite effective in Movie mode, but needs forethought. For example, if you plan to shoot someone in a red coat walking down an otherwise monochrome street, the impact of that single splash of red will be undermined if there's a red car parked further down the street. You can also find that if they pass from sunshine into shade, their red coat may no longer appear red.

🏔 Silhouette

In this mode, the camera's metering favors bright backgrounds such as vivid skies; foreground subjects record as silhouettes. It's most effective for subjects with interesting outlines.

There are no options. The built-in flash is not available; you could attach a separate flashgun but this is very likely to destroy the silhouette effect.

⊞ High key

Produces images filled with light tones, usually with no blacks or deep tones at all. It's not clear, in practical terms, whether this mode does anything more than simple overexposure.

No options; built-in flash not available.

Lo Low key

Low key is basically the opposite, creating a deep, low-toned image. Again, it's not clear whether this mode does anything more than simply underexpose the image.

No options; built-in flash not available.

🖵 HDR Painting

In this mode the camera shoots two images at different exposures and combines them to extend dynamic range (*page 97*). It then adds an effect similar to 🖌 Color Sketch or 🖾 Photo Illustration, producing an (allegedly) "painterly" result. There are no options to control the effect and you can't preview it in Live View. The

🖵 **HDR PAINTING** ⌄

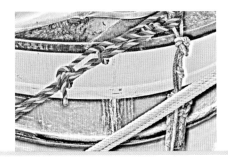

built-in flash is not available and you can't use 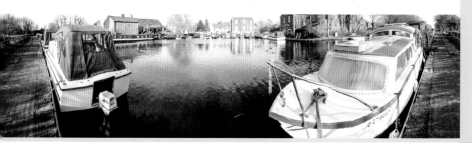HDR Painting when shooting movies (if the camera is set to this mode, movies will be shot in (⚡) Auto—flash off—mode).

If the camera moves even slightly between the two exposures the results will show an obvious "double image" effect. Use a tripod or other solid support for the camera.

Easy panorama

This mode allows you to create a panoramic image; in fact the camera records a series of images and then composites them. The extent of the panorama depends on the lens you are using. I've managed almost a complete 360-degree pan using a 12mm lens, but the joins between the component images were all too obvious.

You set the camera to record either Normal or Wide panoramas. To make this choice, make sure the camera is in Easy panorama mode, then visit the Shooting menu and go to **Image size**.

The normal image size options are replaced by Normal panorama and Wide panorama. You can also use the Active Information Display.

Having done this, press Lv to enter Live View. Frame the image for the start of the panorama, then press the shutter-release button and slowly pan the camera across the scene. You can pan left, right, up, or down, but aim to follow as straight a track as you can. A tripod helps, but it needs to be correctly levelled beforehand. Allow about 15 seconds for a Normal panorama, and 30 seconds for Wide.

On Wide, with a wide-angle lens (for instance, 12mm) it's possible to pan through more than 360 degrees.

For obvious reasons, it's not possible to use Easy panorama mode for movie shooting (but in Movie mode you can pan across a wide panorama in a similar way, *see page 174*).

EASY PANORAMA ⌄

This panorama covers over 180 degrees. The two sections of towpath on either side of the image are actually in a straight line.

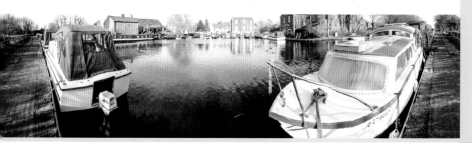

2 » GUIDE MODE

Guide mode is selected from the Mode Dial like the various Exposure modes but, as already observed, it is not in itself an Exposure mode. Instead, Guide mode is intended to guide less experienced users through some of the available options, not only for shooting but also for playback and for camera setup. That word "some" is significant—Guide mode caters for various common scenarios but falls well short of covering all the possibilities that the camera can tackle.

› Guide menu

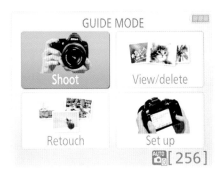

THE GUIDE MENU—OPENING SCREEN ⌃

To enter Guide mode, rotate the Mode Dial to GUIDE. The Guide menu screen appears. To return to this screen if the monitor turns off, or from the Information Display, press **MENU** (this only works while the Mode Dial is in the GUIDE position).

The opening screen offers four choices: **Shoot**, **View/Delete**, **Retouch**, and **Setup**; initially, **Shoot** is highlighted. Use the Multi-selector to select the desired option and press ⓞⓚ to enter.

› Guide menu—Shoot

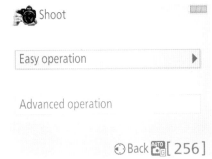

THE GUIDE MENU—SHOOTING OPTIONS ⌃

The Shoot screen offers two options: **Easy operation** and **Advanced operation**. Move between them with ▲ and ▼; use ▶ or ⓞⓚ to enter.

› Easy operation

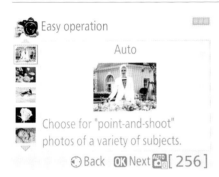

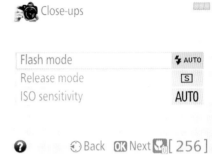

THE GUIDE MENU—EASY OPERATION ⌃

Enter this and the camera offers another series of choices (see the table overleaf). Each leads to one of the Auto or Scene modes, though the Guide menu uses different terminology for some of them, and in a few cases some settings are different. For example, **Sleeping Faces** takes you to 👶 Child mode, but with the flash off and Quiet release mode in operation (though both can be changed).

Once you're familiar with the Scene modes themselves, it will be obvious that selecting them directly via the Mode Dial is much quicker; making a choice through the Guide menu takes multiple button presses, and usually some operation of the Multi-selector too.

Having selected a mode, press ⊙K. This brings up an explanatory screen. Lightly

THE GUIDE MENU—EASY OPERATION: ⌃ MORE SETTINGS

press the shutter-release button to start shooting, or press ⊙K to bring up another screen showing some further options. These are **Start shooting**, **Use live view**, **Shoot movies**, and **More settings**. The first three are largely self-explanatory, though **Shoot movies** takes you into Live View and you must press ⊙ to start recording video.

Select **More settings** and press ⊙K to see some more choices. These will include **Release mode** and **ISO sensitivity** and in most cases also **Flash mode**. As you scroll through the available options the Guide menu provides a brief explanation and an image of an appropriate subject. Having made your choices, lightly press the shutter-release button to start shooting.

2

Guide menu—Easy operation

Guide menu heading	Exposure mode	Notes	Flash mode selection
Auto	AUTO Auto		Available
No flash (flash off)	Auto		Unavailable
Distant subjects	Sports		Unavailable
Close-ups	Close up		Available
Sleeping faces	Child	Unlike regular Child mode (i.e. set from Mode Dial) flash is Off by default, but can be changed in More settings.	Available
Moving subjects	Sports		Unavailable
Landscapes	Landscape		Unavailable
Portraits	Portrait		Available
Night portrait	Night portrait		Available
Photograph night landscapes	Auto (flash off)		Unavailable

› Advanced operation

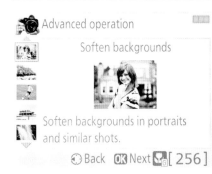

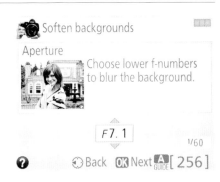

THE GUIDE MENU— ⌃
ADVANCED OPERATION

Select **Advanced operation**, and the next screen shows a list of choices: you need to scroll down to see them all (see the table overleaf). Make a choice by pressing ▶ and you'll see a screen explaining which

Tip

The Freeze motion screens suggest shutter speeds of 1/200 sec. for people and 1/1000 sec. for vehicles. This is all very well, but 1/200 isn't going to give you a sharp image of a champion sprint cyclist in full cry, while 1/1000 could be more than fast enough for many vehicles (e.g. a London bus in normal traffic conditions!) The assumption that vehicles need a faster shutter speed than people is naive, to say the least.

ADVANCED OPERATION— ⌃
OPTIONS SCREEN

Exposure mode comes into force. Whereas Easy operation takes you into Full Auto or Scene modes, Advanced takes you into one of the four User-control modes.

You can now lightly press the shutter-release button to start shooting, or press ▶ again to move to another screen where you can change a key camera setting for each scenario (shutter speed, aperture, white balance, exposure compensation, or ISO sensitivity).

Once you start shooting, further alterations to these settings are made in the normal way, e.g. using the Command Dial to change the aperture.

Guide menu—Advanced operation

Guide menu heading	Exposure mode	Notes	See page for more info
Soften backgrounds	A	Main screen allows you to set aperture using ▲ and ▼; initially sets a wide aperture such as f/4.	*page 64*
Bring more into focus	A	Main screen allows you to set aperture using ▲ and ▼; initially sets a small aperture such as f/16; advises fitting a lens of 24mm or wider.	*page 64*
Freeze motion (people)	S	Main screen allows you to set shutter speed using ▲ and ▼; initially sets 1/200 sec. or faster.	*page 63*
Freeze motion (vehicles)	S	Main screen allows you to set shutter speed using ▲ and ▼; initially sets 1/1000 sec. or faster.	*page 63*
Show water flowing	S	Main screen allows you to set shutter speed using ▲ and ▼; advises 1 sec. or slower.	*page 63*
Capture reds in sunsets	P	Initially sets "direct sunlight" for white balance; main screen allows you to change WB setting.	*page 83*
Take bright photos	P	Sets exposure compensation to +1; main screen allows you to change level of compensation.	*page 70*
Take dark (low key) photos	P	Sets exposure compensation to −1; main screen allows you to change level of compensation.	*page 70*
Reduce blur	P	Engages Auto ISO sensitivity control; main screen allows you to set minimum shutter speed and upper limit for Auto ISO range.	*page 87*

› Further options

Having made any changes, once more you can lightly press the shutter-release button to start shooting. Alternatively, press (OK) to bring up another screen (as in Easy Operation) showing the **Start shooting**, **Use live view**, **Shoot movies**, and **More settings** options.

More settings includes the following: **Flash settings**; **Release mode**; **ISO sensitivity settings**; **Set Picture Control** (*see page 98*); **Exposure compensation** (*see page 70*); and **White Balance** (*see page 82*). Select any of these and press ► to bring up relevant options, though the choices may be limited (e.g. **Set Picture Control** only offers Standard, Vivid, and Monochrome). From this options screen, press ◄ to go back to the main **More settings** screen (in some cases you'll need to use (OK) instead). At any point, pressing the shutter-release button takes you into shooting mode.

› Guide menu—View/delete

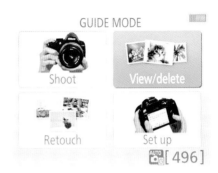

GUIDE MODE
Shoot View/delete
Retouch Set up
[496]

THE GUIDE MENU—VIEW/DELETE ⌃

This section of the Guide menu offers an alternative way to access some of the D3300's playback functions. These are all described in the following pages under **Image playback** and **Playback menu**; there's no need to repeat the information here. The Guide menu headings are:
—**View single photos** (*see page 100*);
—**View multiple photos** (see Viewing images as thumbnails, *page 102*: the Guide menu initially shows four images at a time);
—**Choose a date** (see Calendar view, *page 102*);
—**View a slide show** (see Slide show, *page 108*);
—**Delete photos** (see Deleting images, *page 102*).

2

› Guide menu—Retouch

› Guide menu—Setup

THE GUIDE MENU—RETOUCH ⌃

THE GUIDE MENU—SETUP ⌃

This section of the Guide menu gives access to a small selection of options that would otherwise be accessed, along with many others, through the Retouch menu (*page 121*). Choose one of these and press ▶ or ⊛ to go to a screen where you can select an image to be retouched. Having chosen an image, press ⊛ again to go to another screen which introduces the main options. Operation from then on is just the same as using the Retouch menu itself.

Retouch options available through the Guide menu are:

—**Trim** (*see page 122*);

—**Filter effects (cross screen)** and **Filter effects (soft)** (*see page 123*). Other Filter effects are only accessible through the Retouch menu;

—**Photo illustration** (*see page 127*);

—**Miniature effect** (*see page 128*);

—**Selective color** (see *page 128*).

This section of the Guide menu gives access to a range of settings that would otherwise be accessed through the Playback menu (*page 107*), Shooting menu (*page 111*), and Setup menu (*page 113*); a couple are also accessible through the Active Information Display.

Note:
When you set the Mode Dial to GUIDE, pressing **MENU** brings up the Guide menu and there's no access to the normal camera menus.

Guide menu—Setup

Guide menu heading		Normal menu location	Accessible through Active Information Display
Image quality		Shooting menu (*page 111*)	Yes
Image size		Shooting menu (*page 111*)	Yes
Auto off timers		Setup menu (*page 116*)	No
Print date		Setup menu (*page 119*)	No
Display and sound settings	Monitor brightness	Setup menu (*page 114*)	No
	Info background color	Setup menu (*page 114*)	No
	Auto info display	Setup menu (*page 114*)	No
	Beep	Setup menu (*page 117*)	No
Movie settings	Frame size/rate	Shooting menu (*pages 113, 167*)	No
	Movie quality	Shooting menu (*pages 113, 167*)	No
	Microphone	Shooting menu (*pages 113, 167*)	No
	Manual movie settings	Shooting menu (*pages 113, 167*)	No
Playback folder		Playback menu (*page 108*)	No
Playback display options		Playback menu (*page 108*)	No
DPOF print order		Playback menu (*page 109*)	No
Clock and language	Time zone/date	Setup menu (*page 115*)	No
	Language	Setup menu (*page 115*)	No
Format memory card		Setup menu (*page 114*)	No
Output settings	HDMI	Setup menu (*page 120*)	No
	Video mode	Setup menu (*page 117*)	No
Wireless mobile adapter		Setup menu (*page 119*)	No
Eye-Fi upload		Setup menu (*page 120*)	No
Slot empty release lock		Setup menu (*page 117*)	No

PROGRAMMED AUTO ☆

The remaining four modes are traditional standards, which will be familiar to any experienced photographer. As well as allowing direct control over the basic settings of aperture and shutter speed

(you can do this even in P mode by using flexible program), these modes give you free rein to employ controls like white balance (*page 82*), Active D-Lighting (*page 97*) and Nikon Picture Controls (*page 98*). These extra controls give you lots of ways to influence the look and feel of the image.

› (P) Programmed auto

In (P) Programmed auto mode (often called Program for short) the camera sets a combination of shutter speed and aperture that will give correctly exposed results in most situations. Of course, this much is also true of the Full Auto modes and Scene

PROGRAMMED AUTO «
This mode allows you to tailor camera settings to suit your own creative ideas. *50mm, 1/400 sec., f/11, ISO 400.*

modes, but P mode allows you to adjust other parameters to suit your own creative ideas, including white balance (*page 82*), Active D-Lighting (*page 97*) and Nikon Picture Controls (*page 98*). It also allows manual selection of ISO rating (*page 87*).

You can change things even more in P mode through options like flexible program (see below), exposure lock (*page 71*), and exposure compensation (*page 70*), and you have complete freedom to use flash—or not—as you wish.

1) Rotate the Mode Dial to position P.

2) Frame the picture.

3) Half-press the shutter-release button to activate focusing and exposure. The focus point(s) are displayed in the Viewfinder image and shutter speed and aperture settings appear at the bottom of the Viewfinder.

4) Fully depress the shutter release to take the picture.

> ### Note
> Programmed auto mode is not available with older lenses which don't have a CPU (*see page 181*).

Flexible program

Without leaving P mode you can change the combination of shutter speed and aperture by rotating the Command Dial. While flexible program is in effect, the **P** indication in the Information display changes to **P***. The shutter speed and aperture combination in the Viewfinder can be seen to change.

This does not change the overall exposure: in other words, it does not make the picture darker or lighter. What it does do is shift the combination of shutter speed and aperture. This gives you a speedy way to choose, for example, a faster shutter speed to freeze action, or a smaller aperture to increase depth of field (*page 65*), quickly gaining much of the control that Shutter- or Aperture-priority modes (see following pages) offer.

› (S) Shutter-priority auto

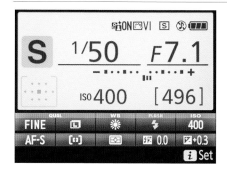

In Shutter-priority (S) mode, you control the shutter speed while the camera sets an appropriate aperture to give correctly exposed results in most situations. Control of shutter speed is key for moving subjects (*see page 63*). You can set speeds between 30 sec. and 1/4000 sec.. You can fine-tune the exposure, if necessary, through exposure lock (*page 71*), exposure compensation (*page 70*), or possibly auto bracketing (*page 72*).

SLOW MOTION

A slow shutter speed blurred the moving water, but the rocks and trees are perfectly sharp. Is it even necessary to say that the camera was on a tripod? *12mm, 1.6 sec., f/22, ISO 100.*

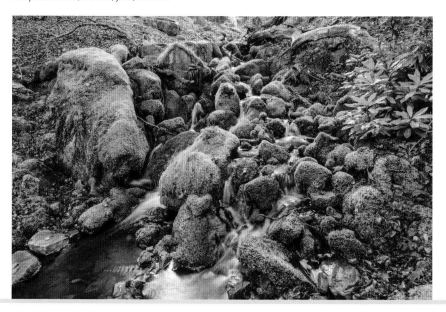

1) Rotate the Mode Dial to position S.

2) Frame the picture.

3) Half-depress the release button to activate focusing and exposure. The focus point(s) will be illuminated in the Viewfinder image and shutter speed and aperture settings appear at the bottom of the Viewfinder. Rotate the Command Dial to alter the shutter speed; the aperture will adjust automatically.

4) Fully depress the shutter-release button to take the picture.

Other modes and shutter speed

Sports mode aims to set a fast shutter speed. This is fine as far as it goes, but does not give the direct, precise control that you get in S mode. S mode also allows you to shift quickly to a much slower shutter speed, which can be a great way to get a more impressionistic view of action. In Guide mode, there are also options— **Freeze motion (people), Freeze motion (vehicles)**, and **Show water flowing**— which take you into Shutter-priority by the back door, so to speak. As you gain familiarity with the effect of a range of shutter speeds on different kinds of motion, it becomes natural, and much quicker, to go directly to Shutter-priority.

FREEZING THE ACTION »
A fast shutter speed freezes the action very effectively. I could probably have used Sports mode here but the default setting (1/200 sec.) in Guide mode's **Freeze motion (people)** tab would have been nowhere near fast enough. *50mm, 1/800 sec., f/4, ISO 3200.*

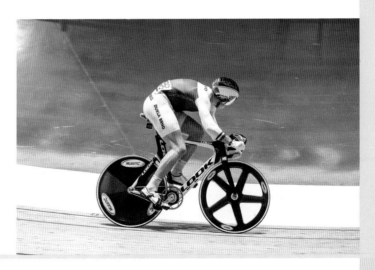

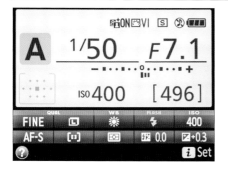

In Aperture-priority (A) mode, you control the aperture, and the camera then sets an appropriate shutter speed which will give correctly exposed results in most situations. Control of aperture is particularly useful for regulating depth of field (see opposite). The range of apertures available is limited by the lens that's fitted, not by the camera.

You can fine-tune exposure through exposure lock (*page 71*), exposure compensation (*page 70*), or possibly auto bracketing (*page 72*).

1) Rotate the Mode Dial to position A.

2) Frame the picture.

3) Half-depress the shutter-release button to activate focusing and exposure. The focus point(s) will be displayed in the Viewfinder, and shutter speed and aperture settings will appear below the Viewfinder image.

4) Rotate the Command Dial to alter the aperture; the shutter speed will adjust automatically. The Information Display (in Graphic mode) also shows a graphic representation of the aperture.

5) Fully depress the shutter-release button to take the picture.

FOREGROUND FOCUS «
The combination of focal length, shooting distance, and aperture means that the background is thrown out of focus and doesn't clutter or confuse the image. *62mm, 1/500 sec., f/8, ISO 200.*

Depth of field

Depth of field describes the zone in which objects appear to be sharp in the image. It will extend both in front of and behind the actual point of focus. The two images on these pages give contrasting illustrations: one where depth of field is very shallow, one where it's much deeper. Sometimes, shallow depth of field is exactly what you want, as it makes the subject stand out against a soft background. For other images you may want to try and have everything sharp from front to back: this is the traditional approach in landscape photography, for instance.

Aperture is an important factor in determining how much depth of field you can get, but it's not the only one. The other key factors are the focal length of the lens and the distance to the subject. With long lenses and/or nearby subjects, depth of field may remain quite shallow even at small apertures.

> ### Note
> "Small" apertures are shown by large numbers, and vice versa. This is because aperture numbers are actually fractions—and as such they should always be written as, for example, f/8 not f8.

Depth of field preview

When you look through the D3300's Viewfinder, the lens is set at its widest aperture; if you've set a smaller aperture, the lens only "stops down" at the moment the picture is actually taken. What this means is that what you see in the finder isn't necessarily what you'll get in the resulting picture; if you're concerned about depth of field, check the image on playback.

In Live View, on the other hand, the camera does stop down to the currently set aperture and so you do get a better sense of depth of field (*see page 95*).

FRONT-TO-BACK SHARPNESS ❯❯
A classical approach to a landscape image, with a strong foreground; it would strike most viewers as unnatural if any part of the image appeared unsharp. The short focal length and small aperture speak for themselves, but placement of the focus point was also critical; in fact it was towards the back of the foreground cluster of rocks. *18mm, 1/125 sec., f/11, ISO 200.*

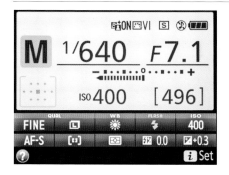

(M) MANUAL MODE ⌃

In M mode, you control both shutter speed and aperture, giving you the ultimate in creative flexibility. Many experienced photographers use it all the time to retain complete control. If you haven't used Manual mode before, try it first when you're shooting without pressure of time and ideally when light conditions aren't changing every few seconds.

Shutter speeds can be set between 30 sec. and 1/4000 sec. In addition there are settings labelled B (for "bulb") and T ("time"). In B, the shutter remains open indefinitely while the shutter-release button is depressed. However, keeping your finger on the button can cause camera shake and soon becomes tedious and uncomfortable. It's better to use a cable release or remote cord (*see page 208*).

Time is different from Bulb in that you can press and release the button and the shutter will stay open, either until you press it again or until 30 minutes have elapsed.

Exposures longer than 30 minutes are only possible in B, and generally require a locking cable release or remote cord. In both modes you'll need a tripod or some other very solid camera support. Because B and T are only available in M mode, it's the only possible choice for exposures longer than 30 sec., which you're likely to need for starry skies, fireworks displays and so on. The range of apertures that you can select is limited by the lens that's fitted.

1) Rotate the Mode Dial to position M.

2) Frame the picture.

3) Half-press the shutter-release button to activate focusing and exposure metering. The focus point(s) will be displayed in the Viewfinder and shutter speed and aperture settings will appear below the Viewfinder image. Check the analog exposure display in the Viewfinder (and/or the playback histogram), and if necessary adjust settings to achieve correct exposure.

4) Rotate the Command Dial to alter the shutter speed as necessary.

5) Hold ⊞ and rotate the Command Dial to alter the aperture as necessary.

6) Fully depress the shutter release to take the picture.

Using the Analog Exposure Displays

In Manual mode, an Analog Exposure Display appears in the center of the Viewfinder readouts and in the Information Display. This shows whether the photograph would be under- or overexposed at current settings. Adjust shutter speed and/or aperture until the indicator is aligned with the **0** mark in the center of the display: the exposure now matches the camera's recommendations. The D3300's metering is good enough that this will generally be correct, but if time allows it is often helpful to review the image and check the histogram display (see Playback, *page 103*) after taking a shot.

If necessary, you can then make adjustments for creative effect or to achieve a specific result. The Analog Exposure Display also appears in P, S, and A modes when you apply Exposure compensation (*see page 70*).

CATHEDRAL »
For this photo of Liverpool Cathedral, I didn't use a tripod, but simply set the camera on its back on the floor and triggered it with the self-timer. To get the exposure right, I used Manual mode and checked the histogram after the first shot. *14mm, 1/25 sec., f/5.6, ISO 1600.*

›› METERING MODES

**SELECTING METERING MODE IN
THE ACTIVE INFORMATION DISPLAY** ⌃

To ensure that images are correctly
exposed, the camera must measure the
light levels—this is known as exposure
metering. The D3300 provides three
different metering modes, which should
cover any eventuality. Switch between
them using the Metering item in the Active
Information Display (this is only possible in
the User-control modes: in other modes
matrix metering is automatically selected).
You can also use the Shooting menu.

› ▣ 3D Color Matrix Metering II

Using a 2016-pixel color sensor, 3D color
matrix metering II analyzes data on the
brightness, color, and contrast of the
scene. When a Type G or D Nikkor lens is
fitted, the system also analyzes distance
information based on where the camera
focuses—that's why it's called 3D. With
other CPU lenses, this distance information
is not used and metering automatically
reverts to a non-3D version.

Matrix metering is recommended for
the vast majority of shooting situations and
will nearly always produce excellent results.

› ▣ Center-weighted metering

This is a very traditional form of metering.
The camera meters from the entire frame,
but gives greater weight (75%) to a central
circle—on the D3300 it's 8mm across.
Center-weighted metering is useful in
areas like portraiture, where the key
subject often occupies the central portion
of the frame (although ⛹ Portrait mode
sticks with matrix metering).

› ■ Spot metering

In this mode the camera meters solely from a small (3.5mm) circular area. This circle is centered on the current focus point, allowing you to meter from an off-center subject. This does not apply if Auto-area AF (AF-A) is in use, when the metering point is the center of the frame.

Spot metering can be very useful where an important subject is very much darker or lighter than the background and you want to be sure it is correctly exposed

(matrix metering is more likely to compromise between subject and background).

SPOT-ON �
With a luminous sky, and deep shadows in the foreground, contrast was very high. Shooting in RAW, the camera was able to capture good color and detail in both highlights and shadows, but only if the exposure was exactly right. Spot metering helped me strike that balance. *18mm, 1/100 sec., f/13, ISO 100.*

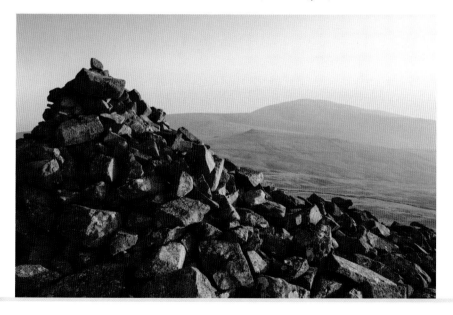

The D3300 will deliver accurate exposures under most conditions, but no camera is infallible. Nor can it read your mind or anticipate your creative ideas. Sometimes it needs a little help to get the result spot-on.

All metering systems still work—at least partly—on the assumption that key subject areas have a middling tonal value (like the gray "cards" inside the covers of this book), and should appear as a mid-tone in the images. With subjects which are very pale or very dark, this can give inaccurate results. We've all seen pictures where brilliant white snow has turned out gray: normal metering has tried to reproduce it as mid-tones, making it darker than it should be. Where very dark tones predominate, the converse is true. To get these tones right, you may have to tell the camera to make the exposure a little lighter or darker; this is exposure compensation.

The principle is simple: to make the subject lighter (to keep light tones looking light), increase exposure: use positive compensation. Conversely, to keep dark tones looking dark, use negative compensation. Digital cameras take the guesswork out of this process, because you can check after shooting and have another go if necessary. The highlights display (*page 103*), and especially the histogram

(*page 103*), are extremely helpful for this. If this judgement is difficult, or lighting conditions are particularly extreme, an extra level of "insurance" is available through exposure bracketing (*see page 72*).

Exposure compensation is only available in P, S, and A modes, plus 🌙 Night Vision. In M mode 🔲 controls the aperture, but you can "compensate" simply by setting shutter speed and/or aperture so that the meter readout shows a + or − value. In Auto, Scene, and Effects modes (other than 🌙) exposure control is fully automatic, although you can still use Exposure lock (see next page).

> ### Using exposure compensation

Exposure compensation is applied in steps of $1/3$ Ev and can be set between −5 Ev and +5 Ev, though you'll rarely need these extremes.

Tip

Reset exposure compensation (step 4) as soon as possible, otherwise it will apply to later shots which don't need it. It is not reset automatically even when the camera is switched off.

EXPOSURE COMPENSATION BUTTON ⌃

1) Press ⊞ and rotate the Command Dial to set negative or positive compensation; the chosen value is shown in the Information Display and in the Viewfinder.

2) Release ⊞. ⊞ appears in the Viewfinder, and the Analog Exposure Display appears with a blinking **0** at its center.

3) Take the picture as normal. If time allows, check that the result is satisfactory.

4) To restore normal exposure settings, press ⊞ and rotate the Command Dial until the value returns to **0.0**.

› Exposure lock

Exposure lock is another way to fine-tune the camera's exposure setting; many people find this a quick and intuitive method. It's useful, for instance, in situations where very dark or light areas (especially light sources) within the frame can over-influence exposure. Exposure lock allows you to meter from a more average area, by pointing the camera in a different direction or stepping closer to the subject, then hold that exposure while re-framing the shot you want. Unlike exposure compensation, it can be used in Scene and Effects modes. However, it's not available in Full Auto modes.

> **Note:**
> Nikon advises against using exposure lock when you're using Matrix metering, but there's absolutely no reason not to do so if it helps you get the desired result.

AE-L/AF-L BUTTON ⌃

Using Exposure lock
1) Aim the camera in a different direction, or zoom the lens to avoid the potentially problematic dark or light areas. If you're using center-weighted or spot metering, look for areas of middling tone (but which are receiving the same sort of light as the main subject).

2) Half-press the shutter release to take a meter reading, then keep it pressed as you press **AE-L/AF-L** to lock the exposure value.

3) Keep **AE-L/AF-L** half-pressed as you reframe the image, then press down fully to shoot.

By default, **AE-L/AF-L** locks focus as well as exposure. Change this using the **Buttons** item in the Setup menu (*page 118*).

› Exposure bracketing

A time-honored way to ensure that an image is correctly exposed is to take several frames at differing exposures, and select the best one later—this is known as exposure bracketing. Unlike most other Nikon DSLRs, the d3300 does not have an automatic bracketing facility, so bracketing must be done manually.

In P, S, and A exposure modes, the easiest way to employ manual exposure bracketing is using exposure compensation (*page 70*). For example, take one shot at the recommended exposure, another with exposure compensation at −1 Ev, and a third at +1 Ev. It is definitely quicker to use the ⊡ button and Command Dial for this, rather than the Active Information Display. With a little practice it takes only a second or two to rattle off three (or more) shots.

In M exposure mode you bracket by directly changing either the aperture or shutter speed. For instance, if the recommended exposure is 1/60 sec. at f/11, changing the shutter speed to 1/125 sec. is equivalent to −1 Ev and 1/30 sec. is equivalent to +1 Ev. There's no practical way to bracket exposure in Scene or Full Auto modes.

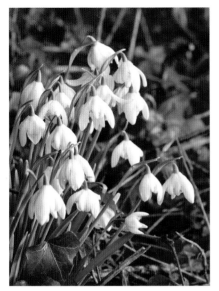

EXPOSURE BRACKETING

To get a bright overall result while keeping good detail in the white flowers was more tricky than you might think. Exposure bracketing let me hedge my bets: −1 Ev (top left)/0 Ev (left)/+1 Ev (above). *155mm, 1/20 sec./1/10 sec./1/5 sec., f/11, ISO 100, tripod.*

Tip

Exposure bracketing isn't ideal when shooting moving subjects, as the best exposure rarely coincides with the subject being in the best position. If possible, use other means to get the exposure right beforehand.

» FOCUSING

Focusing is not simply about ensuring that "the picture" is in focus. It's actually quite difficult, and sometimes impossible, to ensure that everything in an image appears sharp. The first essential is making sure that the camera focuses on the desired subject, or even—especially in close-up photography—the right part of the subject. Control of depth of field (*page 65*) then helps you determine how much of the rest of the image will also be sharp.

The various focus options boil down to how the camera focuses, determined by the focus modes, and where it focuses (what the subject is, if you like). This is determined by the AF-area modes.

› Focus modes

In the Active Information Display, select the focus mode item (by default this reads **AF-A**). Press ⊛ and select from the available options; press ⊛ again to confirm the selection and return to shooting mode.

When the camera is in an Auto, Scene, or Effects mode, only two options are offered. Manual focus can always be selected, but the only autofocus option is AF-A. In P, S, A, or M mode four options are available.

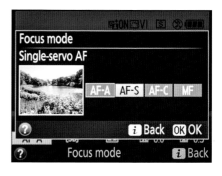

FOCUS MODE SELECTION IN THE ACTIVE INFORMATION DISPLAY ⌃

Note:
This section deals only with focusing in normal shooting (i.e. using the Viewfinder). Focusing works differently in Live View (*page 92*) and movie shooting (*page 168*).

AF-A Auto-servo AF

By default the camera is set to AF-A in all exposure modes. AF-A means that the camera automatically switches between two autofocus modes—single-servo AF and continuous-servo AF (see below). In P, S, A, or M mode you can also select these directly.

AF-S Single-servo AF

The camera focuses when the shutter release is pressed halfway. If you keep it half-pressed, focus remains locked on this point. The shutter cannot release to take a picture unless focus has been acquired (focus priority). This mode is recommended for accurate focusing on static subjects.

AF-C Continuous-servo AF

In this mode, recommended for moving subjects, the camera continues to seek focus as long as the shutter release is depressed: if the subject moves, the camera will refocus. The camera is able to take a picture even if it hasn't acquired perfect focus (release priority).

The D3300 employs predictive focus tracking; if the subject moves while continuous servo AF is active, the camera analyzes the movement and attempts to predict where the subject will be when the shutter is released.

AF-C MODE ⌃
AF-C is recommended for moving subjects.
125mm, 1/1000 sec., f/8, ISO 200.

AF-S MODE ⌃
AF-S is recommended for stationary subjects.
28mm, 1/160 sec., f/11, ISO 100.

› (M) Manual focus

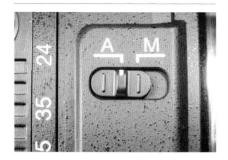

A/M SWITCH ON THE NIKKOR AF-S DX 18–55MM F/3.5–5.6G VR II LENS ☒

When a camera has sophisticated AF capabilities, manual focus might appear redundant, but many photographers still value the extra control and involvement. There are also certain subjects and circumstances which can bamboozle even the best AF systems. Manual focusing is a straightforward process, which hardly requires description: set the focus mode to **MF** and use the focusing ring on the lens to bring the subject into focus.

Tip

Many lenses have an A/M switch: setting this to M will automatically set the focus mode to MF.

Focus confirmation

When using a lens that does not focus automatically with the D3300, you can still take advantage of the camera's focusing technology thanks to focus confirmation. It requires you to select an appropriate focus point, as if you were using autofocus. When the subject at that point is in focus, a green dot appears at far left of the Viewfinder data display. In P, S, and A modes you can also use the exposure display as a focus guide or rangefinder; it can tell you whether focus is just slightly out, or a long way off, and whether the camera's focusing in front of or behind the subject. It takes a little practice to make use of these readings and the rangefinder is off by default. To enable it, use the **Rangefinder** item in the Setup menu (*see page 117*).

› AF-area modes

The D3300 has 11 focus points covering much of the frame—they are lightly outlined in the Viewfinder. To focus on the desired subject, it's vital that the camera uses the appropriate focus point(s); this is the function of AF-area mode. Select AF-area mode in the Active Information Display or the Shooting menu.

By default, the camera selects the focus point automatically (Auto-area), but you can always change to manual selection in any shooting mode. However, the camera

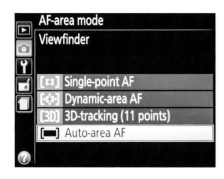

AF-area mode
Viewfinder

[] Single-point AF
[] Dynamic-area AF
[3D] 3D-tracking (11 points)
[] Auto-area AF

**AF-AREA MODE SELECTION IN ⌃
THE SHOOTING MENU**

only "remembers" this selection in P, S, A, or M modes. If you change the default setting in any of the Auto or Scene modes it will remain in effect only as long as you remain in that exposure mode. For instance, if you switch from Portrait to Landscape and then back again, you'll find that the camera has reverted to Auto-area.

Auto-area [■]

In Auto-area, the D3300 selects the focus point automatically, effectively deciding what the subject is. When Type G or D lenses are used, face recognition allows the camera to distinguish a human subject from the background. Determining what the subject is seems a pretty basic decision—and the other AF-area modes let you do just that.

Single-point []

In this mode, you select the focus area, using the Multi-selector to move quickly through the 11 focus points. The chosen focus point is briefly illuminated in the Viewfinder. This mode is best suited to relatively static subjects, and marries naturally with AF-S autofocus mode.

Dynamic-area AF []

Dynamic-area AF is available when using AF-C mode (continuous-servo AF). You still select the initial focus point, as in Single-area AF, but if the subject moves off this point, the camera will then employ other focus points to maintain focus. This mode is naturally best suited to moving subjects, but particularly if they remain generally in line with the initial focus point.

FLOWER FOCUS ⌄
The ability to select focus points is most helpful with off-center subjects, or if you want to focus on a very specific point, like this Herb-robert flower. *100mm macro, 1/640 sec., f/5.6, ISO 200.*

3D tracking (11 points) [3D]

This mode, too, is available when using AF-C continuous-servo AF. Again, the initial focus point is still selected by the user. However, if the subject moves, 3D tracking uses a wide range of information, including subject colors, to maintain focus as long as you keep the shutter release semi-depressed. This mode is probably your best bet for subjects which are moving not only towards or away from you but also across the field of view.

3D TRACKING

3D tracking is best for subjects moving both towards the camera and across the field of view. *120mm, 1/1600 sec., f/4, ISO 1600.*

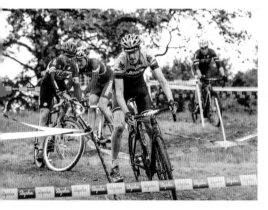

› Focus points

The D3200 has 11 focus points covering most of the central area of the image frame, which means you can generally make a quick and precise selection to focus accurately on any subject.

Focus point selection

1) Ensure the camera is set to an AF-area mode other than [■] Auto-area.

2) Half-depress the shutter release to activate autofocus.

3) Using the Multi-selector, move the focus point to the desired position (pressing OK jumps directly to the central focus point). The chosen focus point is briefly highlighted in red.

4) Press the shutter-release button halfway to focus at the selected point; depress it fully to take the shot. If the AF-area mode is [⟨⟩] or [3D], the focus point may move to track the subject.

› Focus lock

Though the 11 focus points cover a wide area, they do not extend to the edges of the frame, and sometimes you may need to focus on a subject that does not naturally coincide with any of the focus points. To do this, the simplest procedure is as follows:

1) Adjust framing to bring the subject within the available focus area.

2) Select a focus point and focus on the subject in the normal way.

3) Lock focus. In AF-S mode, this can be done by keeping half-pressure on the shutter-release button, or by pressing and holding **AE-L/AF-L**. In AF-C mode, only **AE-L/AF-L** can be used.

4) Reframe the image as desired and press the shutter-release button fully to take the picture. If you maintain half-pressure on the shutter-release button (in AF-S), or hold **AE-L/AF-L** (in any AF mode), focus remains locked for further shots.

Focus lock really only works for static subjects. To maintain focus on moving subjects, make sure they are within the area covered by the focus points when you shoot.

VIEWFINDER FOCUS AREAS ⌄
The Viewfinder displays the available focus areas as well as an in-focus indicator at the left of the menu bar.

Note:
At default settings, **AE-L/AF-L** locks exposure as well as focus, but this can be changed using the **Buttons** item in the Setup menu (*page 118*).

› The AF-assist illuminator

AF-ASSIST ILLUMINATOR ⌄

A small lamp is available to help the camera focus in dim light. It requires the camera to be in AF-S, and either the central focus point must be selected or AF-A must be engaged. If these conditions are met, it illuminates automatically when required. Obviously, its range is limited. It can be turned off in the Shooting menu (**Built-in AF-assist illuminator**), and is always off in some Scene modes.

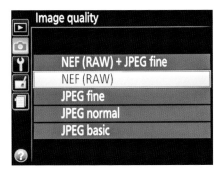

SETTING IMAGE QUALITY IN THE ACTIVE INFORMATION DISPLAY ⌃

The Image quality settings are not some miraculous shortcut to great pictures; that is still—thank goodness—ultimately up to us. Instead, "Image quality" refers to the file format, or the way that image data is recorded.

The D3300 offers a choice of two file types: NEF (RAW) and JPEG. The essential difference is that JPEG files are processed in-camera to produce files that should be usable right away (for instance, for direct printing from the memory card), without further processing on computer.

NEF (RAW) files, on the other hand, record image data from the sensor complete and unadulterated, without onboard processing. The generic term for such files is RAW or Camera RAW; NEF is a Nikon-specific variety of RAW file. Shooting RAW leaves much greater scope for processing later to achieve exactly the pictorial result you desire. RAW files capture much more information than JPEGs and consequently produce larger file sizes. As a result, the camera takes longer to transfer them to the memory card. The maximum continuous shooting rate remains around 5fps, but the number of images you can shoot at this rate is limited. The exact number depends mainly on the write-speed of the memory card, but even with a fast (80Mb/s) card, I've found eight frames to be the limit before the shooting speed slows down drastically. If you want to catch a longer high-speed sequence, shoot JPEG, which allows you to shoot up to 100 images in one burst.

The D3300 also allows you to capture two versions of the same image simultaneously, one NEF (RAW) and one JPEG. The JPEG serves for immediate needs while the RAW version can be processed later for the ultimate result.

It's often assumed that RAW is the "real" photographer's choice and JPEG is for the casual snapper, but it's not quite that clear-cut. You can get great results shooting JPEG (especially at Fine quality setting). However, there's less room to "fix" images later so, if you're serious about great results, shooting JPEG demands at least equal, if not greater care, especially in relation to exposure and white balance.

The D3300's Effects modes do not allow you to capture RAW files, because image processing is integral to these modes. When you use the Retouch menu (*page 121*), the end product is a JPEG image.

Setting image quality

1) In the Active Information Display, select **Image quality**. You can also use the Shooting menu.

2) Press (OK) to bring up the list of options (see the table below). Using the Multi-selector, highlight the required setting then press (OK) again to make it effective.

Tip

*If you've taken a shot in RAW but then wish you had a JPEG version, perhaps for immediate printing or to upload through Wi-Fi, you can create one using the **NEF (RAW) Processing** item in the Retouch menu (see page 124).*

Image quality options

RAW	14-bit NEF (RAW) files are recorded for the ultimate quality and creative flexibility.
FINE	8-bit JPEG files are recorded with a compression ratio of approximately 1:4; should be suitable for prints of A3 size or even larger.
NORM	8-bit JPEG files are recorded with a compression ratio of approximately 1:8; should be suitable for modest-sized prints.
BASIC	8-bit JPEG files are recorded with a compression ratio of approximately 1:16, suitable for transmission by email or website use but not recommended for printing.
RAW + F	Two copies of the same image are recorded simultaneously, one NEF (RAW) and one JPEG (Fine, Normal, or Basic).

› Image size

» WHITE BALANCE

For JPEG files, the D3300 offers three options for image size. **Large** is the maximum available size from the D3300's sensor, i.e. 6000 x 4000 pixels. **Medium** is 4496 x 3000 pixels, roughly equivalent to a 13.5-megapixel camera. **Small** is 2992 x 2000 pixels, roughly equivalent to a 6-megapixel camera. Even **Small** size images exceed the maximum resolution of an HD TV, or almost any computer monitor, and can yield reasonable prints up to at least 12 x 8 inches (30 x 20cm). **Medium** exceeds the resolution of the new breed of 4K TV sets.

RAW files are always recorded at the maximum size, and if you select RAW+F the JPEG image will be Large too.

Setting image size

1) In the Active Information Display, select **Image size**. (If **Image quality** is set to **RAW** or **RAW+F** you will not be able to select this item.)

2) Press (OK) to show the list of options. Using the Multi-selector, highlight the required setting then press (OK) again to make it effective.

You can also use the Shooting menu.

Light sources, natural and artificial, vary enormously in color. The human eye and brain are very good (though not perfect) at compensating for this and seeing people and objects in their "true" colors, so that we nearly always see grass as green, and so on. Digital cameras also have a capacity to compensate for the varying colors of light and, used correctly, the D3300 can produce natural-looking colors under almost any conditions you'll ever encounter.

The D3300 has a sophisticated system for determining white balance (WB) automatically, which produces good results most of the time. For finer control, or for creative effect, the D3300 also offers a range of user-controlled settings, but these are only accessible when using P, S, A, or M modes.

> ### *Tip*
>
> *When shooting RAW images, the in-camera WB setting is not crucial, as white balance can be adjusted in later processing. However, it affects how images look on playback and review, so there is still some value in setting WB appropriately.*

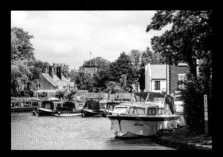

INCANDESCENT ⌃

COOL-WHITE FLUORESCENT ⌃

DIRECT SUNLIGHT ⌃

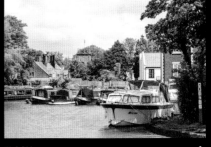

FLASH ⌃

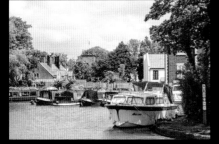

CLOUDY ⌃

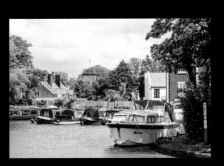

SHADE ⌃

WHITE BALANCE SETTINGS
The effects of different white balance settings.

2

Setting white balance

There are two ways to set white balance (three if you count the **Fn** button, *see page 118*):

Using the Active Information Display

1) In the Active Information Display, select the **WB** item and press (OK) to reveal a list of options.

2) Use the Multi-selector to highlight the required setting, then press (OK) to accept it.

Using the Shooting menu

This is a slower method but makes extra options available.

1) Press **MENU**, select **Shooting menu** and navigate to **White Balance**.

2) Press (OK) to reveal a list of options.

3) Use the Multi-selector to highlight the required setting, then press (OK). Alternatively press ▶.

4) If you press ▶, a graphical display appears. Using this, you can fine-tune the setting using the Multi-selector, or just press (OK) to accept the standard value.

5) If you select **Fluorescent** at step 3, a sub-menu appears from which you can select an appropriate type of fluorescent

lamp (see the table). You can then fine-tune this setting even further by pressing press ▶ as in step 4.

> **Note:**
> If you use the the Active Information Display to select **Fluorescent**, the value will be whatever was last selected in the sub-menu under the Shooting menu. (The default is **4: Cool-white fluorescent**.)

› Preset Manual White Balance

You can set the white balance to precisely match any lighting conditions, by taking a reference photo of a neutral object. Frankly, this is a cumbersome procedure that few of us will ever employ (see the *Nikon Reference Manual* for details—it covers six pages). It's normally much easier to shoot RAW and tweak the white balance later; a reference photo can also be helpful for this when high precision is required.

> ### *Tip*
>
> *The end-papers of this book are designed to serve as "gray cards", ideal for reference photos for these purposes.*

Icon	Menu option	Color temperature	Description
AUTO	Auto	3500–8000	Camera sets WB automatically, using information from imaging and metering sensors. Most accurate with Type G and D lenses.
⚫	Incandescent	3000	Use in incandescent (tungsten) lighting, e.g. traditional household bulbs.
	Fluorescent (Submenu offers seven options):		
	1) Sodium-vapor lamps	2700	Use in sodium-vapor lighting, often used in sports venues.
	2) Warm-white fluorescent	3000	Use in warm-white fluorescent lighting.
	3) White fluorescent	3700	Use in white fluorescent lighting.
☀	**4)** Cool-white fluorescent	4200	Use in cool-white fluorescent lighting.
	5) Day white fluorescent	5000	Use in daylight white fluorescent lighting.
	6) Daylight fluorescent	6500	Use in daylight fluorescent lighting.
	7) High temp. mercury-vapor	7200	Use in high color temperature lighting, e.g. mercury vapor lamps.
☀	**Direct sunlight**	5200	Use for subjects in direct sunlight.
⚡	**Flash**	5400	Use with built-in flash or separate flashgun.
☁	**Cloudy**	6000	Use in daylight, under cloudy or overcast skies.
⬛	**Shade**	8000	Use on sunny days for subjects in shade.
K	**Choose color temp.**	2500–10,000	Select color temperature from list of values.
PRE	**Preset Manual**	n/a	Derive white balance direct from subject or lightsource, or from an existing photo.

2

Note:

Energy-saving bulbs, which have largely replaced traditional incandescent (tungsten) bulbs in many countries, are compact fluorescent units. Their color temperature varies but many of those in domestic use are rated around 2700°K, equivalent to Fluorescent setting 1 Sodium-vapor lamps. In case of doubt, it's always a good idea to take test shots if possible, or allow for later adjustment by shooting RAW files.

Tip

If images consistently appear color-shifted on your computer screen, compensating by adjusting the camera's white balance is probably not the answer; the problem may well be with the computer screen settings. See page 222.

› Color space

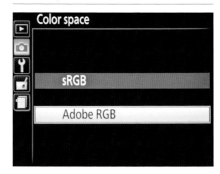

SETTING COLOR SPACE IN THE SHOOTING MENU ⌃

Color spaces define the range (or gamut) of colors which can be recorded. The D3300 offers a choice of sRGB and Adobe RGB color spaces. The chosen color space will apply to all shots taken in all exposure modes. To select the color space, use the **Color space** item in the Shooting menu.

sRGB (the default setting) has a narrower gamut but images appear brighter and more punchy. It's the standard color space online and in photo printing stores, and is a safe choice for images to be used or printed with little or no post-processing.

Adobe RGB has a wider gamut and is used in professional printing and reproduction. It's a better choice for professional applications or where significant post-processing is anticipated. However, images straight from the camera may look dull on most computers and web devices or if printed without full color management.

› ISO SENSITIVITY SETTINGS

The ISO setting governs the camera's sensitivity to greater or lesser amounts of light. At higher ISO settings, less light is needed to capture an acceptable image. As well as accommodating lower light levels, higher ISOs are also useful when you need a small aperture for increased depth of field (*see page 65*) or a fast shutter speed to freeze rapid movement (*see page 63*).

Conversely, lower ISOs are useful in brighter conditions, and/or when you want to use wide apertures or slow shutter speeds. The D3300 offers ISO settings from 100 to 12,800. Image noise (*see page 89*) does increase at higher settings. The D3300 manages this well, but you may still find noise levels at the highest ISOs exceed your tolerance: try a few shots and see for yourself.

There is an additional setting beyond the standard range, **Hi1.0**, equivalent to 25,600 ISO. Here, noise is unquestionably obvious and you'll probably want to use this only as a last resort. You can go even higher using Night Vision in the Effects modes (*page 46*).

› Auto ISO

By default, the D3300 sets the ISO automatically. It's possible to change to a manual setting in most exposure modes (except 📷, ⚡, 🏞, and 🎯). This new setting will continue to apply if you switch exposure modes. However, if you switch to P, S, A, or M mode and then back to a Scene or Effects mode, the camera reverts to Auto ISO. The D3300 only permanently "remembers" manual settings in P, S, A, or M modes.

The **ISO sensitivity settings** item in the Shooting menu has a sub-menu called **Auto ISO sensitivity control**. This is only available in P, S, A, and M modes.

This can be a little confusing, as it is not the same as Auto ISO in other modes, which means the camera takes complete control of ISO. Auto ISO sensitivity control in P, S, A, or M modes, however, is more of a sort of backstop. It allows the camera to override your chosen setting if it determines that this is required for correct exposure. Extra options within this menu allow you to limit the maximum ISO and minimum shutter speed which the camera can employ when applying Auto ISO sensitivity control. For instance, if ISO 3200 produces too much image noise for your liking, you can set the Auto ISO limit to 1600.

The usual way to set the ISO is through the Active Information Display:

1) Select the **ISO** item and press ⓄⓀ to reveal a list of options.

2) Use the Multi-selector to highlight the required setting, then press ⓄⓀ to accept it.

Alternatively, use the **ISO sensitivity settings** item in the Shooting menu.

There is also a third option. You can assign the **Fn** button to **ISO sensitivity** using the **Buttons** item in the Setup menu (*see page 118*); in fact, this is the default setting. At this setting, pressing **Fn** highlights **ISO** in the Information Display; keep it pressed and you can change the setting simply by rotating the Command Dial. If you change ISO settings regularly (and arguably you should), this is the fastest way to do so and probably the best use of the **Fn** button.

HIGH ISO **«**
I needed a high ISO to get a handheld shot of this tour guide at Turku Castle in Finland.
85mm, 1/100 sec., f/4.5, ISO 3200.

› ISO and image quality

Variable ISO is one of the greatest advantages of digital over film, as you'll appreciate if you've ever struggled with a 35mm camera and film of the wrong speed! Being able to vary the ISO at any time gives terrific flexibility. Many digital photographers change it almost as frequently as they do aperture and shutter speed. Others don't, but they should. If you want to ease yourself in gently, just observe what ISO settings the camera is applying when you're shooting in Auto or Scene modes. You can read these from the Information Display. Most photo apps on your computer will also let you see what ISO (and other settings) were used.

The ability to set high ISO ratings is extremely valuable at times, but there are some compromises to be made. Most obviously, image noise increases. Image noise is created by random variations in the amount of light recorded by each

pixel, and appears as speckles of varying brightness or color. It's most conspicuous in areas that should have an even tone, especially in the darker areas of the image. Serious noise also obscures fine detail.

Noise reduction, including the D3300's inbuilt variety, can reduce the grainy appearance of images, but it, too, can erode fine detail, and at higher levels can give images an artificial, "plastic" appearance.

High ISO levels can also reduce color intensity and curtail dynamic range (the range of brightness between the brightest and darkest areas which still hold detail in an image). Sometimes setting a high ISO is the only practicable way to capture an image in poor light (especially with moving subjects), but often using a tripod with a lower ISO and longer shutter speed will give much better results.

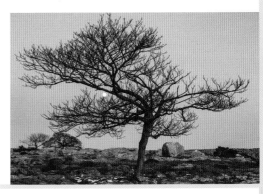

LOW ISO »
I could have set a high ISO and handheld this shot, but I preferred to use a low ISO and a long exposure, mainly to maximize dynamic range. *34mm, 1.3 sec., f/11, ISO 100, tripod.*

Until recently, Live View on a DSLR has been seen as an adjunct to the Viewfinder, not a substitute for it. The SLR is essentially designed around the Viewfinder and it still has many advantages for general picture-taking. For one thing, it's more intuitive and offers the sense of a direct connection to the subject. Also, the risk of camera shake is much reduced. Another important factor is that Viewfinder-based autofocus is very much faster, so the Viewfinder is often the only realistic option for action shooting.

However, attitudes are changing. To get the full benefit from the high image quality of today's cameras, discerning shooters use tripods regularly; this dilutes the handling advantages of the Viewfinder. Also, Live View focusing, though much slower than Viewfinder-based AF, is more accurate. Live View also gives you a form of depth of field preview (*see page 95*), which the D3300's Viewfinder doesn't offer.

Finally, Live View is the jumping-off point for shooting movies, so familiarity with Live View is a big help if you're new to video shooting.

› Using Live View

LIVE VIEW ACTIVATION BUTTON ⌃

To activate Live View, press the Lv button on the back of the camera, above the Multi-selector. To exit Live View press Lv again.

When you enter Live View, the mirror flips up and stays there. The Viewfinder blacks out, and the LCD screen displays a continuous live preview of the scene. A range of shooting information is displayed at top and bottom of the screen, partly overlaying the image. Pressing **INFO** changes this information display, cycling through a series of screens as shown in the table below; a further press returns you to the starting screen.

Live View info	Details
Show detailed photo indicators (default)	Information bars superimposed at top and bottom of screen.
Show movie indicators	Information for movie shooting superimposed; movie frame area also indicated; pressing brings up movie-related options.
Hide indicators	Key shooting information shown at bottom of screen.
Framing grid	Grid lines appear, useful for critical framing.

SHOW DETAILED PHOTO INDICATORS ⌃

When Live View is active, pressing **◄ꞮꞬ►** superimposes a modified Active Information Display on the screen and you can select options in the usual way. Press **◄ꞮꞬ►** again, or half-press the shutter-release button, to hide this display.

Press the release button fully to take a picture, as in normal shooting. In continuous release mode the mirror stays up, and the monitor remains blank, between shots, making it almost impossible to follow moving subjects (another reason why Viewfinder shooting is better for action).

If Auto or Scene modes are selected, exposure control is fully automatic, except that in Scene modes exposure level can be locked by pressing and holding **AE-L/AF-L**. In P, S, A, or M modes, exposure control is much the same as in normal shooting. If you use exposure compensation in P, S, or A modes, the brightness of the Live View display changes to reflect this. However, this can't be relied on as a preview of the final image. In M mode the brightness of the display does not change as you adjust settings.

FOCUSING IN LIVE VIEW ⌃

The focus area (red rectangle) can be positioned anywhere on screen, and you can also zoom in for greater precision.

Focusing in Live View operates differently from normal shooting; because the mirror is locked up, the usual focusing sensor is unavailable. Instead, the camera reads focus information directly from the main image sensor. This is slower than normal AF operation—often very noticeably so—but very accurate. You can also zoom in the view, which helps in placing the focus point exactly where you want it. It can be a big help with manual focusing too.

Live View has its own set of autofocus options, with two AF modes and four AF-area modes.

FOCUS ZOOM ⌃

Live View AF modes

The AF-mode options are Single-servo AF (AF-S) and Full-time servo AF (AF-F). AF-S corresponds to AF-S in normal shooting: the camera focuses when the shutter release is pressed halfway, and maintains that focus if you keep the button held down. You can also lock focus with *AE-L/AF-L* (except in 🄰 and 🄴).

AF-F corresponds roughly to AF-C in normal shooting. However, the camera continues to seek focus as long as Live View remains active. When you press the shutter-release button halfway, the focus will lock, and remains locked until you release the button or take a shot.

anbml

anbml

anbml

anbml

anbml

anbml

anbml

anbml

anbml

anbml

anbml

anbml

anbml

anbml

anbml

anbml

anbml

anbml

anbml

Selecting the Live View AF mode

1) Activate Live View with **Lv**.

2) Press to engage the Active Information Display and use the Focus mode item to select between AF-S and AF-F (Manual Focus is also available).

3) Press again to return to Live View.

Live View AF-area mode

AF-area modes determine how the focus point is selected, as they do in normal shooting. There are four Live View AF-area modes, which are different from those used in normal shooting (see the table below). Again, selection is through the Active Information Display—except in , , and , where AF-area mode is predetermined.

AF Mode	Description
Face priority	Uses face detection to identify people. Yellow border appears outlining faces. If multiple subjects are detected the camera focuses on the closest. Fixed in and . Default in , , , and .
Wide-area	Camera analyzes focus information from area approximately $1/6$ the width and height of the frame; area is shown by red rectangle. Fixed in . Default in , , , , , , , , VI, POP, , .
Normal area	Camera analyzes focus information from a much smaller area, shown by red rectangle. Useful for precise focusing on small subjects. Default in .
Subject tracking	Camera follows selected subject as it moves within the frame. Not available in , , , , , .

⌷ **Wide-area AF and**
⌷ **Normal area AF**

In both these AF modes, you can move the focus area (outlined in red) anywhere on the screen, using the Multi-selector in the usual way. Pressing ⊕ zooms the screen view—press repeatedly to zoom closer. Helpfully, the zoom centers on the current focus point. This allows ultra-precise focus control, especially when shooting on a tripod; it's excellent for macro photography (*page 153*). Once the focus point is set, autofocus is activated as

normal by half-pressing the shutter-release button. The red rectangle turns green when focus is achieved.

> ### *Tip*
>
> *The ability to move the focus point anywhere on screen is useful for off-center subjects, especially when using a tripod. In handheld shooting it's often quicker and easier to use the Viewfinder and employ focus lock (page 78).*

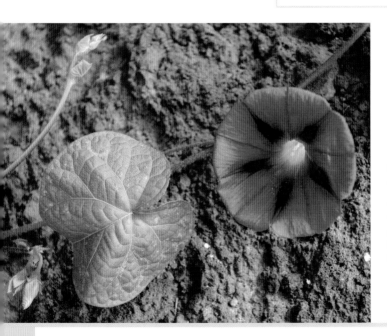

NORMAL «
AREA AF
Normal area AF is the best choice for precision and accuracy, and well suited to the stringent focusing demands of close-up photography.
62mm, 1/100 sec., f/5.6, ISO 200.

⊙ Face-priority AF

When this mode is active, the camera automatically detects up to 35 faces and selects the closest. The selected face is outlined with a double yellow border. You can override this and focus on a different person by using the Multi-selector to shift the focus point. To focus on the selected face, press the shutter-release button halfway. It's no surprise that this is the fixed Live View AF-Area mode for 🅰 and ⚡, but I have never been able to understand why it is the default for ⛰ Landscape as well!

Manual focus

Manual focus is engaged as in normal shooting (*see page 76*). However the Live View display continues to reflect the selected Live View AF mode. It's a good idea to select Wide-area AF or Normal-area AF beforehand.

Depth of Field Preview

Unlike normal shooting, Live View stops the lens down to the aperture you've set, and therefore gives you a good idea of the depth of field in the final shot. However, if you change the aperture setting while you're in Live View, it doesn't update until you either take a shot or exit and re-enter Live View.

⊙ Subject tracking AF

When Subject tracking is selected, a white rectangle appears at the center of the screen. If necessary, move this to align with the desired subject, using the Multi-selector, then press ⓞⓚ. The camera "memorizes" the subject and the rectangle then turns yellow. It will now track the subject as it moves, and can even reacquire the subject if it temporarily leaves the frame. To focus, press the shutter-release button halfway; the target rectangle blinks green as the camera focuses and then becomes solid green. If the camera fails to focus the rectangle blinks red instead. Pictures can still be taken but focus may not be correct. To end focus tracking press ⓞⓚ again.

Warning!

Subject tracking can't keep up with rapidly moving subjects. Viewfinder shooting is much more effective for serious action photography.

2 ›› IMAGE ENHANCEMENT

The D3300 offers two main kinds of in-camera image adjustment and enhancement. First, certain settings can be applied before shooting an image (pre-shoot controls).

Second, changes can be made to existing images on the memory card (post-shoot options). Access these from the Retouch menu (*see page 121*).

› Pre-shoot controls

Many of the controls that we've already looked at have obvious and direct effects in the final image: aperture, shutter speed, ISO, white balance, and many more. In addition, the D3300 offers several other ways to influence how the image will look, notably Active D-Lighting and Nikon Picture Controls.

ACTIVE D-LIGHTING COMPARISON ⌄ ››
The shot with ADL on (right) has better shadow detail (look at the interior) and also looks richer in the highlights (e.g the palest bits of brickwork). *25mm, 1/10 and 1/20 sec., f/11, ISO 200.*

› Active D-Lighting

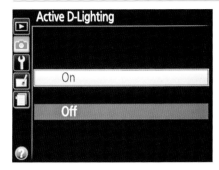

**ACTIVE D-LIGHTING IN
THE SHOOTING MENU** ⌃

Active D-Lighting enhances the D3300's ability to cope with scenes that show a wide range of brightness (dynamic range). In simple terms, it reduces the overall exposure to improve highlight capture, while mid-tones and shadows are boosted as the camera processes the image. Don't confuse it with the similarly-named D-Lighting, which is a post-shoot option (*see page 122*). You turn **Active D-Lighting On** or **Off** in the Shooting menu.

Picture Controls influence the way JPEG files are processed by the camera. In Auto, Scene, and Effects modes, Picture Controls are predetermined, but in P, S, A, or M modes you can freely choose and fine-tune them.

There are six preset Picture Controls. Names like **Neutral (NL)** and **Vivid (VI)** are self-explanatory, and **Monochrome (MC)** even more so. **Standard (SD)** gives a compromise setting which works reasonably well in a wide range of situations. **Portrait (PT)** is designed to deliver milder contrast, saturation and sharpening, with color balance that is flattering to skin-tones. **Landscape (LS)** produces higher contrast and saturation for more vibrant, punchy images.

> **Tip**
>
> *Active D-Lighting and Picture Controls have a direct effect on JPEG images. When shooting RAW files, they have no effect on the basic raw data. However, they do affect the appearance of preview/playback images on the monitor.*

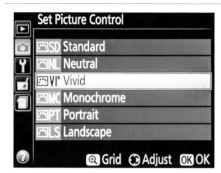

**PICTURE CONTROL SELECTION ☆
IN THE SHOOTING MENU**

Selecting Nikon Picture Controls

1) In the Shooting menu, select **Set Picture Control**.

2) Use the Multi-selector to highlight the required Picture Control and press ⊛.

This Picture Control will now apply to all images taken in P, S, A, or M modes. Scene/Effects modes continue to apply their preset Picture Controls.

Modifying Picture Controls

You can also modify the standard Nikon Picture Controls to your own taste. Use

VIVID AND NEUTRAL ≪
A composite showing Vivid (right) and Neutral (left) Picture Controls applied to the same subject. *35mm, 1/60 sec., f/9, ISO 1600.*

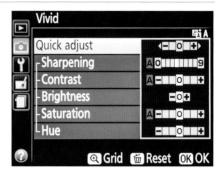

**PICTURE CONTROL ☆
MODIFICATION SCREEN**

Quick Adjust to make swift, across-the-board changes, or adjust the parameters (Sharpening, Contrast, and so on) individually.

1) In the Shooting menu, select **Set Picture Control**.

2) Highlight the required Picture Control and press ▶.

3) Use the Multi-selector to select **Quick Adjust** or one of the specific parameters. Use ▶ or ◀ to change each value as desired.

4) When all parameters are as required, press ⊛. The new values apply until you modify that Picture Control again.

The D3300's excellent screen makes playback pleasurable as well as informative. To display the most recent image, press ▶; if **Image Review** is **On** (selected in the Playback menu), images are also displayed automatically after shooting. (In CH or CL release modes, review begins after the last image in a burst is captured; images are shown in sequence.)

> **Note:**
> To conserve the battery, the monitor turns off after a period of inactivity. The default is 1 min. but intervals from 8 sec. to 5 min. can be set using **Auto off timers** in the Setup menu.

> ## Viewing other images

To view other images on the memory card, use ▶ to view images in the order of capture, ◀ to view in reverse order ("go back in time").

> ## Viewing photo information

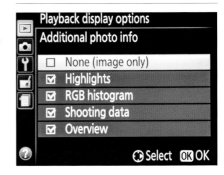

PLAYBACK DISPLAY OPTIONS　　　⌃

A wide range of information about each image can be viewed on playback, using ▲/▼ to scroll through up to nine pages of information.

To determine which pages are visible, visit **Playback display options** in the Playback menu (see table opposite). After checking or unchecking options, scroll up to **Done** and press (ok) to confirm changes.

> ## Playback zoom

To assess sharpness, or for other critical viewing, you can zoom in on a section of an image.

1) Press ⊕ (up to 10 times) to zoom the currently selected image. A small

Playback pages	Selection	Details
File information	Always available.	Displays large image, basic file info displayed at bottom of screen.
Overview	On by default; disable from Playback menu.	Displays small image, simplified histogram, summary information. Focus point used can also be shown: select using **Playback display options>Focus point**.
None (image only) menu	Enable from Playback.	Displays large image with other no data.
Location data	Page only appears when GPS location data was recorded during shooting (*see page 229*).	
Shooting data (3 pages)	Enable from Playback menu.	See below.
RGB histogram	Enable from Playback menu.	See below.
Highlights	Enable from Playback menu.	See below.

navigation window appears briefly, with a yellow outline indicating the visible area.

2) Use the Multi-selector to view other areas of the image.

3) Rotate the Command Dial to see other images at the same magnification.

4) To return to full-frame viewing, press (OK)

Tip

Maximum magnification (10 presses) can make even the best images appear pixelated and can give you the impression that none of your images are properly sharp! Eight presses should be enough even for critical users.

2

VIEWING IMAGES AS THUMBNAILS ⌃

Viewing images as thumbnails

Press ⊖▦▦ to display 4 images; repeat to see 9 images; and again to see 72. Press ⊕ to see fewer. The currently selected image (the one you'll see in full-frame playback) is outlined in yellow.

CALENDAR VIEW ⌃

Calendar View

Calendar View displays images grouped by the date on which they were taken. With 72 images displayed, press ⊖▦▦ again to reach the first calendar page (Date View),

with the most recent date highlighted, and pictures from that date in a strip on the right (the thumbnail list). Use the Multi-selector to select other dates. Press ⊖▦▦ again to enter the thumbnail list so you can scroll through pictures from the selected date; press ⊕ for a larger preview of the selected image.

› Deleting images

To delete the current image, or the selected image in Thumbnail View, press 🗑. A confirmation dialog appears. To proceed, press 🗑 again; to cancel, press ▶.

In Calendar View you can also delete all images taken on a selected date. Highlight that date in Date View, then press 🗑; when the confirmation dialog appears press 🗑 again to delete or ▶ to cancel.

› Protecting images

To protect the current image, press **AE-L/AF-L**. To remove protection, press again. Protected images can't be deleted as above, but be aware that they will be deleted when the memory card is formatted.

RGB HISTOGRAM DISPLAY »
This histogram shows a good spread of tones. There's a spike near the left side for the darkest areas, and a much larger one towards the right which represents the pale background.

› Histogram and highlights displays

The histogram is a graph showing the distribution of dark and light tones in an image. For assessing whether images are correctly exposed it's much more objective than examining the playback image itself—especially in bright conditions, when it's hard to see the screen clearly. The histogram display is a core feature of image playback and is usually the page I view first.

The overview playback page shows a single histogram; checking **RGB histogram** under **Playback display options** in the Playback menu gives access to a display showing individual histograms for the three color channels (red, green, and blue).

The D3300 can also display a flashing warning for areas of the image with "clipped" highlights, i.e. completely white areas with no detail recorded. This is another useful and objective exposure check.

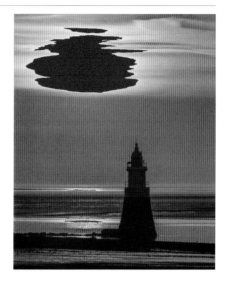

HIGHLIGHTS DISPLAY ⌃
The highlights are shown in red here; in the display on the camera these areas flash black.

ON REFLECTION ⌃
I used the highlight display after the first shot to make sure I wasn't losing detail in the highly reflective areas. *55mm, 1/160 sec., f/11, ISO 200.*

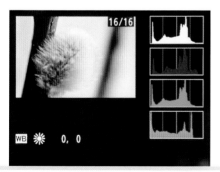

You can take photographs without a lens, even without a camera, but not without light. Light is the essence of photography, so it follows that paying attention to light is vital for a photographer. And light varies in so many ways: intensity, direction, color, and so on.

In the end, getting the exposure "right" isn't about matching some technical definition of what's correct; it's about making sure that images look the way you want them to look. However, you will generally want to preserve detail in both shadows and highlights as far as possible.

EVENING LIGHT
This is classic side-lighting, picking out all sorts of detail— look how it shows up the rivets on the floats, for example. I had to be a bit careful with exposure, as there were some very bright, reflective surfaces which could easily have lost all detail. I was shooting RAW; if I'd been shooting JPEG instead, I'd certainly have wanted Active D-Lighting on, and might well have bracketed my exposures for security.

> Focal length: 50mm
> Shutter speed: 1/250 sec.
> Aperture: f/13
> Sensitivity: ISO 250

Most of the time, the camera does a very good job of determining exposure, and will almost always get close enough so that you can make the final adjustments in post-processing (especially if you shoot RAW files).

However, the times when it may fall short are precisely the times when it matters most: when you want to make a really strong statement with an image, or when the light and the elements are at their most striking. This is when it really pays to make the small extra effort of checking exposure carefully and making an adjustment if necessary, perhaps by using exposure compensation or shooting in Manual mode.

DRAMATIC LIGHT »
The glow of the autumnal birch trees is key to this shot, but the rest of the image is predominantly quite dark and could have fooled the camera into overexposure, which could have destroyed vital highlight detail. In fact the exposure was at least 1 Ev less than the meter reading suggested.

> *Focal length: 170mm*
> *Shutter speed: 1/250 sec.*
> *Aperture: f/8*
> *Sensitivity: ISO 200*

3 MENUS

The options that you can access through buttons and dials are only the tip of the iceberg. There are many more ways in which you can customize the D3300 to suit you, but these are only revealed by delving into the menus. There are five of these: Playback, Shooting, Setup, Retouch, and Recent Settings.

The Playback menu, outlined in blue, covers functions related to playback, including viewing and deleting images. The Shooting menu, outlined in green, is used to control shooting settings such as ISO, white balance, or Active D-Lighting. Of course, many of these are also accessible via the Active Information Display. The Setup menu, outlined in orange, governs a range of functions such as formatting a memory card or adjusting LCD brightness, plus others that you may need to change only rarely, such as language and time settings. The Retouch menu, outlined in purple, lets you create modified copies of images on the memory card. Finally, Recent Settings is underlined in gray and allows fast access to recently used items from any of the other menus.

Tip

You can access help from within the menus by pressing ⊖⊞. *Help information is available when a* **?** *icon appears in the bottom left corner of the monitor.*

Navigating the menus
1) To display the main menu screen, press **MENU**.

2) Scroll up or down with the Multi-selector to highlight the different menus. To enter the desired menu, press ▶.

3) Scroll up or down with the Multi-selector to highlight specific menu items. To select an item, press ▶. In most cases this will take you to a further set of options.

4) Scroll up or down with the Multi-selector to choose the desired setting. To select, press ▶ or ⊛. In some cases you may need to scroll up to **Done** and then press ⊛ to make changes effective.

5) To return to the previous screen, press ◀. To exit the menus completely without effecting any changes, semi-depress the shutter-release button.

» PLAYBACK MENU

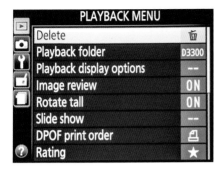

The D3300's Playback menu contains nine different items which affect how images are viewed, stored, shared, printed, or deleted. Most of these items are only accessible when a memory card—with image(s)—is present in the camera.

› Delete

This function allows images stored on the memory card to be deleted, either singly or in batches.

1) In the Playback menu, highlight **Delete** and press ▶.

2) In the menu options screen, choose **Selected, Select date,** or **All.**

3) If you choose **Selected**, images in the active playback folder or folders (see next page) are displayed as thumbnail images. Use the Multi-selector to scroll through the displayed images. Press and hold ⊕ to view the highlighted image full-screen. Press ९ �pad to mark the highlighted shot for deletion (you might think you'd use 🗑, but you can't). The image will be tagged with a 🗑 icon. If you change your mind, highlight a tagged image and press ९ ▪ again to remove the tag. Repeat this process to select further images. Press ⊙ to see a confirmation screen. Select **YES** and press ⊙ to delete the selected image(s); to exit without deleting any images, select **NO**.

4) If you choose **Select date**, you'll see a list of dates on which images on the memory card were taken. Use the Multi-Selector to scroll through the list. Press ▶ to mark the highlighted date for deletion. It will be checked in the list. If you change your mind, highlight the date and press ▶ again to remove the tag. Repeat this procedure to select further dates. Press ⊙ to see a confirmation screen. Select **YES** and press ⊙ to delete all image(s) taken on the selected date(s); to exit without deleting any images, select **NO**.

› Playback folder

By default, the D3300's playback screen will only display images in the current folder. For most of us, there is only ever one folder on the memory card, so this is of no significance. However, if you're one of the few who does end up with multiple folders, you can view images in all folders by changing this setting from **Current** to **All**.

Note:
The current folder is chosen through the Setup menu (*see page 119*).

› Playback display options

This is an important menu item, as it enables you to choose what (if any) information about each image will be displayed on playback, over and above the bare-bones info screen that is always available. These options have already been described on *page 100*.

› Image review

If Image review is **On**, the latest image is automatically displayed on the monitor immediately after shooting. If **Off**, images are only displayed when you press ▶. If you're looking to economize on battery life, choose **Off**.

› Rotate tall

This determines whether portrait format ("tall") images are displayed "right way up" during playback/image review. If set to **Off**, which is the default, these images will not be rotated, meaning that you need to turn the camera through 90° to view them correctly. If set to **On**, these images will be correctly orientated. However, because the monitor screen is rectangular, they will appear smaller.

› Slide show

This enables you to display images as a slide show, either on the camera's own screen or when it is connected to a TV. All images in the folder or folders selected for playback (under the Playback Folder menu) will be played in chronological order.

1) Make sure the playback screen is set to **Image only** (*see page 100*) to ensure an uncluttered slide show.

2) In the Playback menu, select **Slide show.**

3) Select **Image type** (i.e. still images, movies, or both). You can also select **By rating** to, for example, only include images you've rated five stars (*see page 110* for info on rating images).

4) Select **Frame interval**. Choose between **2**, **3**, **5**, or **10** seconds. Press (OK).

5) Select **Start** and press (OK).

6) When the show ends, a dialog screen is displayed. Select **Restart** and press (OK) to play again. Select **Frame interval** and press (OK) to return to the Frame interval dialog. Select **Exit** and press (OK) to exit.

7) If you press (OK) during the slide show, the slide show is paused and the same screen displayed. The only difference is that if you select **Restart** and press (OK), the show will resume where it left off.

› DPOF print order

This allows you to select JPEG image(s) to be printed when you connect the camera to, or insert the memory card into, a printer that complies with the DPOF (Digital Print Order Format) standard. If there are no JPEG images on the memory card this menu item is unavailable. (For more on printing *see page 230*.)

1) In the Playback menu, highlight **DPOF print order** and press ▶.

2) In the next screen, choose **Select/set**. Images in the current playback folder are displayed as thumbnails.

3) Use ▶/◀ to scroll through the displayed images. Press and hold ⊕ to view the highlighted image full-screen.

4) Press ▲ to select the image to be printed as a single copy. It will be tagged with a 🖶 icon and the number "01". To print more than one copy, press ▲ as many times as necessary; the number displayed increases accordingly.

5) Repeat this procedure to select further images. When all desired images have been selected, press (OK).

6) From the confirmation screen select **Print shooting data** if you wish shutter speed and aperture to be shown on all pictures printed. Select **Print date** if you wish the date of the photo to be shown. When you're ready to confirm the order, press (OK).

› Rating

This allows you to assign images a rating from one to five stars—and we've just seen, in **Slide show**, one possible use for this feature.

To assign ratings

1) In the Playback menu, highlight **Rating** and press ▶. Images in the current playback folder are displayed as thumbnails.

2) Use ▶/◀ to scroll through the displayed images. Press and hold ⊕ to view the highlighted image full-screen. Use ▲ to assign the image up to five stars (use ▼ to reduce a rating).

3) Repeat with further images. When finished, press ⊛ to exit.

› Select to send to smart device

This allows you to select existing images to be uploaded to your smartphone or tablet when you connect through Nikon's Wireless Mobile Utility (*see page 224*). As the D3300 does not have built-in WiFi, you'll also need a WU-1a mobile adapter. If the camera is not connected, you won't be able to access this item.

Selecting pictures for playback

1) In the Playback menu, highlight **Select to send to smart device** and press ▶. Images in the current playback folder are displayed as thumbnails.

2) Use the Multi-selector to scroll through the displayed images. Press and hold ⊕ to see a larger version of the highlighted image. Press ⊝🔳 to select the highlighted shot for upload. The image will be tagged with a ▶ icon. If you change your mind, highlight a tagged image and press ⊝🔳 again to remove the tag.

3) Repeat this process to select further images. When satisfied, press ⊛ to send the images and exit.

Selecting a single picture

You can also select an individual picture for upload directly from normal image playback.

1) With the desired image displayed (or highlighted if you're viewing thumbnails or in Calendar View), press ◀🔳.

2) A short list of options appears (**Rating** and **Retouch** are the others). Select **Select to send to smart device/ deselect** and press ⊛.

·› SHOOTING MENU

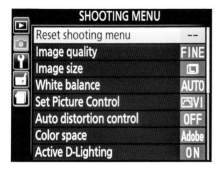

The Shooting menu contains numerous options, but many of these are also accessible through the Active Information Display and have already been discussed (*see page 31*).

› Reset shooting menu

This is simply a quick way to restore Shooting menu settings to the camera's original default settings. Use with caution as it can wipe out rafts of settings that you have carefully created. Note that it not only resets the full range of Shooting menu settings, but also other changes you may have made through the Active Information Display. These include focus mode (*page 74*), flash mode (*page 139*), exposure compensation (*page 70*), and flash compensation (*page 142*).

1) In the Shooting menu, select **Reset shooting menu** and press ⓞⓚ.

2) Select **Yes** and press ⓞⓚ. Or select **No** to make no changes.

› Image quality

Use this to choose between NEF (RAW) and JPEG options, as described on *page 80*.

› Image size

Use this to select image size, as described on *page 82*. If RAW is selected for Image quality this item is grayed out and cannot be accessed.

› White balance

Allows you to set the white balance, discussed in depth on *page 82*.

› Set Picture Control

This menu governs the use of Nikon Picture Controls, discussed in depth on *page 98*.

› Auto distortion control

If **On**, this automatically corrects for distortion (*see page 188*) which may arise with certain lenses. It's available only with Type G, E, and D lenses (*see page 182*), excluding fisheye and perspective correction lenses, and only affects JPEG images. Distortion affecting RAW images can only be dealt with in post-processing.

› Color space

Allows you to choose between sRGB and Adobe RGB color spaces (*see page 86*).

› Active D-Lighting

Governs the use of Active D-Lighting, discussed in depth on *page 97*.

› Noise reduction

Photos taken at long shutter speeds and/or high ISO sensitivity settings can be subject to increased "noise" (*see page 89*) and the D3200 offers the option of extra image processing to counteract this. If noise reduction (NR) is **ON**, it applies at all ISO settings, but the difference is much more obvious at higher settings.

When noise reduction is applied at long shutter speeds, image processing takes a time roughly equal to the shutter speed in use. During this time, **Job nr** appears,

blinking, in the Viewfinder, and no further pictures can be taken until the processing is complete. This can obviously cause significant delays in shooting and it's often preferable to tackle image noise in post-processing instead. Because of this, the recommended setting is **OFF**.

Even when NR is **OFF**, a limited degree of noise reduction will still be applied to JPEG images shot at ISO 1600 or above, but this does not appear to cause significant processing delays.

> ### *Tip*
>
> *High levels of NR will remove noise very effectively, but can also "smooth" the image so much it looks "plastic" and loses any semblance of fine detail. With JPEG images, you can't restore any of the lost texture or detail. Unless you're in a hurry, it's generally better to apply noise reduction in post-processing, when you can see the effect more clearly and back off if necessary.*

› ISO sensitivity settings

This menu governs ISO sensitivity settings, already discussed in depth on *page 87*.

› AF-area mode

Select the AF-area mode (*page 76*). AF-area mode is more usually chosen through the Active Information Display.

› Built-in AF-assist illuminator

This determines whether the AF-assist lamp operates in appropriate exposure modes (*see page 79*) or remains off in all modes.

› Metering

Use this to select the metering pattern (*page 68*). Metering pattern is more usually chosen through the Active Information Display.

› Flash cntrl for built-in flash

This governs how the built-in flash is regulated. The default is **TTL**, which means flash output is regulated automatically by the camera's metering system. If you select **Manual** instead, you can press ▶ and use a sub-menu to determine the strength of the flash, ranging from **Full** down to **1/32** power.

› Movie settings

Sets key options for movie shooting (*see page 167*).

» SETUP MENU

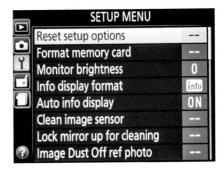

The Setup menu controls many important camera functions. While you might change Shooting menu options from one shot to the next, the Setup menu is mainly comprised of items that you will need to access only occasionally, if at all.

› Reset setup options

This resets most options in this menu to default settings; in other words, it returns the camera to the state it was in when you first unpacked it. There are a few exceptions, namely **Time zone and date**, **Language**, **Storage folder**, and **Video mode**; you can only reset these by going directly to that menu item.

› Clean image sensor and Lock mirror up for cleaning

For more details *see page 212*.

› Monitor brightness

This allows you to change the brightness of the LCD display with ▲/▼. Use with care; making review/playback images appear brighter does not mean the images themselves (e.g. as viewed on your computer) will be any brighter.

The point of this is to adapt to changing light levels in your surroundings. The screen shows a "step-wedge" with ten bands ranging from very dark to very light gray. It should be possible to distinguish clearly between all of them.

› Info display format

This lets you choose between **Graphic** (default) and **Classic** modes for the Information Display (see page 30). You can also select different background colors for each display mode.

There are separate options for User-control modes (P, S, A, and M) and for Auto, Scene, Effects modes. Setting a different screen mode, or just a different background color, could be a handy reminder of which group of modes you're in. However, the default for both groups is the same (Graphic mode with blue background).

› Format memory card

This is the one item in this menu you're likely to use regularly. The process is outlined on page 27.

› Auto info display

By default (i.e. this item is **On**), the Information Display appears automatically when you half-press the shutter-release button. If Image Review is Off (page 108), it will also appear immediately after you take a shot.

If you turn this item **Off**, the Information Display only appears when you press **INFO** or ◆🗐. You can turn Auto info display off to save power, or if you're working entirely through the Viewfinder.

› Image Dust Off ref photo

Nikon Capture NX2 (see page 226) offers automatic removal of dust spots on images, by comparing them to a reference photo which maps dust on the sensor. This can save a lot of "grunt work" compared to manually removing spots from individual images. This menu item allows you to take a suitable reference photo.

To take a dust-off reference photo

1) Fit a CPU lens of at least 50mm focal length. Locate a featureless white object

(e.g. a sheet of plain paper), large enough to fill the frame.

2) In the Setup menu, select **Image Dust Off Ref Photo** and press ▶.

3) Select **Start** or **Clean sensor** and then **Start** and press (ок). (Select Start if you have already taken the picture from which you want to remove spots.) **rEF** is shown in the Viewfinder readout.

4) Frame the white object at a distance of about 4in. (10cm). Press the shutter-release button halfway; focus is automatically set at infinity. This creates a soft white background against which dust spots stand out clearly.

5) Press the shutter-release button fully to capture the reference image.

› Flicker reduction

Some light sources can produce visible flicker in the Live View screen image and in movie recording. To minimize this, use this menu to match the frequency of the local mains power supply. **60Hz** is common in North America, and **50Hz** is normal in the European Union, including the UK. Normally, you can leave this on **Auto** and the camera will adjust automatically.

› Time zone and date

Sets date, time, and time zone, and specifies the date display format (**Y/M/D**, **M/D/Y**, or **D/M/Y**). Set your home time zone first, then set the time correctly. If you travel to a different time zone, simply change the time zone setting and the time will be updated automatically.

> **Note:**
> If the camera is connected to a GPS unit, it can correct the clock functions using the very accurate data from the satellite system. See Chapter 9 (*page 229*).

› Auto image rotation

If set to **ON** (default), information about the orientation of the camera is recorded with every photo taken, ensuring that they will appear the right way up when viewed with Nikon View NX2/Capture NX2 and most third-party imaging applications. To regulate how photos appear on the camera's own screen, use **Rotate tall** in the Playback menu (*page 108*).

› Language

Set the language which the camera uses in its menus. The options include over 30 European and Asian languages.

› Image comment

ENTERING TEXT

You can append brief comments (36 characters, or about a quarter of a Tweet) to images. Comments appear in the third info page on playback (*see page 100*) and can be viewed in Nikon View NX2 and Nikon Capture NX2. To attach a comment, select **Input comment** and press ▶.

To enter text, move through the onscreen "keypad" using the Multi-selector. Press **OK** to select the highlighted letter or number and move automatically to the next position. You can also use the Command Dial to move the cursor to a different position. When finished press ⚲. Select **Attach comment**, then select **Done**, and press ⊙. The comment will be attached to all new shots until turned off again.

› Auto off timers

This governs the interval before the Information Display, playback display, and Viewfinder display turn off when the camera is idle (i.e. you don't take any pictures, or operate any of the other controls). A shorter delay is, naturally, good for battery life. **Short/Normal/Long** determine standard times for each of the three displays. **Custom** allows the user to set timings for each display individually. The meters will not turn off automatically if the D3300 is connected to a computer or printer, or powered by a mains adapter.

› Self-timer

This menu has two sub-menus governing the operation of the self-timer. **Self-timer delay** determines the interval between pressing the button and the shot being taken. The default is **10 sec.**, alternatives are **2**, **5**, and **20 sec.** As well as taking a single shot, you can create sequences from one press of the release button. **Number of shots** can be set anywhere from **1** to **9**; if you set any value larger than 1, the interval between successive shots is approximately 4 sec..

› Remote on duration

If you're using the optional ML-L3 remote control (*see page 208*), this governs how

long the camera will remain on standby for a signal from the remote before remote control mode turns **Off** and the camera reverts to normal (Single frame) release mode. Options range from **1 min.** (default) to **15 min.** This does not apply in Live View shooting.

› Beep

If you wish, the camera can emit a beep when the self-timer operates, and to signify that focus has been acquired when shooting in single-servo AF mode. You can choose a **High** or **Low** pitch for the beep or turn the darn thing **Off** entirely.

› Rangefinder

This allows you (in P, S, and A modes) to use the Viewfinder exposure display as a focus guide or rangefinder (*see page 76*).

› File number sequence

This controls how image numbers are set. If it's **Off**—which is the default—file numbering is reset to 0001 whenever you insert a new memory card, format an

> **Note:**
> Even if sequence numbering is **On**, numbering does reset to 0001 after you've shot 9999 images.

existing card, or create a new storage folder (*see page 119*). If it's **On**, numbering continues from the previous highest number used; this may help you manage images on your computer. **Reset** creates a new folder and begins numbering from 0001.

› Slot empty release lock

By default (i.e. **Release locked** is selected in this menu), the shutter can't be released unless there's a memory card in the camera. The obvious lack of response protects you against shooting away happily for hours, only to discover later that none of your images have been recorded.

Alternatively you can select **Enable release**. In this case, images are held in the camera's buffer and can be displayed on the monitor, but are not recorded. This is known as demo mode. The most obvious use for this is when the camera is on display at a shop or trade show.

› Video mode

The name is potentially confusing, as this item is not related to the camera's Movie mode. You can connect the camera to a TV or VCR to view images; this menu sets the camera to **NTSC** or **PAL** standards to match the device you're connecting to. NTSC is used in North America and Japan, but most of the world uses PAL.

3 > Buttons

This menu item has three sub-sections, which allow you to change the functions of three of the camera's control buttons.

Section	Options
Assign Fn button	**Image quality/size**: press button and rotate Command Dial to scroll through full range of image quality/size options (*see page 81*).
	ISO sensitivity: press button and rotate Command Dial to select ISO setting (*page 87*). (This is the default.)
	White balance (P, S, A, or M modes only): press button and rotate Command Dial to select white balance setting (*see page 84*).
	Active D-Lighting (P, S, A, or M modes only): press button and rotate Command Dial to toggle ADL **On** or **Off** (*see page 97*).
Assign *AE-L/AF-L* button	**AE/AF lock** (default): press and hold button to lock focus and exposure.
	AE lock only: press and hold button to lock exposure (*see page 72*).
	AF lock only: press and hold button to lock focus.
	AE lock (hold): press button to lock exposure (*see page 72*).
	AF-ON: when AF-ON is selected, only the AE-L/AF-L button (not the shutter-release button) can be used to initiate autofocus.
Shutter release button AE-L	**On**: half-pressure on shutter-release button locks exposure and focus.
	Off (default): half-pressure on shutter-release button locks focus only (*see page 79*).

› Print date

This allows you to imprint **Date**, or **Date and time**, on photos (JPEG only) as they are taken. **Date counter** imprints number of days to/from a selected date.

> **Note:**
> Date and time info is always embedded in metadata (*page 225*), without needing to deface the image itself.

› Storage folder

By default the D3300 stores images in a single folder (named "100D3300"). If multiple memory cards are used they will all end up holding folders of the same name. This isn't usually a problem: it's organizing images on the computer that counts (*see page 227*). However, you can change this if you wish, perhaps so you can create specific folders for different shoots or different types of image.

The camera will automatically create a new folder when the current one becomes full. "Full" means it contains 999 images. If you download to your computer regularly and then format the card for reuse, this may never happen. However, it is a possibility if you are very prolific or you're travelling for long periods without access to a computer. In this case you might prefer to create an ordered series of folders, organized by location or date.

To create a new folder
1) In the Shooting menu, select **Storage folder** and press ▶.

2) Select **New** and press ▶.

3) Name the folder. The first three digits are assigned automatically, so only five (letters or numbers) are available. For details on text entry, see Image comment, *page 116*.

4) When you've set the name, press ⊙ to create the new folder. It automatically becomes the active folder.

You can also **Rename** an existing folder using a similar process.

To change the active folder
1) In the Shooting menu, select **Select folder** and press ▶.

2) Scroll through the list (assuming more than one folder exists) and press ⊙ to select a folder.

› Wireless mobile adapter

This simply lets you **Enable** or **Disable** the WU-1a Wireless Mobile Adapter, if one is connected.

3

› Accessory terminal

This menu item has two sub-sections:
Remote control and **Location data**.

Remote control sets some options
which apply if you're using one of Nikon's
more sophisticated Wireless Remote
Controllers (*see page 208*). They don't
apply if you're using the simpler ML-L3.
Remote shutter release dictates whether
the release button on the remote takes a
photo or starts/stops movie recording.
Assign Fn button determines what
happens when you press the **Fn** button on
the remote; you can set this to **Same as
camera *AE-L/AF-L* button**, in which case it
will activate whichever function you
selected for this (see Buttons, *page 118*).
You can also set it to **Live view**, in which
case it starts/stops Live View, mirroring the
Lv button on the camera.

Location data regulates the operation
of the onboard GPS. See Chapter 9
Connection, *page 229*.

› HDMI

You can also connect the camera to HDMI
(High Definition Multimedia Interface)
TVs—you'll need a special cable. This
menu sets the camera's **Output
resolution** to match the HDMI device. Get
this information from that device's specs or
instructions if you need it, but normally
you can leave this on **Auto**. The **Device**

control submenu applies when connected
to an HDMI-CEC television, and allows the
TV remote to be used to navigate through
the images.

› Eye-Fi upload

You can also set up a WiFi network
connection using an Eye-Fi card: see
Chapter 9 Connection (*page 224*). This
menu item is only visible when there's
an EyeFi card in the memory card slot.

› Firmware version

Firmware is the onboard software which
controls the camera's operation. Nikon
issues updates periodically. This menu
shows the version presently installed, so
you can verify whether it is current.
When new firmware is released, download
it from the Nikon website and copy it to a
memory card. Insert this card in the
camera then use this menu to update
the camera's firmware.

> **Note:**
> Firmware updates may include new
> functions and new menu items, which
> can make this Guide (and Nikon's own
> manuals) appear out of date.

»» RETOUCH MENU

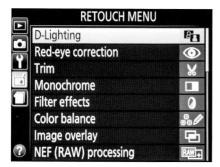

RETOUCH MENU

D-Lighting	
Red-eye correction	
Trim	
Monochrome	
Filter effects	
Color balance	
Image overlay	
NEF (RAW) processing	

The Retouch menu is used to make corrections and enhancements to images, including cropping, color balance, and much more. This does not affect the original image but creates a copy to which the changes are applied. Further retouching can be applied to the new copy, but you can't apply the same effect twice to the same image. Many of the effects are similar to those which can be created at the time of shooting through the Effects modes.

Copies are always created in JPEG format but the size and quality depends on the format of the original (a few exceptions, such as Trim and Resize, produce copies smaller than the original).

› To create a retouched copy

1) In the Retouch menu, select a retouch option and press ▶. If subsidiary options appear, make a further selection and press ▶ again. A screen of image thumbnails appears.

2) Select the required image using the Multi-selector, as you would during normal image playback. Press (OK). A preview of the retouched image appears.

3) Depending on the type of retouching to be done (see below), there may be further options to choose from.

4) Press (OK) to create a retouched copy. Or press ◀ to go back to the options screen. To exit without creating a copy, press [▶].

> **Note:**
> Retouched copy images are indicated by a ⧉ icon in normal image playback.

Format of original photo	Quality and size of copy
NEF (RAW)	JPEG (Fine, Large)
JPEG	JPEG (Quality and size same as original)

D-Lighting

Though related, D-Lighting should not be confused with Active D-Lighting. Active D-Lighting is applied before shooting; D-Lighting is applied later. In essence, it lightens the shadow areas of the image. The D-Lighting screen shows a side-by-side comparison of the original image and a preview of the retouched copy; a press on 🔍 zooms in on this preview. Use ▲ and ▼ to select the strength of the effect, from **Lo** to **Hi**. If your photo contains faces, you can select the **Portrait subjects** box. This will confine the effect to the faces. It will only work if the camera detects faces in the picture, and for three faces at most.

Red-eye correction

This tackles the notorious problem of "red-eye", caused by on-camera flash (see page 141). This option can only be selected for photos taken using flash. The camera analyzes the photo for evidence of red-eye; if none is found the process ends. If red-eye is detected a preview image appears; use the zoom controls and Multi-selector to view it more closely.

Trim

This allows you to crop images to improve framing or to match a specific print size. A preview screen indicates the crop area with a yellow rectangle. Change the aspect ratio of the crop with the Command Dial (see the table below). Adjust its size using 🔍 and 🔍. Shift its position using the Multi-selector.

Aspect ratio	Possible sizes for trimmed copy										
3:2	5760 x 3840	5120 x 3416	4480 x 2984	3840 x 2560	3200 x 2128	2560 x 1704	1920 x 1280	1280 x 856	960 x 640	640 x 424	
4:3	5328 x 4000	5120 x 3840	4480 x 3360	3840 x 2880	3200 x 2400	2560 x 1920	1920 x 1440	1280 x 960	960 x 720	640 x 480	
5:4	5008 x 4000	4800 x 3840	4208 x 3360	3600 x 2880	3008 x 2400	2400 x 1920	1808 x 1440	1200 x 960	896 x 720	608 x 480	
1:1	4000 x 4000	3840 x 3840	3360 x 3360	2880 x 2880	2400 x 2400	1920 x 1920	1440 x 1440	960 x 960	720 x 720	480 x 480	
16:9	6000 x 3376	5760 x 3240	5120 x 2880	4480 x 2520	3840 x 2160	3200 x 1800	2560 x 1440	1920 x 1080	1280 x 720	960 x 536	640 x 360

TRIM ⌃

The area of the new image is shown by the yellow rectangle.

Monochrome

Create monochrome copies: straight **Black-and-white**, **Sepia** (a brownish-toned effect), or **Cyanotype** (a bluish-toned effect). For **Sepia** or **Cyanotype**, you can make the toning effect stronger or weaker with ▲/▼.

MONOCHROME ⌄

Comparison of Sepia (left) and Cyanotype.

Filter effects

Mimics several common photographic filters (perhaps we should say they used to be common in the days of film). **Skylight** reduces the blue cast which can affect photos taken on clear days with a lot of blue sky. Applied to other images its effect is very subtle, even undetectable. **Warm filter** has a much stronger warming effect. **Red**, **green**, and **blue intensifier** are all fairly self-explanatory, as is **Soft**.

Cross screen, however, is an enigmatic name. It creates a "starburst" effect around light sources and other very bright points, like sparkling highlights on water. (Surely **Star** would have been a better name?) There are multiple options within this item, governing the number, angle, and length of the star points.

Color balance

Creates a copy with modified color balance. When this option is selected a preview screen appears and the Multi-selector can be used to move a cursor around a color grid. The effect is shown both in the preview and in the histograms alongside.

Image overlay

Image overlay allows you to combine two existing photos into a new image. This can only be applied to originals in RAW format.

You can even create a new RAW image by this method—the only Retouch menu option which allows you to do this.

Nikon claim that the results are better than combining the images in applications like Photoshop because Image overlay makes direct use of the raw data from the camera's sensor, but this is debatable; certainly, a large, calibrated computer screen gives you a much better preview of the result.

To create an overlaid image

1) In the Retouch menu, select Image overlay and press (OK). The next screen has panels labelled **Image 1**, **Image 2**, and **Preview**. Initially, **Image 1** is highlighted. Press (OK).

2) The camera displays thumbnails of RAW images on the memory card. Select the first image required for the overlay and press (OK). Press ▶ to move to Image 2 and select the second image.

3) Use the **Gain** control below each image to choose its "weight" in the final overlay. The preview changes to show the effect.

4) Use ◀ and ▶ to move between Image 1 and 2 if further changes are required. You can press (OK) to change the selected image in either position.

5) Finally, press ▶ to reach the **Preview** panel. With **Overlay** highlighted, press ⊕ to preview the overlay. Return to the main screen by pressing ⊖⊞. To save the combined image, highlight **Save** and press (OK).

› NEF (RAW) processing

This menu creates JPEG copies from images originally shot as RAW files. It's no substitute for full RAW processing on computer (*see page 225*), but it does let you create quick copies for previewing or printing. Processing options are displayed in a column alongside a preview image (see the table opposite above). When satisfied with the previewed image, scroll up to select **EXE**. Press (OK) to create the JPEG copy. Pressing **MENU** exits without creating a copy.

Option	Description
Image quality	Choose Fine, Normal, or Basic (*see page 81*).
Image size	Choose Large, Medium, or Small (*see page 82*).
White balance	Choose a white balance setting; options are similar to those described on *page 85*.
Exposure comp.	Adjust exposure (brightness) levels from +2 to −2.
Set Picture Control	Choose any of the range of Nikon Picture Controls (*see page 98*) to be applied to the image.
High ISO NR	Choose level of noise reduction as appropriate (*see pages 89, 112*).
Color space	Choose color space (*see page 86*).
D-Lighting	Choose D-Lighting level (High, Normal, Low, or Off) (*see page 122*).

› Resize

This option creates a small copy of the selected picture(s), suitable for immediate use with various external devices. Four possible sizes are available: see the table below.

› Quick retouch

Provides basic "quick fix" retouching, boosting saturation and contrast. D-Lighting is applied automatically to improve shadow detail. Use ◀ and ▶ to increase or reduce the strength of the effect, then press (OK) to create the retouched copy.

Option	Size (pixels)	Possible uses
2.5M	1920 x 1280	Display on HD TV, larger computer monitor, new iPad.
1.1M	1280 x 856	Display on typical computer monitor, older iPad.
0.6M	960 x 640	Display on standard TV, iPhone 4/5.
0.3M	640 x 424	Display on majority of mobile devices.

› Straighten

It's best to get horizons level at the time of shooting, but it doesn't always work out. This option offers a fall-back, with correction up to 5° in 0.25° steps. Use ▶ to rotate clockwise, ◀ to rotate anticlockwise. Inevitably, this crops the image.

› Distortion control

Some lenses create noticeable curvature of straight lines (*see page 188*): this menu allows you to correct this in-camera. This inevitably crops the image slightly. **Auto** allows automatic compensation for the known characteristics of Type G and D Nikkor lenses (**Auto Distortion control**, in the Shooting menu, can apply this automatically to JPEG images).

If you have images taken with other lenses, you'll have to use **Manual** instead.

› Fisheye

Instead of correcting it, this exaggerates barrel distortion to give a rough imitation of a fisheye lens effect. Use ▶ to increase the effect.

› Color outline

This detects edges in the photograph and uses them to create a "line-drawing" effect. There are no options to alter the effect.

COLOR **«**
OUTLINE

› Photo illustration

This simplifies colors and adds dark outlines where there are clear borders in the image. You can reduce or increase the **Thickness** of these outlines.

› Color sketch

This creates a copy resembling a colored pencil drawing. Controls for **Vividness** and **Outlines** adjust the strength of the effect.

› Perspective control

Corrects the convergence of vertical lines in photos taken looking up, for example, at tall buildings. Grid lines help you assess the effect, and you control its strength with the Multi-selector. The process inevitably crops the image, so leave room around the subject when you shoot. For alternative approaches to perspective control, and an example, *see page 194*.

COLOR SKETCH (VIVIDNESS AND OUTLINES BOTH SET TO MAX)

3

› Miniature effect

This option mimics the fad—already done to death—for shooting images with extremely localized depth of field, making real scenes look like miniature models. It usually works best with photos taken from a high viewpoint, which typically have clearer separation of foreground and background. A yellow rectangle shows the area which will remain in sharp focus. You can reposition and resize this using the Multi-selector. Press ⊕ to preview results and press ⊛ to save a retouched copy of the image.

› Selective color

You can select up to three specific colors to be preserved in the retouched copy, while any other hues are transformed to monochrome.

1) Use the Multi-selector to place the cursor over an area of the desired color. Press **AE-L/AF-L** to choose that color.

2) To select another color, turn the Command Dial again to highlight another "swatch" and repeat steps 1 and 2.

3) To save the retouched copy, press ⊛.

› Edit movie

This grandly-titled item merely allows you to trim the start and/or end of movie clips. It's nothing like proper editing (*see page 178*), but may have its uses. To trim a movie clip:

1) Select a movie clip in full-frame playback (do not play the movie).

2) Press ⬙, select **Edit Movie**, press ▶.

3) Select **Choose start/end point** and press ⊛. The screen shows the opening frame of the clip. Press **AE-L/AF-L** to jump between start and end points. Rotate the Command Dial to jump forward or backward in 10-second steps.

4) Press ⊛ to start playing the movie from the selected point. Press ▼ to pause.

5) With the clip paused at the required point, press ▲ to set the start/end point. Select **Yes** and press ⊛ to save the clip.

6) You can opt to **Save as new file** to create a trimmed copy while retaining the original. Alternatively select **Overwrite existing file** to save the trimmed copy and delete the original (there's no going back!)

7) Repeat if necessary to trim the other end of the clip.

RECENT SETTINGS MENU

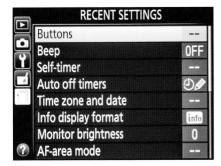

The Recent Settings menu automatically stores the most recent items that you have accessed from any of the other menus, providing a quick way to access controls that you have used recently. The list contains up to 20 items and so is likely to include any that you visit frequently.

SELF-PORTRAIT
Recent Settings can be the quickest way to access regular menu items: here it gave me quick access to self-timer options without burrowing into the Setup menu. *24mm (image cropped), 1/250 sec., f/11, ISO 200.*

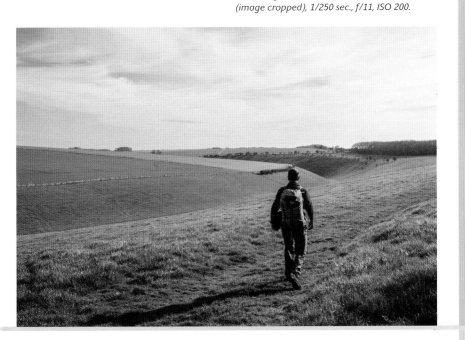

There's a lot of nonsense talked about composition, and above all about "rules" of composition. Composition—or framing, which is the word I prefer—is about what you can see and what you want to say about it. It's about what's in the picture and

BALANCE ⌄

Reflections in still water may suggest a perfectly symmetrical composition, with the horizon line across the center of the image. Here, however, the stones in the foreground shallows disturbed that exact symmetry. My first thought was to stand as far forward and as high as I could, to minimize intrusion of the stones into the reflection of the hills. The rest was just a case of looking at the frame as a whole and adjusting the framing until the balance seemed right. In fact, the horizon line has ended up just slightly lower than the mid-line of the frame.

> Focal length: 8mm
> Shutter speed: 1/100 sec.
> Aperture: f/10
> Sensitivity: ISO 100

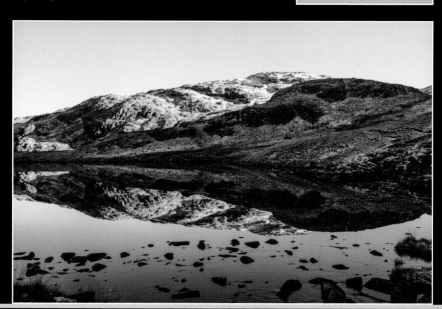

what's left out. It's about where you shoot from and the focal length you use. With all this going on, "rules", if they have any value at all, are a long way down the list and fretting about them just takes your mind off more important things.

FILLING THE FRAME »

It's great discipline to work with a fixed focal length—but there are times when a zoom lens really aids precise composition, especially when you can't move around much. I certainly couldn't move nearer to the subject without swimming! The clouds above the peak and the gray waters below were almost equally uninteresting, so I excluded them almost entirely from the frame. This meant that the remaining decisions were about shifting the camera slightly to left or right—and, crucially, about timing, to catch the fleeting moment when the sun picked out both the nearest slope and the rocky ridge in the middle ground.

> › *Focal length: 86 mm*
> › *Shutter speed: 1/250 sec.*
> › *Aperture: f/11*
> › *Sensitivity: ISO 200*

4 FLASH

Flash can be immensely useful, and the D3300 has impressive capabilities, but flash is not the answer to every low-light shot. Understanding its limitations helps us understand when to seek alternatives, as well as when and how we can use flash effectively.

› Principles

All flashguns are small. All flashguns are weak. These two facts are key to understanding flash photography. They are especially true for built-in units like that on the D3300 and most other DSLRs (those on compact cameras are typically even smaller and weaker).

Because it's small, the flash produces very hard light. It's similar to direct sunlight, but even the strongest sunlight is slightly softened by scattering and reflection; we can use the same principles to soften the flash, too.

The weakness of flash is even more fundamental. All flashguns have a limited range, and on-camera flash is more limited than most accessory flashguns.

Built-in flash units raise a third issue, too. Their fixed position, close to the lens, makes the light one-dimensional—and the same for every shot, which can create boring results! See Operating the built-in flash on *page 135*.

› Guide Numbers

The Guide Number (GN) is a measure of the power of a flash. In the past, photographers relied on GNs to calculate flash exposures and working range. With modern flash metering, like Nikon's i-TTL system (see the next page), these computations are rarely needed. However, the GN does help us compare different flashguns. For instance, the GN for the built-in flash is 12 (meters at ISO 100); for the Nikon SB-910 it is 34, indicating almost three times the power. This allows shooting at three times the distance, at a lower ISO, or with a smaller aperture.

Tip

GNs are specified in feet and/or meters and usually for an ISO rating of 100. When comparing different units, be sure that both GNs are stated in the same terms.

THROWING SHADOWS
The built-in flash creates obvious shadows of both the cockerel and the cartwheel behind.
32mm, 1/200 sec., f/6.3, ISO 800.

4 » FILL-IN FLASH

One of the most important uses for flash is for "fill-in" light, giving a lift to dark shadows like those cast by direct sunlight. This is why professionals regularly use flash in bright sunlight (exactly when most people would think it unnecessary).

Fill-in flash doesn't need to illuminate the shadows fully, only to lighten them a little. This means the flash can be used at a smaller aperture, or greater distance, than when it's the main light (averaging around 2 Ev smaller, or four times the distance).

› i-TTL balanced fill-flash for DSLR

Nikon's i-TTL balanced fill-flash helps achieve natural-looking results when using fill-in flash. It comes into play automatically provided (a) matrix or center-weighted metering is selected, and (b) a CPU-equipped lens is attached—most of the time, in other words.

The flash (built-in or compatible flashgun) emits a series of virtually invisible pre-flashes immediately before exposure. Light reflected from these is detected by the metering sensor and analyzed together with the ambient light. If Type D or G lenses are used, distance information is also incorporated.

› Standard i-TTL flash for DSLR

If spot metering is selected, this mode is activated instead (it can also be selected directly on some accessory flashguns). The camera controls flash output to light the subject correctly, but doesn't try to balance it with background illumination. This mode is more appropriate when flash is the main light source, rather than providing fill light.

FILL-IN FLASH　　　　　　　　　　　　　　**《**
The background exposure is the same for both shots, but the shadows are much darker in the shot without fill-in (top). *100mm macro, 1/125 sec., f/11, ISO 200.*

› Operating the built-in flash

THE ⚡ BUTTON ⌃

The D3300's built-in flash, like all such units, is small, low-powered, and fixed in position close to the lens axis. Together,

these factors mean it has a limited range, and produces a flat and harsh light which is unpleasant for portraits and most other subjects. It's certainly better than nothing at times, but its real value is for fill-in light.

In 📷 Auto, and many of the Scene modes, the flash activates when the camera deems it necessary (Auto flash), though it can always be turned off. In ⚡ Auto (flash off), and certain Scene modes, the built-in flash is not available. In P, S, A, or M modes and 🍴 Food, the flash is always available but you must activate it manually as follows.

I-TTL BALANCED »
FILL-FLASH
This gives a very natural result, lifting the foreground figures while allowing the overall exposure to capture the bright background. Flash can also help to give a sharper result with action shots. *24mm, 1/200 sec., f/8, ISO 800.*

Activating the built-in flash

1) Select a metering method (*see page 68*)—matrix metering is advised for fill-in flash. Spot metering may be a better bet when you're using flash as your main light.

2) Press ⚡ and the flash will pop up and begin charging; this normally takes just a second or two. When it is charged the ready indicator ⚡ is displayed in the Viewfinder.

3) Choose a flash mode from the Active Information Display. Highlight the current flash mode and press ⊛. Select the desired flash mode and press ⊛ again. (*See page 139* for explanation of flash modes.)

4) Take the photo(s) in the normal way.

5) When finished, lower the built-in flash, pressing gently down until it clicks into place.

Tip

The built-in flash is recommended for use with CPU lenses between 18mm and 300mm focal length. Some lenses may block part of the flash output at close range—removing the lens hood often helps. The Nikon Reference Manual *details limitations of use with certain lenses.*

SHADOW «
Even with the lens hood removed, the built-in flash can throw a very obvious shadow, especially on close-up subjects.

FLASH EXPOSURE

Whether the shutter speed is 1/200 sec. or 20 sec., the flash normally fires just once and therefore delivers the same amount of light to the subject. In the absence of other light, the subject would look the same whatever the shutter speed. Shutter speed becomes relevant when there is other light around, which we call ambient light. Slower shutter speeds give the ambient light more chance to register.

Aperture, however, affects both flash exposure and ambient light exposure. The camera's flash metering takes this into account but it is useful to understand this distinction for a clearer sense of what's going on, especially with slow-sync shots.

The combinations of shutter speed and aperture that are available when using flash depend on the Exposure mode in use.

Exposure mode	Shutter speed	Aperture
P	Set by camera. The normal range is between 1/200 and 1/60 sec., but in certain flash modes all settings up to 30 sec. are available.	Set by camera
S	Selected by user. All settings between 1/200 sec. and 30 sec. are available. If user sets a faster shutter speed, the D3300 will fire at 1/200 sec. while the flash is active.	Set by camera
A	Set by camera. The normal range is between 1/200 and 1/60 sec., but in certain flash modes all settings up to 30 sec. are available.	Set by user
M	Selected by user. All settings between 1/200 sec. and 30 sec. are available, plus Bulb and Time. If you set a faster shutter speed, the D3300 will fire at 1/200 sec. while the flash is active.	Set by user
AUTO ⚡ 🌷 🏃 🌃 🍽 VI, POP, 🎴	Set by camera, between 1/200 and 1/60 sec.	Set by camera
🌆	Set by camera, between 1/200 and 1 sec.	Set by camera

› Flash range

The range of any flash depends on its power, ISO sensitivity setting, and the aperture set. The table below details the approximate range of the built-in flash for selected distances, apertures, and ISO settings. The table is based on Nikon's own figures, confirmed by practical tests. There's no need to memorize these figures, but it does help to have a general sense of the limited range that always applies when using flash. A quick test shot will tell you if any given subject is within range.

Officially, even at higher ISO settings than in the table, the maximum range is just 8.5 meters (28 ft). The flash may be able to illuminate more distant subjects but i-TTL flash metering may become less accurate. However, it can't do any harm to try. Accessory Speedlights have longer range limits.

FLASH RANGE ⌃
Even at ISO 1600, and using a Nikon Speedlight rather than built-in flash, the range is limited. It lights the front of the car really well but doesn't really reach the figures behind.

ISO equivalent setting						Range	
100	200	400	800	1600	3200	meters	feet
1.4	2	2.8	4	5.6	8	1.0–8.5	3′ 3″–27′ 11″
2	2.8	4	5.6	8	11	0.7–6.1	2′ 4″–20′
2.8	4	5.6	8	11	16	0.6–4.2	2′–13′ 9″
4	5.6	8	11	16	22	0.6–3.0	2′–9′ 10″
5.6	8	11	16	22	32	0.6–2.1	2′–6′ 11″
8	11	16	22	32		0.6–1.5	2′–4′ 11″
11	16	22	32			0.6–1.1	2′–3′ 7″
16	22	32				0.6–0.7	2′–2′ 4″

FLASH SYNCHRONIZATION AND FLASH MODES

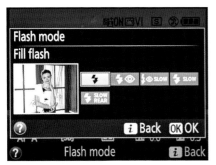

FLASH MODE SETTING IN
THE ACTIVE INFORMATION DISPLAY ⌃

Flash, as the name implies, is virtually instantaneous, lasting just a few milliseconds. If the flash is to cover the whole image frame it must be fired when the shutter is fully open, but at faster shutter speeds SLRs like the D3300 do not in fact expose the whole frame at once. In the case of the D3300, the fastest shutter speed which can be used with flash is 1/200 sec. This is therefore known as the sync (for synchronization) speed.

Flash modes are mainly differentiated by how they regulate synchronization and shutter speed. Choose a flash mode by pressing ⚡ and rotating the Command Dial, or by using the Active Information Display.

› Standard flash mode (front-curtain sync)

This is the default flash mode in most Exposure modes. However, the flash mode item in the Active Information Display labels it **Fill-flash** when using P, S, A, and M Exposure modes and "Auto" in other modes.

In standard flash operation, the flash fires as soon as the shutter is fully open, i.e. as soon as possible after the shutter-release button is pressed. This gives a fast response and the best chance of capturing the subject as you see it. However, it can create odd-looking results when dealing with moving subjects: for these, rear-curtain sync (see next page) may be more suitable.

In P and A Exposure modes, the camera will set a shutter speed in the range 1/60—1/200 sec. In S and M Exposure modes, you can set any shutter speed down to 30 sec., which means that standard flash also encompasses Slow sync (see next page).

› Slow sync

This mode allows longer shutter speeds (right up to 30 sec.) to be used in P and A Exposure modes, so that backgrounds can be captured even in low ambient light. Movement of the subject or camera (or even both) can result in a partly blurred image created by the ambient light, combined with a sharp image where the subject is lit by the flash. This may sometimes be unwelcome, but can also be used for creative effect.

This mode is also available, in a limited form (longest exposure 1 sec.), with Night portrait mode—here it's labelled **Auto slow sync**. You can't select Slow sync in S and M Exposure modes, but it isn't necessary, as longer shutter speeds are available anyway.

› Rear-curtain sync

Rear-curtain sync triggers the flash not at the first available moment (as front-curtain sync does), but at the last possible instant. This makes sense when photographing moving subjects because any image of the subject created by the ambient light then appears behind the sharp flash image, which usually looks more natural than having it appear to extend ahead of the direction of movement. Rear-curtain sync can only be selected when using P, S, A, and M Exposure modes. In P and A modes it also allows slow shutter speeds (below 1/60 sec.) to be used, and is then called

SLOW SYNC «
Slow sync combines a flash image with a motion-blurred image from the ambient light, but front-curtain sync makes the blurred elements run ahead of the flash image, not behind it (look at the rider's helmet, for example).

slow rear-curtain sync. When using longer exposure times, shooting with rear-curtain sync can be tricky, as you need to predict where your subject will be at the end of the exposure, rather than immediately after pressing the shutter-release button. It is often best suited to working with cooperative subjects—or naturally repeating action, like races over numerous laps of a circuit—so you can fine-tune your timing after reviewing images on the screen.

› Red-eye reduction

On-camera flash often creates "red-eye", caused by light reflecting off the subject's retina. Red-eye reduction works by shining a light (the AF-assist illuminator) at the subject just before the exposure, causing their pupils to contract. While it's pretty effective in reducing red-eye, this creates a noticeable delay, which kills spontaneity and can cause you to miss the shot entirely. Generally, it's better to remove red-eye in post-processing or with **Red-eye correction** in the Retouch menu (*see page 122*). Alternatively, use a separate

flash, or up the ISO rating and avoid flash altogether.

Unfortunately, red-eye reduction is on by default in 🎉 Party/indoor, but can be changed in the Active Information Display.

› Red-eye reduction with slow sync

This combines the two modes named, allowing backgrounds to register. This mode is only available when using P and A Exposure modes and, in a more limited form, with 🌃 Night portrait.

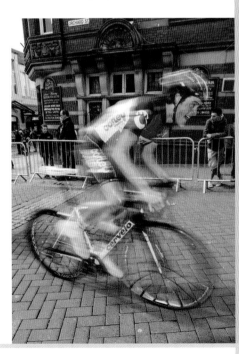

REAR-CURTAIN SYNC »
Rear-curtain sync means that the motion-blurred elements of the image appear behind the sharp image created by the flash. Again, the helmet is a good place to see this.

› Flash compensation

Although the D3300's flash metering is extremely sophisticated, it's not 100% infallible. You may also want to adjust flash output for creative effect. Image review helps you assess the effect of the flash, allowing compensation to be applied with confidence to further shots.

Flash compensation is only available in P, S, A, and M modes and is activated via the Active Information Display. Alternatively, press ⚡ and ⚹ and rotate the Command Dial. This requires some dexterity, but can be quicker.

Compensation can be set from −3 Ev to +1 Ev in ¹⁄₃ Ev steps. Positive compensation will brighten areas lit by the flash, but have no effect on areas lit by other light sources (ambient light). However, if the subject is already at the limit of flash range, positive compensation can't make it any brighter. Negative compensation reduces the brightness of flash-lit areas, again while leaving other areas unaffected.

After use, reset flash compensation to zero. Otherwise the camera will retain the setting next time you use flash.

FLOWER FLASH »
The background exposure remains the same, but the flash level on the flower varies, with compensation set to +1, 0, and −1 respectively. *100mm macro, 1/200 sec., f/11, ISO 400.*

› Manual flash

By using the **Manual** option under **Flash cntrl for built-in flash** (Shooting menu), you can control flash output even more precisely, from full power to as low as 1/32.

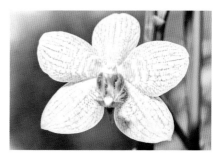

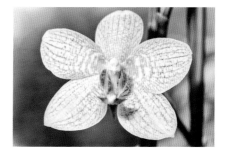

USING OPTIONAL SPEEDLIGHTS

If you're serious about portrait or close-up photography, in particular, you'll soon find the built-in flash inadequate. Accessory flashguns, which Nikon calls Speedlights, enormously extend the power and flexibility of flash with the D3300.

Nikon Speedlights integrate fully with Nikon's Creative Lighting System for outstanding results using flash. There are currently four models, all highly sophisticated units mainly aimed at professional and advanced users, and priced accordingly. The flagship SB-910 is particularly impressive—but costs more than many Nikkor lenses!

Independent makers such as Sigma and Metz offer alternatives, many of them also compatible with Nikon's i-TTL flash control. Some are considerably cheaper than Nikon's own units, but don't offer the same control and flexibility.

Even the cheapest flashgun offers many possibilities. For instance, any flashgun, however basic, that allows manual triggering with a "test" button can be used for the "painting with light" technique

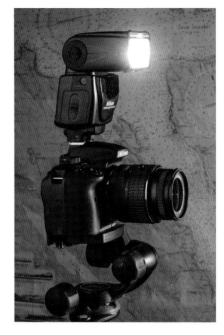

D3300 AND SPEEDLIGHT SB-700 ⌃

outlined on page 146. You may have an old flashgun at the back of a cupboard, and it's always worth checking the bargain bin at the local camera shop.

Mounting an external Speedlight

1) Check that the camera and the Speedlight are both switched off, and that the pop-up flash is down. Remove the hotshoe cover.

2) Slide the foot of the Speedlight into the camera's hotshoe. If it does not slide easily, check whether the mounting lock on the Speedlight is in the locked position.

3) Rotate the lock lever at the base of the Speedlight to secure it in position.

4) Switch on both the camera and the Speedlight.

> ### Tip
>
> *Speedlights are greedy for battery power. It is always wise to carry at least one set of spares.*

› Bounce flash and off-camera flash

The fixed position of the built-in flash throws odd shadows on nearby subjects and makes portraits ugly. A hotshoe-mounted Speedlight will improve matters slightly, but you can make a much bigger difference by either:

1) Bouncing the flash light off a ceiling, wall, or reflector.

2) Taking the Speedlight off the camera.

Bounce flash

Bouncing the flash light off a suitable surface both spreads the light, softening hard-edged shadows, and changes its direction, eliminating the ugly flatness of direct on-camera flash.

Nikon's SB-910 and SB-700 Speedlights have heads which can be tilted and swivelled through a wide range, allowing light to be bounced off walls, ceilings, and other surfaces. The SB-300 has a more limited tilt capability, allowing light to be bounced off the ceiling or a reflector.

> ### Tip
>
> *Most surfaces will absorb some of the light, and in any case the light has to travel further to reach the subject. i-TTL metering will automatically adjust for this, but the effective range is reduced. Bounce flash works better in domestic interiors with fairly low ceilings (especially if they are white or light in color) than in larger spaces. Alternatively, you can use a reflector.*

Off-camera flash

Taking the flash off the camera gives you complete control over the direction of the light. The flash can be fired using a flash cord; Nikon's dedicated cords preserve i-TTL metering (see under Accessories, *page 148*).

3D FLASH

The first shot (top) was taken using the built-in flash, making this three-dimensional arrangement look distinctly flat. The second (center) uses indirect flash from the left. The third image (bottom) uses flash bounced off a ceiling. This gives softer, more even, light but still has a strong 3D quality. *100mm macro, f/8, ISO 400.*

You can try this with any flashgun, even the cheapest, that can be triggered manually. By firing multiple flashes at the subject from different directions, you build up overall coverage of light without losing the sparkle that directional light gives. It requires trial and error, but that's part of the fun. The basic steps are:

1) Set up so that neither camera nor subject can move during the exposure.

2) Use Manual mode. Set a long shutter speed such as 20 or 30 seconds. Set a small aperture such as f/16 (this may need trial and error). Focus on the subject then turn the focus selector to M so the camera doesn't try to refocus.

3) Turn out the lights. It helps to have just enough background light to see what you are doing, but no more.

4) Trip the shutter and then fire the flash at the subject from different directions (without aiming directly into the lens). If using Time, press the shutter-release button again when finished.

5) Review the result and start again! For example, if results are too bright, use fewer flashes, a lower ISO, a smaller aperture, hold the flash further away, or a mix of the above. If the flash has a variable power setting you could turn this down.

TOOL TIME ⌄
Four bursts of flash (roughly speaking, from left front, left rear, right front, and right rear) gave something of a studio look to this shot with just a single flashgun. *65mm, 15 sec., f/16, ISO 100.*

NIKON SPEEDLIGHTS

SPEEDLIGHT SB-300 ⌃

The table below summarizes the key features of current Nikon Speedlights.

› Wireless flash

Nikon's Creative Lighting System includes the ability to regulate the light from multiple Speedlights through a wireless system. The built-in flash units on professional DSLRs like the D800 can be used as the "commander" for a wireless setup, as can the SB-910 and SB-700 Speedlights. There's also a stand-alone commander, the SU-800. The D3300 can operate within such a system but must be physically connected to a commander unit. There are alternative wireless systems too, like Pocket Wizard and Phottix Odin.

	SB-910	SB-700	SB-300	SB-R200
Flash coverage (lens focal length range, mm)	17–200	24–120		
Guide Number (ISO 100, meters)	34	28	18	
Tilt/swivel	Yes	Yes	Tilt only	No
Dimensions (width x height x depth, mm)	78.5 x 145 x 113	71 x 126 x 104.5	57.4 x 65.4 x 62.3	80 x 75 x 55
Weight (without batteries)	420g	360g	97g	120g
Use as commander?	Yes	Yes	No	No (cannot be used in camera hotshoe, only as a slave within Creative Lighting System).

» FLASH ACCESSORIES

To add even more flexibility and control of lighting effects, a wide variety of flash accessories is available. Nikon has an extensive range, and some third-party suppliers offer even more, but when time is short or money is tight substitutes can often be improvised.

› Battery packs

Nikon produces add-on power packs for its SB-910 Speedlights to speed up recycling and extend battery life.

› Color filters

Flash filters can be used to create striking color effects, or to match the color of the flash to that of the background lighting. Nikon produces various filters to fit its Speedlight range.

› Flash cords

Because the D3300's built-in flash can't act as a wireless commander, you can only maintain full metering and control of an external Speedlight if it's physically connected to the camera, either in the hotshoe or using a flash cord (also known as a sync lead). Dedicated cords like Nikon's SC-28 allow full communication between camera and Speedlight, retaining i-TTL flash control. The SC-28 extends up to 8ft or 2.5m.

› Flash diffusers

Flash diffusers are a simple, economical way to spread and soften the hard light from a flashgun. They may slide over the flash head or be attached by low-tech means like elastic bands or Velcro. Sto-Fen make Omni-Bounce diffusers to fit most

A D3300 AND A HONL "SOFTBOX" ⌄

flashguns. Even a white handkerchief can be used at a pinch (but beware, flash units can get hot). Diffusers reduce the light reaching the subject—the D3300's metering system will allow for this, but the effective range will be shorter.

A step beyond a simple diffuser is the portable "softbox" which can attach to a Speedlight to create a wider spread of light.

› Flash extenders

A flash extender slips over the flash head, using mirrors or a lens to create a tighter beam and extend the effective range of the flash. Again, the D3300's metering system will automatically accommodate the use of an extender. Nikon do not make flash-extenders, so a third-party option will be required—the best-known is the Better Beamer.

› Flash brackets

Nothing gives you more flexibility and control over the quality of light than being able to take the flash off camera, but you need somewhere to put the flash once you've detached it. Nikon's Speedlights can be mounted on a tripod or stand on any flat surface using the AS-19 stand, but for a quick, portable solution many photographers prefer a light flexible arm or bracket which attaches to the camera and supports the Speedlight. Novoflex produces a range of such products.

I generally think that flash photographs are most successful if you can't readily tell that flash has been used at all: no glare, no over-lit subjects popping out from the background, and no ugly shadows going in the wrong direction. But that's partly personal preference.

CABIN ⌄

This shot was taken with the built-in flash, which works pretty well here as the light bounces around the small space. I used the same shutter speed and aperture settings as I'd been using for outside shots, and the balance between interior and exterior light is pretty good.

> › Focal length: 14mm
> › Shutter speed: 1/125 sec.
> › Aperture: f/6.3
> › Sensitivity: ISO 400

It also doesn't lend itself to examples for this chapter: if you can't see the effect of the flash, what does the image tell you? So here are a couple of examples where the use of flash is fairly obvious.

PORTRAIT «
I'll go to almost any lengths rather than use direct on-camera flash as the main light for portraits, but for fill-in it works just fine. In this case the strong sunlight on its own would have given a very harsh result. The flash also puts a sparkle or "catchlight" in the eyes.

> Focal length: 70mm
> Shutter speed: 1/250 sec.
> Aperture: f/10
> Sensitivity: ISO 200

5 CLOSE-UP

For close-up photography the 35mm SLR and digital successors like the D3300 have long reigned supreme. Reflex viewing, once essential in close-up work, is now supplemented by Live View. Also, the D3300 is part of the legendary Nikon system of lenses and accessories, which offers many additional options for close-up photography.

» DEPTH OF FIELD

Depth of field (*see page 65*) is a key issue. As you move closer to the subject, depth of field becomes ever narrower. This has several consequences. First, it's often necessary to stop down to small apertures, which can make long exposures essential. Second, the slightest movement of either subject or camera can ruin the focus.

For both reasons, a tripod or other solid camera support is often required. It may also be necessary to prevent the subject from moving (within ethical limits, of course!)

CLOSE-UP «
Close-up subjects are everywhere, and close-up photography really encourages us to look more attentively. *56mm, 1/250 sec., f/6.3, ISO 400.*

➔ FOCUSING

Because depth of field is so slim, focusing becomes critical. Merely focusing on "the subject" is no longer good enough and you must decide which part of the subject—an insect's eye, the stamen of a flower—should be the point of sharp focus. With its 11 AF points, the D3300 is capable of focusing accurately within much of the frame, but this is also where Live View really shines. Live View AF is impeccably accurate, but the real value is that you can put the focus point wherever you want (in ▣ WIDE Wide-area AF or ▣ NORM

Normal area AF, *see page 93*)—right out to the edges of the frame. In Live View, you can also zoom the view, to set the focus point even more precisely.

This ability to zoom also makes manual focusing easy, and ultra-precise. This is now my preferred method for macro photography, especially with static subjects. In Live View, I find manual focus quicker as well as more intuitive. For years I was a "Live View Luddite" but now I'm an enthusiastic convert.

POINT OF FOCUS »
In serious close-up shooting, depth of field is minimal even at smaller apertures. This makes accurate focusing essential— and this begins with precise placement of the focus point.
100mm macro, 1/50 sec., f/8, ISO 200.

5 » MACRO PHOTOGRAPHY

There's no exact definition of "close-up" but the term "macro" really should be used more precisely. Macro photography strictly means photography of objects at life-size or larger, implying that a true macro lens should allow a reproduction ratio of at least 1:1. Many zoom lenses are badged "macro" when their reproduction ratio is around 1:4, or 1:2 at best. This still allows a great deal of fascinating close-up photography, but it isn't macro by the classical definition.

If you want to explore true macro photography without going to the expense of a dedicated macro lens, there are several possibilities (*see page 159*).

› Reproduction ratio

The reproduction ratio (or image magnification) is the ratio between the actual size of the subject and the size of its image on the D3300's imaging sensor, which measures 23.5 x 15.6mm. An object of the same dimensions (smaller than an SD memory card) captured at 1:1 would exactly fill the image frame. When the image is printed, or displayed on a computer screen, it may appear many times larger, but that's another story.

MACRO MAGNIFICATION «
The first shot (top) has a reproduction ratio of approximately 1:4; this is about as good as you'll get with most "normal" lenses. The second, taken with a macro lens at the closest possible distance, gives approximately life size (1:1) reproduction. *100mm macro, 1/100 sec., f/11, ISO 200.*

A 1:4 reproduction ratio means that the smallest subject that would give you a frame-filling shot is one that's four times as long/wide as the sensor. With DX-format cameras like the D3300 this is approximately 3.7 x 2.5 inches (94 x 62mm)—a fraction larger than a credit card.

› Working distance

Working distance is the distance required to obtain the desired reproduction ratio with any given lens. It is directly related to the focal length of the lens: with a 200mm macro lens the working distance for 1:1

Tip

Working distance, and the minimum focus distance of a lens, are normally measured from the subject to the focal plane, which equates to the position of the sensor. A 10-inch or 25-cm working distance therefore means that the subject, or the bit of the subject you're focusing on, can be less than 4 inches or 10cm from the front of the lens. Other paraphernalia like lens hoods or ring-flash can narrow this gap even more.

reproduction is double what it is with a 100mm lens (roughly, 20 inches or 50cm, rather than 10 inches or 25cm). The extra distance can be a big help when photographing living subjects, especially mobile ones. It can also be helpful with delicate subjects, living or not, which might be damaged by accidental contact.

FLOWER POWER
In the field, longer focal lengths and longer working distances can make it easier to get clean, uncluttered backgrounds. *100mm, 1/200 sec., f/8, ISO 100.*

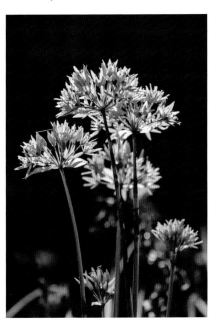

5 » MACRO LIGHTING

Of course, many fine close-up and macro shots can be taken using available light. However, you'll often find that your own shadow, or the camera's, can intrude. Many subjects (like the interiors of flowers) can create their own shadows too. For these and other reasons, you'll soon start to want more controlled lighting. This usually means flash, but regular Speedlights are not designed for ultra-close work. If

mounted on the hotshoe, short working distances mean that the lens may throw a shadow onto the subject. This is even worse with the built-in flash, which is essentially useless for real close-up photography.

RINGLIGHTING

This shot was taken with the Sunpak Macro Ring Light. It gives even, almost shadowless illumination on the subject. *100mm macro, 1/15 sec., f/16, ISO 400, tripod.*

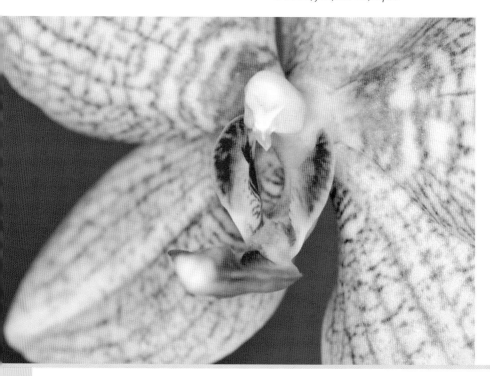

› Macro flash

Specialist macro flash usually takes the form of either ring-flash or twin flash. Because operating distances are short, units do not need high power and can be relatively light and compact.

Ring-flash units encircle the lens, giving even illumination even on ultra-close subjects (they're also preferred by some portrait photographers). Nikon no longer makes a ring-flash, but alternatives come from Sigma and Nissin.

Nikon itself favors a twin-flash approach with its Speedlight Commander Kit R1C1 and Speedlight Remote Kit R1. Both use two Speedlight SB-R200 flashguns, mounting either side of the lens. The R1C1 uses a Wireless Speedlight Commander SU-800 unit which fits into the camera's hotshoe, while the R1 needs a separate Speedlight to act as commander. These kits are expensive but give very flexible and precisely controllable light on macro subjects.

› LED light

An alternative is to use LED lights, like the very cheap Sunpak DSLR67 LED Macro Ring Light. Its continuous output allows you to preview the image in a way not possible with flash. Its low power limits it to very close subjects, but that of course is all you need in a macro light. You may need to use quite high ISO ratings to get short enough shutter speeds for mobile subjects. There is also a distinct color cast and you may need to experiment with white balance settings (and/or shoot RAW).

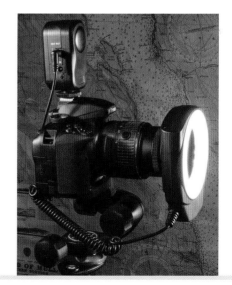

D3300 AND SUNPAK LED **»**
MACRO RING LIGHT

» IMPROVISATION

Dedicated macro-flash units aren't cheap, and may be unaffordable or unjustifiable when you only shoot macro occasionally. Fortunately, you can do lots with a standard flashgun, plus a flash cord. With basic units, you'll lose the D3300's advanced flash control, but it only takes a few test shots to establish settings that you can use repeatedly (remember to keep notes). Also essential is a small reflector, like a piece of white card—place it really close to the subject for maximum benefit. This system is not only cheap, it's very flexible and can deliver very polished results.

I've also found that a flash diffuser, like the HONL "softbox" I use (*see page 148*), can give excellent results; on small subjects it gives a really good spread of light.

DIFFUSER ⹉
This shot was taken using the HONL flash diffuser on a Speedlight SB-700 with a remote cord, fired from the left of the subject. Compare the shot with the Sunpak Macro Ring Light shot of the same subject, using the same lens and camera position. *100mm macro, 1/100 sec., f/11, ISO 100, tripod.*

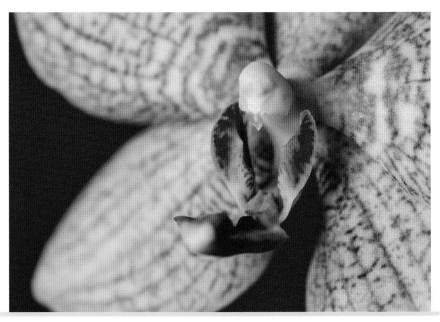

EQUIPMENT FOR MACRO PHOTOGRAPHY

› Close-up attachment lenses

Close-up attachment lenses are simple magnifying lenses that screw into the filter thread of the lens. They are light, convenient, inexpensive, and fully compatible with the camera's exposure and focusing systems. For best results, it's recommended to use them with prime lenses (*see pages 180, 193*).

Nikon produces six close-up attachment lenses—see the table below.

› Extension tubes

Extension tubes are another simple, relatively inexpensive, way of extending the close-focusing capabilities of a lens. An extension tube is essentially a simple tube fitting between the lens and the camera. This decreases the minimum focusing distance and thereby increases the magnification factor. Again they are light, compact, and easy to carry and attach.

The Nikon system includes four extension tubes (PK-11A, PK-12, PK-13, and PN-11) which extend the lens by 8mm,

14mm, 27.5mm, and 52.5mm respectively. The PK-11 incorporates a tripod mount. The basic design of these tubes has not changed for many years, which means that many of the camera's functions are not available. In particular, there's no autofocus. Used on the D3300, you may be restricted to Manual (M) mode and exposure determination will be by trial and error—but that's what the histogram's for!

Kenko also produce compatible extension tubes, which do support matrix metering, but still do not permit autofocus on the D3300. They're also far more reasonably priced than Nikon's own offerings.

Warning!

Some recent lenses are not compatible with accessories such as extension rings, bellows, and teleconverters (*see page 195*). Check the camera or lens manual beforehand (to view before purchase, manuals can be downloaded from Nikon websites).

Product number	Attaches to filter thread	Recommended for use with
0, 1	52mm	Standard lenses
3T, 4T	52mm	Short telephoto lenses
5T, 6T	62mm	Telephoto lenses

> ## Bellows

Like extension tubes, bellows extend the spacing between the lens and the camera body, but they are not restricted to a few set lengths. Again, there's no extra glass to impair optical quality. However, bellows are expensive, heavy, and take time to set up. They are usually employed in a studio or other controlled setting.

Nikon's PB-6 bellows offer extensions from 48mm to 208mm, giving a maximum reproduction ratio of about 11:1. Focusing and exposure are manual only.

> ## Reversing rings

Also known as reverse adapters or inversion rings, these allow lenses to be mounted in reverse; the adapter screws into the filter thread. This allows much closer focusing than when the lens is used normally. They are ideally used with a prime lens.

> **Note:**
> Extension tubes and bellows increase the physical length of the lens and therefore the effective focal length. However, the physical size of the aperture does not change. The result is to make the lens "slower"; that is, a lens with a maximum aperture of f/2.8 behaves like an f/4 or f/5.6 lens. This also makes the Viewfinder image dimmer than normal, and means a longer exposure is required. Reversing rings do not have this effect.

» MACRO LENSES

True macro lenses achieve reproduction ratios of 1:1 or better and are optically optimized for close-up work, though normally very capable for general photography too. This is certainly true of Nikon's Micro Nikkor lenses, of which there are currently five. Two of them are specifically designed for the DX format, and will be described first, but the others work just as well on the D3300.

The most recent addition to the range is the **40mm f/2.8G AF-S DX Micro Nikkor**. It's Nikon's lightest, and least expensive, macro lens, and works well as a standard lens too. However, its working distance at 1:1 reproduction ratio is just 6 inches (16cm), leaving very little room between the subject and the front of the lens.

The **85mm f/3.5G ED VR AF-S DX Micro Nikkor** also achieves 1:1 reproduction and has VRII, internal focusing, and ED glass. Its longer working distance makes it more flexible for most macro shooting.

The **60mm f/2.8G ED AF-S Micro Nikkor** is an upgrade to the previous 60mm f/2.8D: advances include ED glass for superior optical quality and Silent Wave Motor for ultra-quiet autofocus.

The **105mm f/2.8G AF-S VR Micro Nikkor** also features internal focusing, ED glass, and Silent Wave Motor; it was also

the world's first macro lens with VR (Vibration Reduction).

The most venerable member of the range, the **200mm f/4D ED-IF AF Micro Nikkor**, is particularly suitable for shooting the animal kingdom, as its longer working distance reduces the risk of disturbing your subject. However, it lacks a built-in motor and so can't autofocus with the D3300; this can be an issue when shooting lively animals. When shooting static subjects, manual focus is easy.

> **Note:**
> There's no doubt that Nikon's macro lenses are excellent—but the lens used for all the close-up illustrations in this book is a 100mm Tokina.

40MM F/2.8G AF-S DX MICRO NIKKOR ≈

85MM F/3.5G ED VR AF-S DX MICRO NIKKOR ≈

› Vibration Reduction

As the slightest camera shake is magnified at high reproduction ratios, VR (Vibration Reduction) technology is extremely welcome, allowing you to employ shutter speeds up to four stops slower than otherwise possible. However, it can't compensate for movement of the subject.

It's almost impossible to avoid swaying slightly when handholding, and at close range the slightest change in subject-to-camera distance can completely ruin the focus. In macro shooting, VR is no substitute for care and a good tripod.

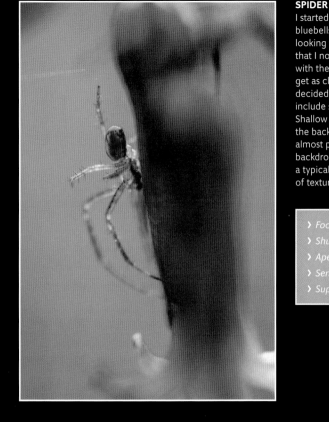

SPIDER «

I started out photographing the bluebells, and it was only when looking through the macro lens that I noticed this spider. I started with the lens at its closest focus to get as close as possible, but then decided to pull back slightly to include slightly more of the flower. Shallow depth of field means that the background looks like an almost perfectly even green backdrop, but in reality it was a typical woodland floor, full of texture and detail.

> › Focal length: 100mm macro
> › Shutter speed: 1/60 sec.
> › Aperture: f/8
> › Sensitivity: ISO 200
> › Support: tripod

FLOWER ⌄

I photographed this flower in a conservatory to ensure there was no wind, but worked entirely with the natural light. In this instance I didn't even need a reflector. Precise focusing was key and I used Live View, zoomed in, and focused manually. This is the most accurate focusing method I know.

> › *Focal length: 100mm macro*
> › *Shutter speed: 1/500 sec.*
> › *Aperture: f/5.6*
> › *Sensitivity: ISO 200*

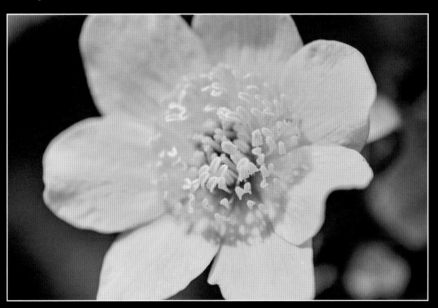

6 MOVIES

Nikon pioneered movies on DSLRs, launching the D90 in August 2008. For many, the true purpose of the SLR is to shoot stills and its ergonomics are still best for this, but the addition of video is no mere sideshow. Dedicated movie makers have embraced DSLRs for their distinctive image quality, while photojournalists welcome the ability to shoot high-quality stills and video on the same camera. However, still photography and movies are very different media, requiring quite different approaches for the best results.

› Movie size and quality

The D3300 can shoot movies in Full HD (High Definition) quality with a frame size of 1920 x 1080 pixels. It can also record 1280 x 720-pixel ("720p") and 640 x 424-pixel footage. Shooting at the maximum frame size is by no means always essential. For example, 720p is the standard on Vimeo.com, a prime site for quality video online, and will look excellent on most computer screens. However, the latest iPads have a 2048 x 1536 display, boasting more pixels than Full HD.

WIDE ANGLE ❯❯
The D3300 allows wide-angle shooting (focal length 12mm).

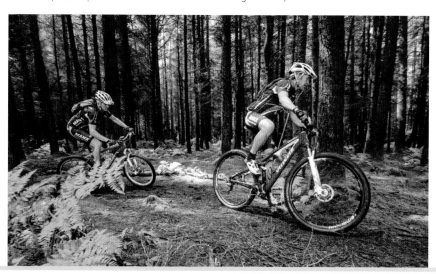

Smaller size settings allow you to record more video on the same memory card, and consume less disk space on your computer. However, it must be said, footage shot in Full HD may be more "future-proof".

› Advantages

DSLRs in general, and the D3300 in particular, have several real advantages over standard camcorders. One is the ability to achieve very shallow depth of field (*see page 65*); and movie-makers have particularly embraced this "DSLR look".

This is a direct consequence of the large sensor, which also brings greater dynamic range (*page 97*) and better

> **Note:**
> Most digital video cameras claim enormous zoom ranges (often 800x or more) but these are only achieved by "digital zoom", which is a software function that enlarges the central portion of the image—inevitably losing quality. "Optical zoom" range is what matters, and interchangeable lenses give a potential range of at least 80x (10mm–800mm). The widest range currently available in a single lens is 18–300mm, though Tamron has announced a 16–300mm lens.

quality at high ISO ratings, extending the possibilities for shooting in low light.

Another plus is the D3300's ability to use the entire array of Nikon-fit lenses (see chapter 7, *page 180*): in particular, it can use wide-angle lenses which go well beyond the range of most camcorders. In addition, the full range of exposure settings, Nikon Picture Controls, and many other options can be used, giving a high level of creative control.

› Limitations

The use of DSLRs like the D3300 for movie shooting is now well established, but some limitations remain. The rear screen, and the overall balance of a DSLR, makes handheld shooting awkward. There are now many accessory grips and stabilizers to improve handling and stability.

Also, Live View AF is nowhere near agile enough for fast-moving subjects, and sound quality from the built-in microphone is at best moderate.

There is one other limitation: you cannot record a clip longer than 20 minutes in High quality or 30 minutes in Normal quality.

This is hardly ever a problem—and for those who have to view your movies, 20 minutes will seem like a very long time for a single clip!

› Preparation

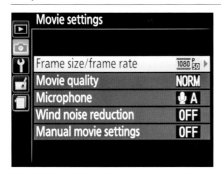

MOVIE SETTINGS ⌃

Before shooting, select key settings in the **Movie settings** section of the Shooting menu (see opposite).

You also need to think carefully about your other camera settings. There's no "RAW" setting for video; your video clips are equivalent to JPEG images, so there's limited scope to adjust exposure, white balance, and so on. This means it's very important to get these things right before shooting each clip.

Expert shooters will often use a Neutral Picture Control, and even turn contrast and sharpening down further, to give them maximum leeway for making adjustments later. This is as near as you can get to shooting RAW. Whether you want to take this approach depends on how much work you are prepared to do in post-processing.

If you use these settings but don't make any adjustments afterwards the footage will almost always look dull and flat, whereas if you shoot with, say, a Vivid Picture Control, first impressions will be much more vibrant.

A good way to check the general look of a shot is by taking a still frame; you can do this from Live View without starting movie recording first—but if you're planning to do some post-processing, bear in mind that the still frame is only a guide. In fact, shooting decent video almost always demands some level of post-processing (see Editing movies on *page 178*) and apps like iMovie make adjusting your clips easy.

> ### *Tip*
>
> *Full Auto modes and Scene modes don't allow you to set a Neutral Picture Control, let alone fine-tune it further. If you want to do this to facilitate post-processing, you'll need to shoot in P, S, A, or M Exposure modes.*

› Movie settings in the Shooting menu

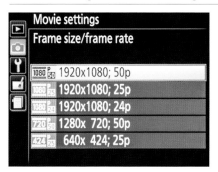

**SETTING FRAME SIZE/FRAME RATE ⌃
IN THE MOVIE SETTINGS MENU**

Quality sets the image size, frame rate, and quality for movie recording. The size options are: **1920 x 1080** pixels (default); **1280 x 720** pixels; **640 x 424** pixels. The frame rate options vary according to the size chosen and whether NTSC or PAL (*see page 117*) is selected for video mode.

Movie quality sets the compression level; options are **High** or **Normal**.

Microphone determines the sensitivity of the built-in microphone (or an external microphone if attached). The options are: **Auto**, **Manual Sensitivity** (in steps from 1–20), and **Off**. You can see an audio-level display while in this menu, which helps to establish a correct setting.

If you set **Manual movie settings** to **On**, you can adjust shutter speed while actually shooting a clip in M mode. You can also change ISO settings, not while actually shooting but at least without exiting Live View.

By default **Manual movie settings** is **Off**. When it is, you can dial in changes to the settings but they have no effect.

Whether this is **On** or **Off**, if you're shooting in M or A modes, you can't change the aperture without exiting Live View. Again, you can turn the dial and the screen will appear to show that the setting changes, but in fact it doesn't update until you exit and reenter Live View.

> **Tip**
>
> *You can't change Manual microphone level settings while actually shooting a clip: this is another setting that needs to be sorted beforehand.*

The focus modes and AF-area options for movie shooting are the same as for Live View (*page 92*). If Full-time servo AF (AF-F) is selected, the D3300 will automatically maintain focus while movie recording is in progress, though it can lag behind rapid camera/subject movements. If Single-servo AF (AF-S) is selected the camera will only refocus when you half-press the shutter-release button. In both cases, shifts in focus are often all too obvious in the final movie clip.

Manual focusing is also possible, but can be yet another recipe for wobbly pictures. Yet again, this indicates the use of a tripod, especially with longer lenses, where focusing is more critical and wobbles are magnified. Some lenses have a smoother manual focus action than others. The physical design of older lenses often makes them more suitable, with large and well-placed focus rings.

Older lenses often have a distance scale marked on the lens barrel, which can offer a viable alternative to using the Live View display to focus.

Study the credits for major movies and TV shows and you'll often see someone called a "focus puller". This is an assistant camera operator, whose sole task is to

SHALLOW DEPTH OF FIELD ⌄
It's easier to get really shallow depth of field than with most video cameras. *55mm, f/6.3.*

› Exposure

adjust the focus, normally between predetermined points (for instance, shifting from one character's face to another). This leaves the lead camera operator free to concentrate on framing, panning, and/or zooming. Frequently, the focus puller uses the distance scale on the lens barrel, relying on previously measured distances. Executing this kind of deliberate and controlled focus shift is not easy, especially when you're the sole camera operator—and if it's not right, it will be very obvious in the final footage.

This all underlines the fact that changing focus during the shooting of a clip is tricky. If not done smoothly and accurately it can also be very disconcerting when viewing the footage. There are attachments which allow you to control focus more smoothly and precisely, but they are a significant investment.

Fortunately, changing focus during shooting is often not necessary anyway. Using a fixed focus for each shot is often perfectly viable, especially when depth of field is good. The best way to do this is by focusing manually before shooting. Alternatively, use AF and then change the focus mode to manual.

A third option is to keep half-pressure on the shutter-release button to lock focus, but this seems like an unnecessary extra hassle.

Exposure control depends on the exposure mode selected before shooting begins. If Auto or Scene modes are selected, exposure control is fully automatic, except that in Scene modes exposure level can be locked using the **AE-L/AF-L** button. This is useful, for instance, to prevent the main subject appearing to darken if it moves in front of a brighter background.

In P, S, or A mode, exposure levels can be adjusted mid-shot by ±5 Ev using ⚡ and the Command Dial. If you enable Auto **ISO sensitivity control** in the Shooting menu, then the camera will normally set the shutter speed automatically, and adjust the ISO sensitivity if necessary to keep shutter speed within suitable limits. If Auto **ISO sensitivity control** is **Off**, the camera will adjust shutter speed.

In mode M, and providing the Manual movie settings option (*see page 167*) is **On**, shutter speed can be adjusted "live" while shooting. In this case, ISO sensitivity is not adjusted automatically.

While all these adjustment options are welcome, making them while shooting is fiddly. It's hard to avoid jogging the camera unless it's on a solid tripod, and the built-in microphone may pick up the sounds of the operations. Another consequence can be abrupt brightness changes in the final footage. It's better to get the settings right before you start shooting.

LOW-LIGHT SHOOTING ⌃
The D3300 also scores when it comes to low-light shooting (here at ISO 1600).

› Shutter speed

You can (if the light's good) set shutter speeds right up to 1/4000 sec., but there are inevitable limits to the slowest speed you can select. For instance, if frame rate is 24, 25, or 30, the slowest possible speed is 1/30 sec.. After all, if you're shooting 25 frames a second you can't expect each frame to have a 1/2 second exposure! Similarly, if your frame rate is 50p the slowest possible shutter speed is 1/50 sec., and 1/60 sec. for 60p.

Based on still photography experience, you'll probably expect faster shutter speeds to give sharper pictures. In movies it doesn't work that way. If you shoot at, say, 1/500 sec., you will find that each frame of the movie might appear sharp when examined individually, but the motion appears jerky when you play the movie. This is because you have recorded 25 tiny slices of the continuous action (assuming a 25p frame rate). 25 times 1/500 sec. is just 5% of the action. The nearer the shutter speed is to 1/25 sec., the nearer you get to capturing 100% and the smoother the motion appears.

However, in bright conditions, you can't shoot at 1/30 sec. and at the same time use a really wide aperture for shallow depth of field, even at ISO 100. Sometimes you need to compromise, although a Neutral Density filter (*page 206*) could come in very handy.

› Sound

Often, one of the easiest ways to identify skilled or professional video footage is not with your eyes but with your ears. Good quality of sound and the absence of extraneous background noise are vital for movies that are enjoyable to "watch".

The D3300's built-in microphone gives modest-quality stereo output. It is liable to pick up any sounds you make during operation (focusing, zooming, even breathing). You always have the option to add a new soundtrack later. However, this is difficult if your film includes people speaking (though "post-syncing" is standard practice in Hollywood, especially for musicals). If you want to include dialog or "talking heads", keep subjects close to the camera and ensure that background noise is minimized.

Fortunately, the D3300 also allows you to attach an external microphone: plug in to a standard 3.5mm mini-jack socket under the cover on the left side of the camera. This automatically overrides the internal microphone.

An external microphone like Nikon's ME-1, mounted in the hotshoe, will improve general sound quality and be more selective about direction, so will pick up less background noise. However, if there is background noise from the direction in which it's aimed, it will still pick it up. There's a reason why film and TV productions usually use mikes on a boom above the characters: by aiming the mike downwards they minimize their exposure to extraneous noise.

Tip

Video shooting is a real drain on the battery. If you plan to spend a full day shooting movie clips, then you'll probably need several spare batteries, or a mains adapter (page 208) if you have access to mains power.

» SHOOTING MOVIES

⦿ BUTTON ⌃

1) Choose exposure mode, AF mode, and AF-area mode as for Live View shooting. If using A or M Exposure mode, set the aperture. If using S mode, or M mode with **Manual movie settings** set to **On**, set the shutter speed.

2) Activate Live View by pressing **Lv** . It's a good idea to go to the "movie indicators" screen: press **INFO** one or more times (*see page 91*) as required.

3) Check framing and initial exposure level (possibly taking a still frame or very short clip as a test). Set initial focus by half-pressure on the shutter-release button, or focus manually.

4) Press ⦿ to start recording the movie. **REC** flashes on the monitor screen while recording, and an indicator shows the maximum remaining shooting time.

5) To stop recording, press ⦿ again.

6) Exit Live View by pressing **Lv** .

› Shooting

The golden rule is: think ahead. If a still frame isn't quite right, you can review it, change position or settings, and be ready to reshoot within seconds. To shoot and review even a short movie clip eats up much more time, and you may not get a second chance anyway. It's doubly important to get shooting position, framing, and camera settings right before you start. It's easy to check the general look of the shot by shooting a still frame beforehand, but this does not allow for movement of subject, camera, or both; you can also do a rehearsal in Live View before shooting for real.

If you're new to the complexities of movies, start with simple shots. Don't try zooming, panning, and focusing simultaneously: do one at a time. Many moving subjects can be filmed very well with a fixed camera: waterfalls, birds at a feeder, musicians playing, and loads more.

Equally, you can become familiar with camera movements shooting static subjects: try panning across a wide landscape or zooming in from a broad cityscape to a detail of a single building.

› Handheld or tripod shooting

It's impossible to overstress the importance of a tripod for shooting decent movies. Shooting movie clips handheld is a good way to reveal just how wobbly you really are—especially as you can't use the Viewfinder. VR lens technology can counteract short-frequency shake, but does nothing to eliminate slower (and often larger) movements. Even if you're a Zen master, you cannot hold the camera perfectly still.

Of course, even "real" movie directors sometimes use handheld cameras to create a specific feel, but there's a huge difference between controlled movement for deliberate effect, and incessant, uncontrolled wobbliness. Using a tripod, or other suitable camera support, is the simplest way to give movie clips a polished, professional look.

In the last few years we've also seen lots of new devices intended to stabilize the camera when you simply have to shoot handheld, from simple brackets to smaller versions of the legendary Steadicam. If

none of these are available, look for other alternatives, for instance by sitting with elbows braced on knees. For moving shots, too, improvisation can pay dividends. For instance, I've seen a tripod mounted in the bed of an old-style pram, whose large wheels and sprung body gave a remarkably smooth result in a tracking shot.

Whatever you do, for whatever kind of shot, the golden rule is "think steady".

Tip

A standard tripod with a pan-and-tilt head is a good start. If you're serious about movies, consider a dedicated video tripod (or tripod head). This isn't necessarily heftier than its standard counterpart, but the tripod head is specifically designed to move smoothly. The best (and most expensive) are fluid-damped for maximum smoothness.

The panning shot is a movie-maker's staple. Often essential for following moving subjects, it can also be used with static subjects; for instance, sweeping across a vast panorama. Of course, landscapes aren't always static, and a panning shot combined with breaking waves, running water, or grass blowing in the breeze can produce beautiful results.

Handheld panning is very problematic; it may be acceptable when following a moving subject, but a wobbly pan across a grand landscape will definitely grate. You really, really need a tripod for this. Make sure it's properly levelled, too, or you may start panning with the camera aimed at the horizon but finish seeing nothing but ground or sky: do a "dry run" before shooting.

Keep panning movements slow and steady. Panning too rapidly can make the shot hard to "read" and even leave viewers feeling nauseous. Smooth panning is easiest with video tripods, but perfectly possible with a standard model: leave the pan adjustment slightly slack. Hold the panning arm on the tripod head, not the camera, and use the front of the lens as a reference to track steadily across the scene.

ON THE LEVEL ❯❯
When panning on a tripod, get it levelled correctly in advance, or the sea could appear to be on a slope.

› Zooming

With moving subjects, the speed and direction of panning are dictated by the need to keep the subject in frame. Accurate tracking of fast-moving subjects is very challenging and takes a lot of practice.

The zoom is another fundamental technique. Moving from a wide view to a tighter one is called zooming in, the converse zooming out. Again, a little forethought makes all the difference to using the zoom effectively—consider the framing of the shot at both start and finish. If you're zooming in to a specific subject, double-check it's central in frame.

No current lenses for the D3300 are designed specifically for shooting movies; this is very obvious in relation to zooming. Firstly, none of them have such a wide zoom range as video camera lenses; the widest range in a single lens is currently 18–300mm, with 16–300mm in the works. More seriously, it's hard to achieve a really

PANNING ⌄
This is a classic panning shot, but very tricky to follow neatly when handholding—slower subjects make a smooth, even movement harder, not easier.

smooth, even-paced zoom action. Practice does help, and firmly mounting the camera on a solid tripod helps even more. Zooming while handholding virtually guarantees an uneven zoom rate as well as overall wobbliness. It's also worth experimenting to see which lens has the smoothest zoom action. There's definitely a gap in the market for a lens with wide focal length range and powered zoom.

When zooming, remember that depth of field (*see page 65*) decreases at the telephoto end of the range. Your subject may appear perfectly sharp in a wide-angle view but end up looking soft when you zoom in. Set focus at the telephoto end, whether your planned shot involves zooming out or zooming in.

› Lighting

For obvious reasons, you can't use flash. There are now many LED light units specifically designed for DSLR movie shooting. The D3300's ability to shoot at high ISO ratings is also invaluable.

EXPLORING THE SCENE ⌄⌄
The camera can "explore" a scene like this, either by panning around to see more of the setting or by zooming in for a closer look.

> Still frame capture

To capture a still frame during movie shooting, press the shutter-release button and keep it pressed until you hear the shutter operate (you may have to wait a second or so). This will end movie-recording, take the shot, and return you to Live View. The resulting image will use the 16:9 aspect ratio; quality and size are determined by your still-image settings (*see pages 80, 82*). For image sizes see the table below.

You can also extract a still frame from a movie clip you've already shot, but don't expect too much. The image size will be the same as your selected movie frame size (1920 x 1080, 1280 x 720, or 640 x 424 pixels), and motion which appears smooth when playing the movie may well look blurred in the single frame.

Image area	Image size setting	Size in pixels
DX movie	Large (or RAW)	6000 x 3368
	Medium	4496 x 2528
	Small	2992 x 1680
1.3x crop	Large (or RAW)	4800 x 2696
	Medium	3600 x 2024
	Small	2400 x 1344

6 » EDITING MOVIES

We've talked in this chapter about the D3300 shooting movies, but actually it doesn't. Like all movie cameras, it shoots movie clips.

In general, turning a collection of clips into a movie that people actually want to see requires editing, and specifically Non-Linear Editing (NLE). This simply means that clips in the final movie don't have to appear in the same order in which they were shot. Digital editing is also non-destructive; this means that it does not affect your original clips (unlike cutting and splicing bits of film in the "old days"). During editing, you manipulate preview versions of these clips and the software merely keeps "notes" on the edit. At the end, you export the result as a new movie; this can take a long time to "render".

NIKON MOVIE EDITOR ☆

IMOVIE ☆

› Software

Nikon now provides movie editing software for Mac and Windows as part of the View NX2 suite provided with the camera. Nikon Movie Editor is a basic, simple editing package but it handles all the key tasks.

Other, more sophisticated options are also available at no cost. Mac users have iMovie, part of the iLife suite, included with all new Macs. The Windows equivalent is Windows Movie Maker, pre-installed with

WINDOWS MOVIE MAKER ☆

Windows Vista; for Windows 7 or 8 it's a free download from windowslive.com. A more advanced (but not free) option, for either platform, is the Adobe Premiere Elements application.

All these apps make it easy to trim and reorder your original clips. Instead of simply cutting instantaneously between shots, you can apply various transitions such as dissolves, wipes, and fades. You can also adjust the look of any clip or segment of the movie—as well as basic controls for brightness, color, and so on, a range of special effects can be added. You can, for instance, make your movie look scratched and faded, as if shot on film 50 years ago rather than yesterday with a digital SLR.

Tip

Effects and transitions are great fun—and non-destructive editing means you can experiment to your heart's content—but, for the sake of the audience, it's best to use a limited selection in the final version. Most TV shows and movies don't use transitions at all, just cut straight from one shot to the next.

You can also add other media, like still photos and sound. You can insert stills individually at appropriate points or create slideshows within the main movie. Again, effects and transitions can be applied to give slideshows a more dynamic feel.

It's equally easy to add a new soundtrack, like a voiceover or music, to part or all of the movie. Last but not least, you can also add titles and captions.

Tip

If you haven't created them yourself, all photos, music, and other media are someone else's copyright. Look for open-source material or get the copyright owner's permission to use their work.

› Taking it further

There's far more to movie-making than we can cover in a single chapter. A useful next step would be reading *Understanding HD Video* by Chiz Dakin, from this publisher.

7 LENSES

There are many reasons to choose an SLR like the D3300. One of the most important is the ability to use a vast range of lenses, including Nikon's own legendary system as well as lenses from other makers. Even the growing numbers of Compact System ("mirrorless") cameras don't yet have access to such a wide choice.

Nikon's F-mount lens mount is now 50 years old, though it has evolved in that time. Still, most Nikkor lenses will fit the D3300, and they will work (albeit sometimes with major limitations). However, there are still sound reasons why more recent lenses are most suitable, notably that many older lenses cannot autofocus on the D3300—see opposite. Another reason for preferring lenses designed specifically for digital cameras relates to the way light reaches the minute individual photodiodes or "photosites" on the camera's sensor. Because these are slightly recessed, there can be some cut-off if light hits them at an angle. This is less

critical with film, for which older Nikkor lenses were designed. Many older lenses can still be used, and can give very good results, but critical examination may show some peripheral loss of brightness (vignetting), and perhaps a hint of chromatic aberration (color fringing). Wide-angle lenses are usually more susceptible. Much depends on the size of print or reproduction you require, and these shortcomings can to some extent be corrected in post-processing (especially if you shoot RAW).

Nikon's DX-series and other newer lenses are specifically designed for digital cameras, maintaining illumination and image quality right across the frame. DX lenses are therefore listed first in the table of Nikkor lenses on *pages 196–201*.

› Using older lenses

When older lenses are used on the Nikon D3300, important functions may be lost. In particular, autofocus is only available with lenses with a built-in motor. Suitable Nikon lenses are designated AF-I or AF-S. Check

D3300 WITH 55–200MM LENS «
This ten-year-old Sigma lens is light in weight and amazingly sharp, so there's still a place for it in my kit selection, but it requires manual focusing when used with the D3300.

carefully when considering lenses from independent makers (e.g. with Sigma lenses, look for the "HSM" tag).

Other AF lenses with a built-in CPU will support some or all of the camera's metering functions and Exposure modes, but will require manual focusing. The electronic rangefinder (*see page 76*) can be helpful.

Older lenses without a built-in CPU, such as AI and AI-S types, can be attached, but the camera's metering will not operate. You'll need to use Exposure mode M; set aperture and shutter speed using an external meter or by trial and error, and use Image review (*page 100*) to check exposure. When using flash or indoor lighting, the same settings can often be used repeatedly. With these lenses, of course, you'll also need to focus manually.

Warning!

Some older lenses, specifically pre-AI lenses, should not be used as they can damage the camera. There are a few other specific (and uncommon) lenses which should be avoided—see the *Nikon Reference Manual*.

7 › Lens technology

Nikon lenses have a high reputation, and many incorporate special features or materials. As these are referred to extensively in the table on *pages 196–201*, brief explanations of the main terms and acronyms are given here.

Abbreviation	Term	Explanation
AF	Autofocus	Lens focuses automatically. The majority of current Nikkor lenses are AF but a substantial manual focus range remains.
ASP	Aspherical Lens Elements	Precisely configured lens elements that reduce the incidence of certain aberrations. Especially useful in reducing distortion with wide-angle lenses.
CRC	Close-range Correction	Advanced lens design that improves picture quality at close-focusing distances.
D	Distance information	Type D and G lenses communicate information to the camera about the distance at which they are focusing, supporting functions like 3D Matrix Metering.
DC	Defocus-Image Control	Found in a few lenses aimed mostly at portrait photographers; allows control of aberrations and thereby the appearance of out-of-focus areas in the image.
DX	DX lens	Lenses specifically designed for DX-format digital cameras (see previous page).
G	G-type lens	Modern Nikkor lenses with no aperture ring; aperture must be set by the camera.
ED	Extra-low Dispersion	ED glass minimizes chromatic aberration (the tendency for light of different colors to be focused at slightly different points).

IF	Internal Focusing	Only internal elements of the lens move during focusing—the front element does not extend or rotate.
M/A	Manual/Auto	Many Nikkor AF lenses offer M/A mode, allowing seamless transition from automatic to manual focusing.
N	Nano Crystal Coat	Said to virtually eliminate internal reflections within lenses, minimizing flare.
RF	Rear Focusing	Lens design where only the rearmost elements move during focusing; makes AF operation faster.
SIC	Super Integrated Coating	Nikon-developed lens coating that minimizes flare and "ghosting".
SWM	Silent Wave Motor	Special in-lens motors that deliver very fast and very quiet autofocus operation.
VR	Vibration Reduction	System which compensates for camera shake. VR is said to allow handheld shooting up to three stops slower than would otherwise be possible (i.e. 1/15th instead of 1/125 sec.). New lenses now feature VRII, said to gain an extra stop over VR (1/8th instead of 1/125 sec.).

Though familiar, the term "focal length" is often used in confusing or even misleading ways.

The focal length of any lens is a basic optical characteristic, and it is not changed by fitting the lens to a different camera. A 20mm lens is a 20mm lens, no matter what.

However, what is often called the "effective focal length" can and does change. I can fit the same lenses to the D3300 or to my full-frame (FX) D600, but the results are different because the D600's larger sensor "sees" more of the image that the lens projects.

Of course, zoom lenses have variable focal length—that's what zoom means—but an 18–55mm zoom is always an 18–55mm zoom, regardless of whether it's fitted on a DX-format camera like the Nikon D3300 or an FX-format camera like the D600. However, because the D3300 has a smaller sensor than the D600, the image that's captured shows a smaller field of view.

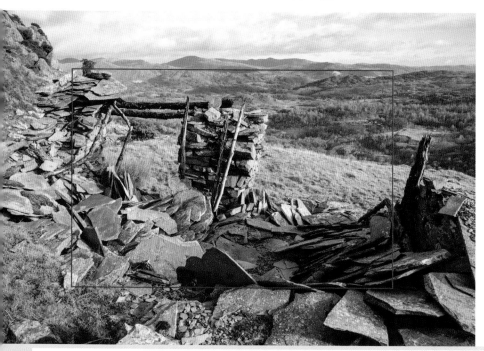

Tip

The lenses on digital compact cameras are normally labelled not with their actual focal length but by their "35mm equivalent"; i.e. the focal length that would give the same angle of view on a 35mm or full-frame camera.

› Field of view

The field of view, or angle of view, is the area covered by the image frame. While the focal length of a lens remains the same on any camera, the angle of view seen in the image is different for different sensor formats. The angle of view is usually measured on the diagonal of the frame (as in the table on *page 196*).

› Crop factor

The D3300's smaller sensor, relative to the 35mm/FX standard, means that it has a crop factor, or focal length magnification factor, of 1.5. If you fit a 200mm lens to a D3300, the field of view equates to what you'd see with a 300mm lens on a full-frame camera (e.g. D4s or D800). For sports and wildlife photography this can be an advantage, allowing long-range shooting with relatively light and inexpensive lenses. On the other hand, the crop factor makes wide-angle lenses effectively less wide, which is unhelpful for landscape shooters in particular. However, this has fostered the development of new ultra-wide lenses, like the 10–24mm f/3.5–4.5G DX Nikkor.

Tip

Throughout this book, and specifically in the shooting details for the photos, the true focal length is used.

FX/DX IMAGE AREA **«**
The original was shot with a 24mm lens on a Nikon D600. The red rectangle shows the area that would be captured using the same lens, from the same position, on a DX-format camera like the D3300.

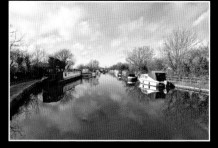

12MM

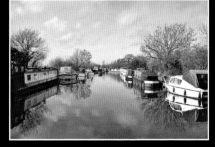

24MM

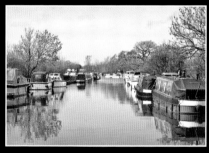

50MM

100MM

200MM

300MM

LENS COMPARISON

A series of images taken on a Nikon D3300, from a fixed position. *1/160 sec., f/11, ISO 100.*

PERSPECTIVE

Perspective concerns the visual relationship between objects at different distances. The apparent fading of distant objects due to haze is atmospheric perspective, while optical perspective relates to the changes in apparent size of objects at different distances.

It's often stated that different lenses give different perspective. This is wrong: perspective is determined purely by distance. However, different lenses do lend themselves to different working distances and are therefore often associated with different perspectives.

A strong emphasis on the foreground may be called "wide-angle perspective" because a wide-angle lens allows you to move closer to foreground objects. Similarly, the apparent compression of perspective in telephoto shots is a result of the greater working distance with the long lens. In this series of shots, the tree-stump remains the same apparent size even though viewed from different distances, but its apparent shape and its relationship to the background change radically.

PERSPECTIVE ⌃
Comparison of perspective as shot with 200mm (top), 50mm (center), and 12mm (bottom) lenses. *1/200 sec., f/11, ISO 400, tripod.*

» LENS ISSUES

› Flare

Lens flare is usually seen when shooting towards the sun or other bright light sources; caused by reflections within the lens, it may produce a string of colored blobs or a more general "veiling" effect.

Advanced lens coatings help reduce flare, so does keeping lenses and filters clean. Even so, when the sun's directly in shot, some flare may be inescapable. You can sometimes mask the sun, perhaps behind a tree. If the sun isn't actually in shot, you can shield the lens.

A good lens hood is essential, but may need to be supplemented with a piece of card, a map, or your hand. This is easier when using a tripod; otherwise it requires assistance, or one-handed shooting.

Check carefully to see if the flare has gone—and that the shading object hasn't crept into shot!

› Distortion

Distortion makes lines which are really straight appear curved in the image. Distortion is usually worst with zoom lenses, especially at the extremes of the zoom range. When straight lines bow outwards, it's called barrel distortion; when they bend inwards it's pincushion distortion. Distortion often goes unnoticed when shooting natural subjects with no straight lines, but can still rear its ugly head when level horizons appear in landscape or seascape images.

Distortion can be corrected using **Auto Distortion Control** in the Shooting menu; this requires a compatible lens and only works on JPEG images. It can also be tackled using **Distortion Control** in the

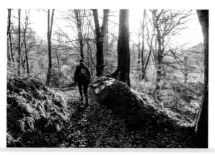

FLARE «
The flare in the first shot is all too obvious, but was almost completely eliminated in the second by a slight shift in position to mask the sun behind a tree. *18mm, 1/100 sec., f/8, ISO 400.*

DISTORTION ⌃
Distortion was exaggerated in post-processing—it's camouflaged by curves and irregular shapes in the foreground but it's all too obvious in the building. *26mm, 1/200 sec., f/13, ISO 200.*

VIGNETTE ⌃
A strong vignette effect was added in post-processing: along with an "antique" treatment, it makes this recent digital shot look like an old photo. *18mm, 1/250 sec., f/11, ISO 250.*

Retouch menu or in post-processing. However, all these methods crop the image.

› Chromatic aberration

Chromatic aberration occurs when light of different colors is focused in slightly different places on the sensor, and appears as colored fringing when images are examined closely. The D3300 has built-in correction for chromatic aberration during processing of JPEG images. Aberration can also be corrected in post-processing; with RAW images this is the only option.

› Vignetting

Vignetting is a darkening towards the corners of the image, most conspicuous in even-toned areas like clear skies. Most lenses show slight vignetting at maximum aperture, but it should reduce on stopping down. It can be tackled in post-processing. Severe vignetting can arise if you use unsuitable lens hoods and filter holders, or "stack" multiple filters on the lens.

› Lens care

Lenses require special care. Glass elements and coatings are easily scratched and this will degrade your images. Remove dust and dirt with a blower. Fingerprints and other marks should be removed using a dedicated lens cleaner and optical grade cloth. A skylight or UV filter (*see page 204*) will help protect the lens, and lens caps should be replaced when the lens is not in use.

7 » STANDARD LENSES

In traditional 35mm photography (and full-frame digital), a 50mm lens is called standard, as its field of view is said to approximate that of the human eye; this is debatable, but the label has stuck. Because of the crop factor of the D3300, the equivalent lens would be around 35mm. Standard lenses are typically light, simple, and have wide maximum apertures. Zoom lenses whose range covers the 35mm focal length are often referred to as "standard zooms".

NIKKOR 35MM F/1.8G AF-S ⌃

STANDARD LENS ⌄
Using a fixed focal-length "standard" lens can often encourage a photographer to be more creative. *42mm, 1/160 sec., f/13, ISO 100.*

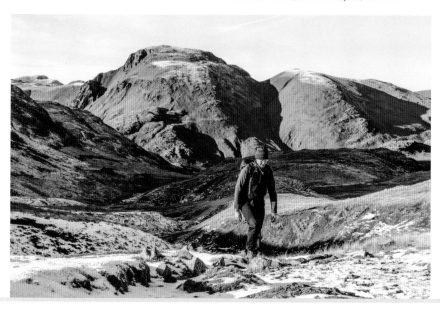

WIDE-ANGLE LENSES

A wide-angle lens is really any lens wider than a standard lens—for the D3300 this means any lens shorter than 35mm. Wide-angle lenses are valuable for working close to subjects or bringing foregrounds into greater prominence. They lend themselves both to photographing expansive scenic views and to working in cramped spaces where you can't step back to "get more in".

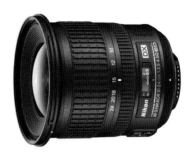

NIKKOR 10-24MM F/3.5-4.5G DX ⌃

Because of the D3300's crop factor, a lens such as an 18mm, once regarded as "super-wide", gives a less extreme angle of view. This has promoted the development of a new breed of even wider lenses like Nikon's and Sigma's 12-24-mm offerings.

WIDE-ANGLE LENS �

WIDE-ANGLE LENS «
Wide-angle lenses are most commonly used for landscape photography. *12mm, 1/250 sec., f/8, ISO 100.*

7 » TELEPHOTO LENSES

Telephoto lenses, often simply called long lenses, give a narrow angle of view. They are mostly employed where working distances need to be longer, as in wildlife and sports photography, but have many other uses, such as singling out small and/or distant elements in a landscape.

Moderate telephoto lenses are favored for portrait photography, because the greater working distance gives a natural-looking result—and it's more comfortable for nervous subjects. The traditional "portrait" range is 85–135mm, equivalent to using lenses of around 60–90mm with the D3300. The laws of optics, and greater working distances, mean depth of field is limited. This is often beneficial in portraiture, wildlife, and sport, as it concentrates attention on the subject by throwing backgrounds out of focus. It can be less welcome in landscape shooting.

NIKKOR 200MM F/2G ED-IF AF-S VRII ⌃

The size and weight of longer lenses makes them harder to handhold comfortably, and their narrow angle of view also magnifies any movement—high shutter speeds and the use of a tripod or other camera support are recommended. Nikon's Vibration Reduction (VR) technology also mitigates the effects of camera shake—but it can slow down the maximum frame rate. This can be an issue if you're shooting sports or wildlife.

> ### Tip
>
> Switch VR **OFF** when using the camera on a tripod. Otherwise, it can sometimes add shake instead of removing it!

TELEPHOTO «
Telephoto lenses can be useful for isolating distant details in a landscape. *150mm, 1/250 sec., f/10, ISO 200.*

ZOOM LENSES

The term "zoom" covers lenses with variable focal length, like the AF-S DX Nikkor 18-105mm f/3.5-5.6G. A zoom lens can replace a bagful of prime lenses and cover the gaps in between, scoring highly for weight, convenience, and economy. Flexible focal length also allows very precise framing.

While once considered inferior in optical quality, there is now little to choose between a good zoom and a good prime lens, at least in terms of general sharpness and contrast. Most zoom lenses will have a "sweet spot" somewhere in the zoom range where distortion is minimal, but many show discernible barrel distortion at wide settings and pincushion at the long end.

Zooms with a very wide range (e.g. 18-200mm or 28-300mm) may still be optically compromised, and usually have a relatively small ("slow") maximum aperture, but they are undeniably versatile. That wide, uninterrupted zoom range can prove useful for movie shooting in particular. The widest range currently available in a single lens is Tamron's 16-300mm f/3.5-6.3.

The Nikkor AF-S DX 18-55mm f/3.5-5.6G VRII lens, commonly supplied as part of a kit with the D3300, is currently unique among DSLR lenses in its retractable design—*see page 29.* (Many compact cameras have retractable lenses, and Nikon

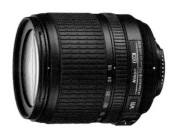

**ZOOM-NIKKOR 18-105MM ⊗
F/3.5-5.6G AF-S VR**

has already produced an equivalent lens for its 1 series mirrorless cameras.) This lens has been very well received, but can be frustrating if you forget to extend the barrel before attempting to take a shot. You can, of course, leave it extended until you need to stow the camera away.

ZOOM LENS ⊗
Zoom lenses can help you frame images that would otherwise take a lot of legwork to capture. *86mm, 1/640 sec., f/5.6, ISO 125.*

7 » MACRO LENSES

For specialist close-up work there is little to beat a true macro lens. For more on these *see page 160.*

» PERSPECTIVE-CONTROL LENSES

PC-E NIKKOR 24MM F/3.5D ED ≫

Perspective-control (PC or "tilt and shift") lenses give unique flexibility in viewing and controlling the image. Their most obvious application is in photographing architecture, where with a "normal" lens it often becomes necessary to tilt the camera upwards, resulting in converging verticals (buildings appear to lean back or even to one side). The shift function allows the camera-back to be kept vertical, which in turn means that vertical lines in the subject remain vertical in the image. Tilt movements also allow extra control over depth of field, whether to extend or to minimize it.

The current Nikon range features three PC lenses, with focal lengths of 24mm, 45mm, and 85mm. They retain many automatic functions, but require manual focusing.

PERSPECTIVE CONTROL ≫
These two images show how a shot of a building looks with a normal wide-angle lens (top) and with a perspective control or "tilt-and-shift" lens (bottom), which corrects the distorted verticals. *1/100 sec., f/14, ISO 400.*

TELECONVERTERS

Teleconverters are supplementary units which fit between the main lens and the camera body, and magnify the focal length of the main lens. Nikon currently offers the TC-14E II (1.4x magnification), TC-17E II (1.7x), and TC-20E II (2x). The advantages are obvious, allowing you to extend the focal length range with minimal additional weight (the TC-14E II, for example, weighs just 7oz or 200g).

However, teleconverters can degrade image quality; as you might expect, the higher the magnification factor of the converter the more noticeable this is. The TC-20E III, in particular, produces a significant loss of sharpness, especially if you try and shoot at maximum aperture. Results improve when the lens is stopped down to f/8 or f/11; beyond this, sharpness

AF-S TELECONVERTER TC-20E III ⌃

tails off again due to diffraction. Converters also cause a loss of light. Fitting a 2x converter to an f/4 lens turns it into an effective f/8. One consequence is that the camera's autofocus may become sluggish or will only work with the central focus points.

Warning!

Some lenses are incompatible with these teleconverters. Check carefully before use.

TELECONVERTER ⌄
A teleconverter is a convenient (and relatively inexpensive) way of increasing the focal range of a lens, albeit with some limitations. *140mm, 1/640 sec., f/13, ISO 200.*

» LENS HOODS

A lens hood serves two main functions. It shields the lens against knocks, rain, and other hazards. It also helps to exclude stray light which does not contribute to the image but may degrade it by causing flare. Most Nikkor lenses come with a dedicated lens hood.

Optical features/notes

DX Lenses

Lens	Optical features/notes
10.5mm f/2.8G DX Fisheye	CRC
10-24mm f/3.5-4.5G ED AF-S DX	ED, IF, SWM
12-24mm f/4G ED-IF AF-S DX	SWM
16-85mm f/3.5-5.6G ED VR AF-S DX	VRII, SWM
17-55mm f/2.8G ED-IF AF-S DX	ED, SWM
18-55mm f/3.5-5.6G VR II AF-S DX (Retractable)	VRII, SWM
18-55mm f/3.5-5.6G AF-S VR DX	VR, SWM
18-70mm f3.5-4.5G ED-IF AF-S DX	ED, SWM
18-105mm F/3.5-5.6G ED VR AF-S DX	ED, IF, VRII, NC, SWM
18-140mm F/3.5-5.6G ED VR AF-S DX	ED, IF, VRII, SWM
18-200mm f/3.5-5.6G ED AF-S VRII DX	ED, SWM, VRII
18-300mm f/3.5-5.6G ED VR AF-S DX	ED, IF, SWM, VRII
35mm f/1.8G AF-S	SWM
40mm f/2.8G AF-S DX Micro NIKKOR	SWM
55-200mm f/4-5.6 AF-S VR DX	ED, SWM, VR
55-200mm f/4-5.6G ED AF-S DX	ED, SWM
55-300mm f/4.5-5.6G ED VR	ED, SWM
85mm f/3.5G ED VR AF-S DX Micro Nikkor	ED, IF, SWM, VRII

AF Prime lenses

Lens	Optical features/notes
14mm f/2.8D ED AF	ED, RF
16mm f/2.8D AF Fisheye	CRC
20mm f/2.8D AF	CRC
24mm f/1.4G ED	ED, NC
24mm f/2.8D AF	

Angle of view on DX format	Minimum focus distance (m)	Filter size (mm)	Dimensions diameter x length (mm)	Weight (g)
180	0.14	Rear	63 x 62.5	300
109–61	0.24	77	82.5 x 87	460
99–61	0.3	77	82.5 x 90	485
83–18.5	0.38	67	72 x 85	485
79–28.5	0.36	77	85.5 x 11.5	755
76–28.5	0.28	52	66 x 59.5 (retracted)	195
76–28.5	0.28	52	73 x 79.5	265
76–22.5	0.38	67	73 x 75.5	420
76–15.3	0.45	67	76 x 89	420
76–11.5	0.45	67	78 x 97	490
76–8	0.5	72	77 x 96.5	560
76–5.3	0.45	77	83 x 120	830
44	0.3	52	70 x 52.5	210
38.5	0.163	52	68.5 x 64.5	235
28.5–8	1.1	52	73 x 99.5	335
28.5–8	0.95	52	68 x 79	255
28.5–5.2	1.4	58	76.5 x 123	530
18.5	0.28	52	73 x 98.5	355
90	0.2	Rear	87 x 86.5	670
120	0.25	Rear	63 x 57	290
70	0.25	62	69 x 42.5	270
61	0.25	77	83 x 88.5	620
61	0.3	52	64.5 x 46	270

Optical features/notes

28mm f/1.8G AF-S	NC, SWM
28mm f/2.8D AF	
35mm f/2D AF	
35mm f/1.8G AF-S	RF, SWM
35mm f/1.4G AF-S	NC, SWM
50mm f/1.8G AF-S	SWM
50mm f/1.8D AF	
50mm f/1.4D AF	
50mm f/1.4G AF-S	IF, SWM
58mm f/1.4G AF-S	NC, SWM
85mm f/1.4G AF	SWM, NC
85mm f/1.8D AF	RF
85mm AF-S f/1.8G	IF, SWM
105mm f/2D AF DC	DC
135mm f/2D AF DC	DC
180mm f/2.8D ED-IF AF	ED, IF
200mm f/2G ED-IF AF-S VRII	ED, VRII, SWM
300mm f/4D ED-IF AF-S	ED, IF
300mm f/2.8G ED VR II AF-S	ED, VRII, NC, SWM
400mm f/2.8G ED VR AF-S	ED, IF, VRII, NC
400mm f/2.8D ED-IF AF-S II	ED, SWM
500mm f/4G ED VR AF-S	IF, ED, VRII, NC
600mm f/4G ED VR AF-S	ED, IF, VRII, NC
800mm f/5.6E FL ED VR AF-S	ED, NC, SWM, FL

Angle of view on DX format	Minimum focus distance (m)	Filter size (mm)	Dimensions diameter x length (mm)	Weight (g)
53	0.25	67	73 x 80.5	330
53	0.25	52	65 x 44.5	205
44	0.25	52	64.5 x 43.5	205
44	0.25	58	72 x 71.5	305
44	0.3	67	83 x 89.5	600
31.3	0.45	58	72 x 52.5	185
31.3	0.45	52	63 x 39	160
31.3	0.45	52	64.5 x 42.5	230
31.3	0.45	58	73.5 x 54	280
27.3	0.58	72	85 x 70	385
18.5	0.85	77	86.5 x 84	595
18.5	0.85	62	71.5 x 58.5	380
18.5	0.8	67	80 x 73	350
15.2	0.9	72	79 x 111	640
12	1.1	72	79 x 120	815
9.1	1.5	72	78.5 x 144	760
8.2	1.9	52	124 x 203	2930
5.2	1.45	77	90 x 222.5	1440
5.2	2.2	52	124 x 267.5	2900
4	2.9	52	159.5 x 368	4620
4	3.8	52	160 x 352	4800
3.1	4	52	139.5 x 391	3880
2.4	5	52	166 x 445	5060
2	5.9	52	160 x 461	4590

AF Zoom lenses

14–24mm f/2.8G ED AF-S	IF, ED, SWM, NC
16–35mm f/4G ED VR	NC, ED, VR
17–35mm f/2.8D ED-IF AF-S	IF, ED, SWM
18–35mm f/3.5–4.5G ED AF-S	ED, SWM
24–70mm f/2.8G ED AF-S	ED, SWM, NC
24–85mm f/2.8–4D IF AF	IF
24–85mm f/3.5–4.5G ED VR AF-S	ED, VRII, SWM
24–120mm f/4G ED-IF AF-S VR	ED, SWM, NC, VRII
28–300mm f/3.5–5.6G ED VR	ED, SWM
70–200mm f/2.8G ED-IF AF-S VRII	ED, SWM, VRII
70–200mm f/4G ED AF-S VRIII	ED, IF, SWM, NC, VRIII
70–300mm f/4.5–5.6G AF-S VR	ED, IF, SWM, VRII
80–400mm f/4.5–5.6D ED VR AF-S	ED, VR, NC
200–400mm f/4G ED-IF AF-S VRII	ED, NC,VRII, SWM

Macro lenses

60mm f/2.8G ED AF-S Micro	ED, SWM, NC
105mm f/2.8G AF-S VR Micro	ED, IF, VRII, NC, SWM
200mm f/4D ED-IF AF Micro	ED, CRC

Perspective control

24mm f/3.5D ED PC-E (manual focus)	ED, NC
45mm f/2.8D ED PC-E Micro (manual focus)	ED, NC
85mm f/2.8D ED PC-E Micro (manual focus)	ED, NC

Angle of view on DX format	Minimum focus distance (m)	Filter size (mm)	Dimensions diameter x length (mm)	Weight (g)
90–61	0.28	None	98 x 131.5	97
83–44	0.29	77	82.5 x 125	680
79–44	0.28	77	82.5 x 106	745
76–44	0.28	77	83 x 95	385
61–22.50	0.38	77	83 x 133	900
61–18.5	0.5	72	78.5 x 82.5	545
61–18.5	0.38	72	78 x 82	465
61–13.5	0.45	77	84 x 103.5	710
53–5.2	0.5	77	83 x 114.5	800
22.5–8	1.4	77	87 x 209	1540
22.5–8	1	67	78 x 178.5	850
22.5–5.20		67	80 x 143.5	745
20–4	2.3	77	95.5 x 203	1570
8–4	2	52	124 x 365.5	3360
26.3	0.185	62	73 x 89	425
15	0.31	62	83 x 116	720
8	0.5	62	76 x 104.5	1190
56	0.21	77	82.5 x 108	730
34.5	0.25	77 x 94	83.5 x 112	780
18.9	0.39	77	82.7 x 107	650

7 » LENSES AND DEPTH OF FIELD

As discussed earlier (*see page 65*), focal length is one of the key factors affecting depth of field—and it's intimately linked with distance, which is another. What you gain by switching to a wide-angle lens, you can lose again (at least partly) if you then move closer to your main subject.

LANDSCAPE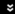

Photographing this scene, there is no single localized "subject" and I knew that the result would look unnatural if any part of the image ended up unsharp. The combination of a short focal length, a fairly small aperture, and a focus point fairly close to me ensured that depth of field covered everything.

> Focal length: 18mm
> Shutter speed: 1/160 sec.
> Aperture: f/11
> Sensitivity: ISO 250

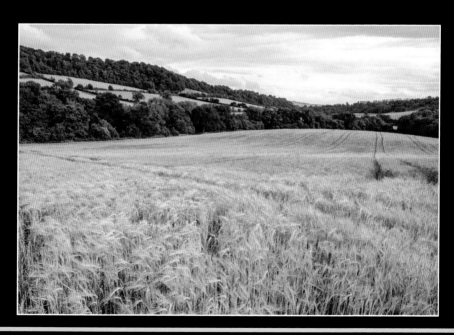

FOREGROUND ⌄

Another landscape, but I opted for a different approach, with a longer lens, wide aperture, and close focus point. You can still see what everything is, but the background is soft enough to reduce its "weight" in the image, concentrating attention on the colorful weeds and particularly those in the foreground.

> ❯ *Focal length: 55mm*
> ❯ *Shutter speed: 1/2000 sec.*
> ❯ *Aperture: f/5*
> ❯ *Sensitivity: ISO 250*

8 ACCESSORIES

Digital SLRs are system cameras: as well as lenses and flash units, there are many other accessories which can extend the capabilities of the camera. Nikon's system is huge, and third-party suppliers offer even more options.

» FILTERS

Some types of filter are virtually redundant with digital cameras; the white balance controls (*page 82*) have largely eliminated the need for color-correction filters, which were essential for accurate color on film, especially transparency film.

Avoid using filters unnecessarily. Adding extra layers of glass in front of the lens can degrade the image and increase flare (*see page 188*). There is one exception: keeping a UV or skylight filter (see below) attached to each lens provides a first line of defence against knocks and scratches.

› Types of filter

Filters can attach to the lens in several ways. The most familiar type are circular filters which screw to the front of the lens. The filter-thread diameter (in mm) of most Nikon lenses is specified in the table on *pages 196–201*, and usually marked around the front of the lens next to a Ø symbol. Nikon produces high-quality filters in sizes matching Nikkor lenses. Larger ranges are available from Hoya and B+W.

If you use filters extensively, you'll find slot-in filters more economical and convenient. The square or rectangular filters fit into a slotted holder. One holder and one set of filters can serve many lenses, each of which just needs a simple adapter ring.

A few specialist lenses, including super-telephotos, extreme wide-angle, and fish-eye lenses, require equally specialist filters, fitting either at the rear of the lens or by a slot in the lens barrel.

› UV and skylight filters

Both of these filters cut out excess ultraviolet light, which can make images appear excessively blue. The skylight filter also has a slight warming effect. They also protect the front element of the lens, and many photographers keep one permanently attached to the front of each lens.

SKYLIGHT FILTER »
A UV or skylight filter can help guard against an excessive blue cast, which can be particularly problematic in mountain regions. *102mm, 1/250 sec., f/11, ISO 400.*

› Polarizing filters

The polarizing filter cuts down reflections from most surfaces, intensifying colors in rocks and vegetation, for instance. It can make reflections on water and glass virtually disappear, restoring transparency. Rotating the filter strengthens or weakens its effect.

The polarizer can also cut through atmospheric haze (though not mist or fog) like nothing else, and can make blue skies appear more intense. These effects are strongest when shooting at right angles to the sunlight, vanishing when the sun is directly behind or in front. When used with wide-angle lenses, the effect can vary conspicuously across the field of view. You might only use it occasionally, but some of its effects are virtually impossible to reproduce by any other means, even in post-processing. Sometimes it can be priceless.

› Neutral density filters

Neutral density (ND) filters reduce the amount of light reaching the lens, without shifting its color—hence "neutral". ND filters can be either plain or graduated.

A plain ND filter allows you to set slower shutter speeds and/or wider apertures than you could otherwise. A classic example is shooting waterfalls, where you may want a long shutter speed to create a silky blur. ND filters can be particularly useful when shooting video, because of the limited range of shutter speeds available (*see page 170*).

Graduated ND filters have neutral density over half their area, the other half being clear, with a gradual transition at the midline. They are widely used in landscape photography to compensate for big differences in brightness between sky and land.

› Special effects filters

Soft-focus filters are still used in portrait photography, but they have been widely supplanted by digital post-processing. Much the same is true of the "starburst". Both of these can be replicated in-camera, using **Soft** and **Cross Screen** respectively in the **Filter effects** section of the Retouch menu (*page 123*).

"Effects" images were all the rage in the 1970s, when the Cokin system became available to stills photographers, but the appeal soon palled, although there's been a revival with the likes of Instagram. Just remember, if you capture the image "straight", and apply effects through the Retouch menu or in post-processing, you can always change your mind later on!

LOW SHUTTER SPEED **«**
A plain Neutral Density filter may be useful when you want to use really low shutter speeds.
45mm, 1 sec., f/32, ISO 100, tripod.

› ESSENTIALS

Nikon includes several items in the box with the camera, but these are really essentials, not extras.

› EN-EL14a battery

Without a live battery, your D3300 is a useless deadweight. It's always wise to have a fully charged spare on hand—especially in cold conditions, when using the screen extensively, or when shooting movies. If you shoot movies seriously, make that "several fully charged spares". Older EN-EL14 batteries can also be used.

› MH-24 charger

Vital for keeping the battery charged.

› BF-1A/1B body cap

The body cap protects the interior of the camera when no lens is attached.

› Camera cases

Nikon don't supply a case, but one should be seen as essential. The most practical is a simple drop-in pouch which can be worn on a waist-belt. If you want to carry a larger system, including several lenses, a flash, and a tripod, then a backpack-type bag is kindest on your spine.

POUCH ⌃
A padded pouch (this one's by Think Tank Photo) combines good protection and easy access.

BACKPACK ⌄
Backpacks are best for the spine (photo of the author by Bernie Carter).

» OPTIONAL ACCESSORIES

A selection from Nikon's extensive range is listed here.

› AC Adapter EH-5b

Can be used to power the camera directly from the AC mains, allowing uninterrupted shooting in, for example, long video sessions. (A Power Connector EP-5A is also required.)

› Remote cords and cable releases

Nikon's 3ft- (1m-) long MC-DC2 remote cord can be attached to the D3300's accessory terminal, allowing shutter release without touching the camera. This helps to minimize vibration.

› ME-1 stereo microphone

Greatly improves sound quality in movie shooting (*see page 171*). It's pretty reasonably priced, but of course there are third-party alternatives.

› GP-1 and GP-1A GPS units

These are dedicated Global Positioning System devices (*see page 229*).

› Wireless remote control ML-L3

WIRELESS REMOTE　　　　　　　　　　　⌃
The wireless remote control ML-L3 can be stashed on the camera strap between uses.

This inexpensive little infrared unit allows the camera to be triggered from a distance of up to 16ft (5m). There are receivers on both front and rear of the camera, allowing operation from a wide range of positions.

Nikon's WR-R10 wireless transceiver and WR-T10 wireless transmitter offer a much wider range of functions, at a much higher

price. Third-party units like Hahnel's Giga T Pro II can give you most of this power at a lower cost. However, none of these let you see what the camera is seeing, which Wi-Fi and a smartphone can do (*see page 224*).

› Wireless mobile adapter WU-1a

This small, and relatively inexpensive, adapter allows the D3300 to connect wirelessly to a suitable smartphone or tablet (using iOS or Android). For more about wireless connection, see Chapter 9 (*page 224*).

› Diopter adjustment

The D3300's Viewfinder has built-in dioptric adjustment (*see page 25*). If your eyesight is beyond its range, Nikon produces a series of Viewfinder lenses between −5 and +3 m^{-1}, with the designation DK-20C.

Tip

It's usually easier to wear contact lenses or glasses. My prescription is around −5 m^{-1} and I've never had any problem using the D3300 while wearing contacts.

› Screen shades

Camera LCD screens can be impossible to see properly in bright sunlight. The Viewfinder is much better for shooting in bright light, but you can still need the screen for Live View and especially for shooting movies. Third-party companies produce accessory screen shades (probably the best-known name is Hoodman). However, if you only need one occasionally, you can improvise with bits of card.

8 » CAMERA SUPPORT

There's much more to camera support than tripods, although these remain a staple.

› Tripods

VR lenses, plus the D3300's ability to produce fine images at high ISO settings, do encourage handholding, but there are still many occasions where nothing but a tripod will do. While light weight and low cost always appeal, beware of tripods that simply aren't sturdy enough to provide decent support, especially with longer lenses. A good tripod is an investment that will last for years. The best combination of low weight with good rigidity comes (at a price!) in titanium or carbon fiber. Carbon-fiber tripods are made by Manfrotto and Gitzo, among others. My first Manfrotto carbon tripod outlived several cameras and indeed took me from shooting film into the digital age.

When shooting movies, a tripod is essential, and many tripods are designed specifically for this purpose (*see page 173*).

› Monopods

Monopods can't equal the ultimate stability of a tripod, but are light, easy to carry, and quick to set up. They are favored by sports photographers, who often need to react quickly while using hefty long telephoto lenses.

› Other camera support

There are many other solutions for camera support, both proprietary products and improvised alternatives. It's still hard to beat the humble beanbag; these can be homemade, or bought from various suppliers. For movie-specific camera support, *see page 173*.

TRIPOD ⌄
Tripods are ideal for a wide variety of subjects.
14mm, 0.6 sec., f/11, ISO 400, tripod.

› STORAGE

› Memory cards

The D3300 stores images on Secure Digital (SD), SDHC, and SDXC cards. On long trips it's easy to fill up even large-capacity memory cards and they are now remarkably cheap, so it's advisable to carry a spare or two.

Memory card performance is measured in two ways. **Speed rating** or **rated speed** (e.g. 30MB/s) is the key measure when shooting stills, especially RAW files.

Class or **speed class rating** (e.g. Class 10) is more important when shooting video.

BEANBAG ⌄
A simple homemade beanbag that has served me well for many years.

› Portable storage devices

Memory cards rarely fail but it's always worth backing up valuable images as soon as possible. Dedicated mobile photo storage devices like the Vosonic VP8870 and Epson P7000 are increasingly hard to find, as most people (if they back up at all!) now use a laptop, smartphone, or tablet (*see pages 110, 221*).

› Card care

If a memory card is lost or damaged before downloading or backing up, your images are lost too. Blank cards are cheap but cards full of images are irreplaceable—unlike the camera itself. As SD cards use solid-state memory, they are pretty robust but it's still wise to treat them with care. Keep them in their original plastic cases, or something more substantial, and avoid exposure to extremes of temperature, direct sunlight, liquids, and strong electromagnetic fields.

> **Note:**
> There seems to be no evidence that modern airport X-ray machines have any harmful effect on either digital cameras or memory cards.

The D3300 is robust, but it's also packed with complex and potentially delicate electronic and optical technology. A few simple precautions should help it keep functioning perfectly for many years.

› Basic care

Keeping the camera clean is fundamental. Keep the camera in a case when not in use. Remove dust and dirt with a blower, then wipe with a soft, dry cloth.

The rear screen may be tough enough to survive without a protective cover, but it will need cleaning periodically. Use a blower to remove loose dirt, then wipe the surface carefully with a clean soft cloth or a swab designed for the purpose. Do not apply pressure and never use household cleaning fluids.

Warning!

The reflex mirror is extremely delicate. Never touch it in any way. Remove dust from the mirror with gentle use of an air-blower, and nothing else. Marks on the mirror will not appear in images anyway.

› Cleaning the sensor

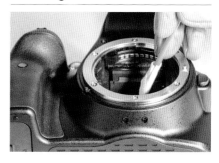

CLEANING THE SENSOR ⌃
Cleaning the sensor requires confidence—and great care!

While the D3300 dispenses with the optical low-pass filter over the sensor (*page 8*), there is still a protective filter in front of the sensor itself. Although everyone refers to "sensor cleaning", it's this filter, not the sensor itself, which can actually attract dust and need cleaning. Dust on the filter will appear as dark spots in your images.

However careful you are, unless you never change lenses, some dust will eventually find its way in. Fortunately, the D3300 has a self-cleaning facility. This can be activated manually at any time or set to occur automatically when the camera is switched on and/or off. Select options using **Clean Image Sensor** in the Setup menu.

Occasionally, however, stubborn spots may remain and it may become necessary to clean the filter manually. This is best done in a clean, draught-free, and well-lit area, preferably using a lamp which can be aimed into the camera's interior.

Ensure the battery is fully charged: use a mains adapter if available. Remove the lens, switch the camera on, and select **Lock mirror up for cleaning** from the Setup menu. Press the shutter-release button to lock up the mirror. First, attempt to remove dust using a hand-blower (**do not use** compressed air or any other aerosol). If this appears ineffective, consider using a dedicated sensor cleaning swab, carefully following its supplied instructions. **Do not use** other brushes or cloths and **never** touch the sensor with your finger. The result could be far worse than a few dust spots! When cleaning is complete, turn the camera off and the mirror will reset.

Warning!

Any damage caused by heavy-handed manual cleaning or the use of inappropriate products could void your warranty. If in doubt, consult a professional dealer or camera repairer.

Tip

If (or when!) spots do appear on images, they can always be removed using, for example, the Clone tool or Healing brush in Adobe Photoshop. In Nikon Capture NX2 this process can be automated by creating a Dust-off reference image (see page 114). Spot-removal can be applied across batches of images in Adobe Lightroom.

› Cold

Nikon specify an operating temperature range of 32–104°F (0–40°C). When ambient temperatures fall below freezing, the camera can still be used, but aim to keep it within the specified range as far as possible. Keeping the camera in an insulated case or under outer layers of clothing between shots will help keep it warmer than the surroundings. If it does become chilled, battery life can be severely reduced (always carry a spare). In extreme cold, the LCD displays may become erratic or disappear completely, and ultimately the camera may cease to function. If allowed to warm up gently, no permanent harm should result.

COLD WEATHER ⌄
Winter conditions offer wonderful photographic opportunities but can be challenging for cameras. *86mm, 1/800 sec., f/11, ISO 200.*

› Heat and humidity

Extremes of heat and humidity (Nikon stipulate over 85%) can be even more problematic, as they are more likely to lead to long-term damage. In particular, rapid transfers from cool environments to hot and humid ones (air-conditioned hotel to sultry streets) can cause internal condensation. If such transitions occur, pack the camera and lens(es) in airtight containers with sachets of silica gel, which will absorb any moisture. Allow equipment to reach ambient temperature before unpacking, let alone using, it.

SPRAY ≫
A dramatic location but potentially hazardous for the camera: salt spray is notoriously insidious. Sand, dust, and dirt all require care too. *18mm, 1/125 sec., f/11, ISO 400.*

The D3300 does not claim to be waterproof, but brief exposure to light rain is unlikely to do permanent harm. Keep exposure to a necessary minimum, and wipe regularly with a microfiber cloth (always handy to deal with accidental splashes). Avoid using the built-in flash and keep the hotshoe cover in place. Double-check that all access covers on the camera are properly closed.

Take extra care to avoid contact with salt water. If this does occur, clean carefully and immediately with a cloth lightly dampened with fresh, preferably distilled water.

IN THE RAIN ⊻
Rain made this sculpture more evocative, but I needed to take care of the camera too. *55mm, 1/50 sec., f/5.6, ISO 800.*

Ideally, protect the camera with a waterproof cover. A simple plastic bag will provide rudimentary protection, but purpose-made rainguards are available, e.g. HydroPhobia from Think Tank. Aquapac's reasonably priced DSLR case is a good match for the D3300 and is rated for immersion to a depth of 10m.

AN SLR CASE FROM AQUAPAC ⌄

› Dust

To minimize ingress of dust into the camera, take great care when changing lenses. Aim the camera slightly downward and stand with your back to any wind. In really bad conditions (such as sandstorms) it's best not to change lenses at all, and better still to protect the camera with a waterproof, and therefore also dust-proof, case. Dust that settles on the outside of the camera is relatively easy to remove; the safest way is with a hand-operated or compressed-air blower. Do this before changing lenses, memory cards, or batteries, keeping all covers closed until the camera is clean.

SAND AND DUST 〈〈

In the excitement of finding yourself in an exotic landscape, it can be easy to overlook routine care of the camera. Deserts often mean extremes of temperature as well as an abundance of sand and dust. *50mm, 1/160 sec., f/11, ISO 125.*

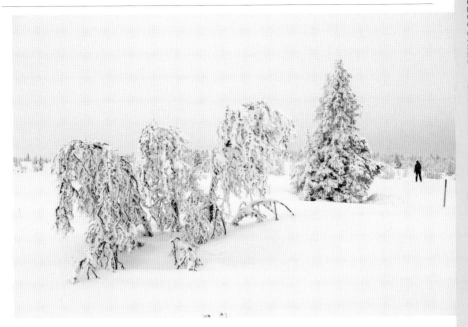

IN THE SNOW ⌃

It was never particularly cold during this week in Norway—perhaps −5°C at coldest—and the D3300 took it in its stride. I kept it in a backpack for maximum protection, and to avoid anything throwing me off my balance as I'm not the most expert skier. A special pocket meant the camera was still easily accessible when needed. *18mm, 1/320 sec., f/8, ISO 500.*

CONNECTION

In digital photography, connecting to external devices—especially computers—is not an optional extra: it's how you store, organize, backup and print images. The D3300 is designed to facilitate these operations, and a couple of useful cables are included with the camera.

» CONNECTING TO A COMPUTER

Connecting to a Mac or PC allows you to store, organize, and backup your images. It also helps you exploit the full power of the D3300, including the ability to optimize image quality from RAW files. Some software packages allow "tethered" shooting, where images appear on the computer straight after capture; Nikon Camera Control Pro 2 (optional purchase) goes further, allowing the camera to be controlled directly from the Mac or PC.

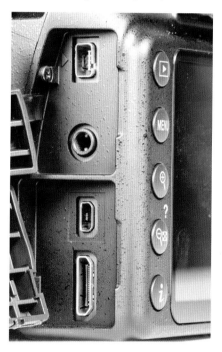

› Computer requirements

The large file sizes produced by the D3300—especially if you shoot RAW—place extra demands on computer systems, stressing processor speed, hard disk capacity, and—above all—memory (RAM). Systems with less than 4GB of RAM may run slowly when dealing with RAW or full-size JPEG images from the camera. Fortunately, adding extra RAM to most systems is relatively easy and inexpensive. Extra hard disk space can also be helpful, as the system will slow significantly when the hard disk becomes close to capacity.

CONNECTION PORTS ON THE LEFT 〈〈
SIDE OF THE D3300

A CD drive is useful but not essential for installing the supplied Nikon View NX2 software, as it can also be downloaded from the Nikon website. Nikon View NX2 requires one of the following operating systems: Mac OS X (Version 10.7.5, 10.8.5, or 10.9); Windows 8.1; Windows 7 (Service Pack 1); Windows Vista (Service Pack 2); Windows XP (Service Pack 3).

A D3300 CONNECTED TO A COMPUTER ⌃

› Backing up

Until they are backed up, your precious images exist solely as data on the camera's memory card. Memory cards are robust but not indestructible, and in any case you will surely wish to format and reuse them.

However, when images are transferred to the computer and the card is formatted, those images once more exist in one single location, the computer's hard drive. If anything happens to that hard drive, whether fire, theft, or hardware failure, you could lose thousands of irreplaceable images. There is only one way to avoid this: always keep a backup.

The simplest form of backup is to a second hard drive; the "gold standard" requires multiple drives, one of which is always kept off site. Online backup is also an option, but unless you shoot very sparingly you'll find free services offer nowhere near enough space. If you shoot a lot, paid services can easily cost more than a couple of spare hard drives.

APPLE'S TIME MACHINE MAINTAINS ⌄
BACKUPS AUTOMATICALLY

› Color calibration

A major headache for digital camera users is that images look one way on the camera monitor, different on the computer screen, different when you email them to your friends, and different again when printed. To achieve consistency across different devices, it's vital above all that your main computer screen is correctly set up and calibrated. This may seem complex and time-consuming but ultimately saves much time and frustration. Detailed advice is beyond the scope of this book but try searching System Help for "monitor calibration". There's more detail in the *Digital SLR Handbook* (from this author and publisher) and there's some useful advice at http://www.cambridgeincolor.com/color-management-printing.htm.

THE DISPLAY CALIBRATOR ASSISTANT INCLUDED IN MAC OS X IS A GOOD STARTING POINT ⌄

› Connecting the camera

To transfer images directly to a laptop or desktop, unless you use an Eye-Fi card (*see pages 120, 224*), you need to connect the camera physically. The camera is supplied with a suitable USB cable.

This description is based on Nikon Transfer, part of the supplied View NX2 package. The procedure with other software will be similar in outline but different in detail.

1) Start the computer and let it boot up. Open the cover on the camera's left side and insert the smaller end of the supplied USB cable into the AV/USB slot; insert the other end into a USB port on the computer (not an unpowered hub or port on the keyboard).

2) Switch on the camera. Nikon Transfer starts automatically (unless you have configured its Preferences not to do so).

3) The Nikon Transfer window offers various options. The following are particularly important.

4) To transfer selected images only, use the check box below each thumbnail to select/deselect as required.

5) Click the Primary Destination tab to choose where photos will be stored. You

can create a new subfolder for each transfer, rename images as they are transferred, and so on.

6) Click the Backup Destination tab if you want Nikon Transfer to create backup copies automatically during transfer (ideally on a separate drive).

7) When transfer is complete, switch off the camera and disconnect the cable.

Tip

Most people find it more convenient to transfer photos by inserting the memory card into a card-reader. The procedure is essentially the same. Many computers have built-in SD card slots but separate card-readers are cheap and widely available. Older card-readers may not support SDHC or SDXC cards.

If you transfer images using a card-reader, remove the card from the system like any other external drive when the download is finished. In Windows, use Safely Remove Hardware; in Mac OS X use Command + E or drag the D3300 icon to the Trash.

› Importing movies

The basic procedure for importing movies is the same as for stills. Nikon Transfer will recognize and import them, but you will probably want to store movies in a different folder than still images. Often it's better to import movies through your editing software (*see page 178*); this ensures that all your movie clips are stored in the same place and that the software can immediately locate them for editing purposes.

NIKON TRANSFER **«**

9 » WI-FI

The D3300 does not have onboard Wi-Fi, but you can easily connect using Nikon's Wireless Mobile Adapter WU-1a or an Eye-Fi card. It's important to be aware that the two do quite different jobs (you may even want both).

› Wireless Mobile Adapter WU-1a

The Wireless Mobile Adapter WU-1a will only connect to mobile devices (using iOS or Android); there appears to be no way to connect to a laptop or desktop computer. Nikon publicity states that you can "control the camera remotely", but this is distinctly optimistic—you can view a Live View image, set focus, and trigger the shutter, but can't change any other settings. You can also view photos on the camera and transfer any or all of them to the smart device. Note, however, that NEF (RAW) files will be converted to JPEG on transfer.

To connect to your iOS or Android device, you'll also need Nikon's Wireless Mobile Utility; it's a free download from the App Store or Google Play.

› Eye-Fi

Eye-Fi looks and operates like a conventional SD card, but includes an antenna which allows it to connect to WiFi networks for transferring images wirelessly. Unlike the WU-1a, it allows you to transfer images to a desktop or laptop computer, but you can't control the camera remotely. Some Eye-Fi cards also support ad-hoc networks, so images can be transferred to a laptop or iPad when out of the range of regular WiFi. Eye-Fi software is installed by plugging the card into any WiFi-enabled Mac or PC; that computer becomes the default destination for Eye-Fi upload. The card can then be inserted in the camera; use **Eye-Fi Upload** in the Setup menu to enable transfers. When out of range of your network, turn Eye-Fi off to save battery power. The card still functions as a regular memory card.

There are other solutions which enable you to do much more with a wireless connection, such as CamRanger, but this costs five times as much as Nikon's WU-1a.

⇢ SOFTWARE AND IMAGE PROCESSING

The D3300 is bundled with Nikon View NX2 software. This includes Nikon Transfer (see Connecting the camera, *page 222*). View NX2 itself covers most of the main processes: you can view and browse images, save them in other formats, and print. However, editing and enhancing images (including RAW files) is neither fast nor intuitive, compared to iPhoto or Lightroom. Theoretically, using Nikon's own software should give the best results, but getting there might try your patience. View NX2 is also weak for organizing and cataloging images.

› Using Nikon View NX2

1) From any browser view (e.g. thumbnail grid), click on an image to highlight it. Image Viewer shows the image larger,

with a histogram, and there's also a Full Screen view.

2) The Metadata tab gives detailed info about the image and the Adjustment palette allows adjustments such as exposure and white balance.

3) Close the image and you will be asked if you want to save any adjustments. You do not need to export the file immediately.

4) To export the file as a TIFF or JPEG that can be viewed, edited, and printed by other applications, choose Convert Files from the File menu. You can resize and rename the image too.

5) The File Format menu in the Convert Files dialog offers three options (see the table overleaf).

NIKON **«**
VIEW NX2

Nikon View NX2 file format options

JPEG	Choose compression ratio: Highest Quality; High Quality; Good Balance; Good Compression Ratio; Highest Compression Ratio.	Suitable if extensive further editing is not envisaged. For good quality prints choose High or Highest Quality.
TIFF (8-bit)		Creates larger file sizes than JPEG, without a noticeable gain in quality: 16-bit is advised for extensive retouching work.
TIFF (16-bit)		The best choice when further editing is anticipated.

› Nikon Capture NX2

NIKON CAPTURE NX2　　　　　　　　　　☆

For a wider range of editing options, especially in relation to RAW files, Nikon Capture NX2 (optional purchase) or one of its third-party rivals is essential. Unlike rivals such as Adobe Lightroom or Photoshop, Capture NX2 cannot open RAW files from non-Nikon cameras. Capture NX2 has a quirky interface; some love it, others just can't get on with it, and in any case you'll need another app for cataloging.

› Camera Control Pro 2

Camera Control Pro 2—a professional product at a professional price—allows you to control the D3300 directly from a Mac or PC ("tethered shooting"). As images are captured you can check them in detail on the large, color-corrected computer screen; Live View integration allows real-time viewing. It requires a physical connection.

› Third-party software

ADOBE PHOTOSHOP ⌃

The undisputed market leader is Adobe Photoshop. Its power is enormous—far beyond most users' needs. Adobe has recently changed to a subscription model under the Creative Cloud label, which means that the software is regularly updated (and version numbers don't mean very much any more)—but it will stop working if you don't keep up the subscription payments.

Many will prefer the far more affordable Photoshop Elements, which still has sophisticated editing features, including the ability to open RAW files from the D3300. It is currently still obtainable on the more familar model where you pay once for a perpetual license to use the software.

Photoshop Elements includes an Organizer module, which allows you to "tag" photos, assign them to "Albums", or add keywords.

Mac users have another excellent choice in the form of iPhoto (latest version

ADOBE PHOTOSHOP ELEMENTS ⌃
The "before" and "after" views in Photoshop Elements' Quick Edit mode.

IPHOTO'S ADJUST PALETTE ⌃
Quick and flexible image editing in iPhoto.

ADOBE LIGHTROOM ⌃
The Library module in Adobe Lightroom makes organizing your images very easy.

LIGHTROOM'S DEVELOP MODULE ⌃
The Develop module offers a very wide spectrum of RAW adjustments.

iPhoto 11), pre-installed on new Macs; like Photoshop Elements, it combines organizing and editing abilities. Unbeatable for ease of use, iPhoto can open RAW files from the D3300, but—unlike Photoshop Elements—cannot edit in 16-bit depth, which is recommended for best results.

Finally, there are two one-stop solutions in the shape of Apple's Aperture (Mac only) and Adobe Lightroom (Mac and PC). Highly recommended if you regularly shoot RAW, both offer powerful organizing and cataloging, seamlessly integrated with advanced image editing. Editing is "non-destructive": edit settings (any changes you make to your image, including color, cropping, and so on) are recorded alongside the original RAW (or DNG) file without creating a new TIFF or JPEG file. TIFF or JPEG versions, incorporating all the edits, can be exported as and when needed. Aperture is now very keenly priced and can be cheaper than Photoshop

Elements, yet is significantly more powerful.

Recent versions of Aperture and Lightroom both support tethered shooting, as do several other apps.

Note:
Older versions of Photoshop, Elements, and Lightroom will not recognize RAW files created by the D3300. One workaround is to use Adobe DNG Converter (free) to convert files to the widely compatible DNG format. However, this adds an extra, time-consuming, step to your workflow. Upgrading Lightroom or Photoshop Elements is an easier, and reasonably affordable, solution.

➛ GPS

Onboard GPS (Global Positioning System) is becoming increasingly common on cameras in most categories, but among Nikon DSLRs only the D5300 has it as yet. To access GPS information on the D3300 you'll need a Nikon GP-1 or GP-1a unit. These can be mounted on the hotshoe or clipped to the camera strap, and link to the camera's accessory terminal using a supplied cable. This allows information on latitude, longitude, altitude, heading, and time to be added to image metadata. This is displayed as an extra page of photo info on playback and can be read by many imaging apps.

When the camera has established a connection and is receiving data from the GPS, a **GPS** icon will be displayed in the Information Display. If this flashes, the GPS is searching for a signal, and data will not be recorded.

The **Location data** item in the Setup menu has three sections:

› Standby timer

If set to **Off (Disable)**, this stops the meters turning off and returning the camera to standby. This ensures that the GPS receiver is always able to connect to the satellite network (unless the signal is blocked). If you select **On (Enable)**, the meters will turn off after 1 minute. This saves battery power, but next time you take a picture the GPS receiver may not have time to get a fix, in which case no location data will be recorded

› Position

Displays the current information as reported by the GPS device. Apart from other uses, this could be handy if you get lost!

› Set clock from satellite

As the GPS network embodies some of the most accurate timing in existence, enabling this should mean that your camera clock is always bang on.

LOCATION DATA ⌄
GPS information allows you to see exactly where the photos were taken.

» CONNECTING TO A PRINTER

CONNECTING TO A PRINTER ⌃

The camera's memory card can be inserted into a compatible printer or taken to a photo-printing store. Alternatively, the camera can be connected to any printer that supports the PictBridge standard.

However, for maximum flexibility and power when printing, transfer photographs to a computer first.

> **_Tip_**
>
> _RAW images can't be printed directly from the camera, but you can use the **NEF (RAW) processing** item in the Retouch menu (page 124) to create a JPEG copy for direct printing._

› To connect to a printer

1) Turn the camera off.

2) Turn the printer on and connect the supplied USB cable. Insert the the smaller end of the cable into the USB slot, under the cover on the left side of the camera.

3) Turn the camera on. You should now see a welcome screen, followed by a PictBridge playback display. There's now a choice between **Printing pictures one at a time** or **Printing multiple pictures**.

› Printing pictures one at a time

1) Select the photo you wish to print, then press (OK). This reveals a menu of printing options (see the table below). Use the Multi-selector to navigate the menu and highlight specific options; press (OK) to select.

2) When the required options have been set, select **Start printing** and press (OK). To cancel at any time, press (OK) again.

Printing options

Option name	Options available	Notes
Page size		Options depend on paper sizes the printer can support.
No of copies	1–99	Use ▲ / ▼ to choose number, then press (OK) to select.
Border	Printer default Print with border No border	If **Print with border** is selected, borders will be white.
Time stamp	Printer default Print time stamp No time stamp	Prints time and date when image was taken.
Crop	Crop No cropping	**Crop** prints selected area only to size selected under **Page size**. Screen shows image with border delineating crop area. Use ◪▦ and ⊕ to change size of this area; use Multi-selector to reposition it. When satisfied, press (OK).

› Printing multiple pictures

You can print several pictures at once. You can also create an index print of all JPEG images (up to a maximum of 256) currently stored on the memory card. NEF (RAW) images cannot be printed. With the PictBridge menu displayed, press (OK). The options listed in the table below are displayed:

Print Select	Use the Multi-selector to scroll through pictures on the memory card. To choose currently selected image for printing, press ▲. The picture is marked 凸 and number of prints set to 1. Press ▲ repeatedly to print more copies. Repeat to select further images and choose number of prints from each. Finally, press (OK) to display PictBridge menu and select printing options, as in table on the previous page. Select Start printing and press (OK).
Select date	Prints one copy of each picture taken on selected date(s).
Print (DPOF)	Prints images already selected using **DPOF print order** option in Playback menu (*see page 109*).
Index Print	Prints all JPEG images on the memory card, up to maximum of 256. If more images exist, only the first 256 will be printed.

CONNECTING TO A TV

You can playback photos and movie clips through both standard TVs and HDMI (High Definition Multimedia Interface) sets. They require different cables, but in other respects the process is essentially the same. An AV cable (for standard TVs) is supplied with the camera.

1) Check that the camera is set to the correct mode in the Setup menu (**NTSC** or **PAL** for standard TVs and VCRs, or **HDMI**).

2) Turn the camera off (important: always do this before connecting or disconnecting the cable).

3) Open the cover on the left side of the camera and insert the cable into the appropriate slot (AV-out or HDMI). Connect the other end to the TV.

4) Tune the TV to a Video or HDMI channel.

5) Turn the camera on and press the playback button. Images remain visible on the camera monitor as well as on the TV and you navigate using the Multi-selector in the usual way. The Slide show item in the Playback menu (*page 108*) can be used to automate playback.

» GLOSSARY

8-bit, 12-bit, 16-bit *See* Bit depth.

Accessory shoe *See* Hotshoe.

Aperture The lens opening which admits light. Relative aperture sizes are expressed in f-numbers.

Artefact Occurs when data or data produced by the sensor is interpreted incorrectly, resulting in visible flaws in the image.

Bit depth The amount of information recorded for each color channel. 8-bit, for example, means that the data distinguishes 2^8 or 256 levels of brightness for each channel. 16-bit images recognize over 65,000 levels per channel, which allows greater freedom in editing. The D3300 records RAW images in 12-bit depth and they are converted to 16-bit on import to the computer.

Bracketing Taking a number of otherwise identical shots in which just one parameter (e.g. exposure) is varied.

Buffer On-board memory that holds images until they can be written to the memory card.

Burst A number of frames shot in quick succession; the maximum burst size is limited by buffer capacity.

Channel The D3300, like other digital devices, records data for three separate color channels. *See* RGB.

Chimping Checking images on the screen after shooting.

Clipping Complete loss of detail in highlight or shadow areas of the image (sometimes both!), leaving them as blank white or black.

CMOS (Complementary Metal Oxide Semiconductor) A type of image sensor used in many digital cameras, including the D3300.

Color temperature The color of light, expressed in degrees Kelvin (K). Confusingly, "cool" (bluer) light has a higher color temperature than "warm" (red) light.

CPU (central processing unit) A small computer in the camera (also found in many lenses) that controls most or all of the unit's functions.

Crop factor *See* Focal length multiplication factor.

Diopter Unit expressing the power of a lens.

dpi (dots per inch) A measure of resolution: should strictly be applied only to printers. *See* ppi.

Dynamic range The range of brightness from shadows to highlights within which the camera can record detail.

Exposure Used in several senses. For instance, "an exposure" is virtually synonymous with "an image" or "a photo": to make an exposure = to take a picture. Exposure also refers to the amount of light hitting the image sensor, and to systems of measuring this. *See also* Overexposure, Underexposure.

Ev (Exposure value) A standardized unit of exposure. 1 Ev halves or doubles the amount of light and is equivalent to 1 "stop" in traditional photographic parlance.

Extension rings/Extension tubes Hollow tubes which fit between the camera tube and lens, used to allow greater magnifications.

f-number Lens aperture expressed as a fraction of focal length; f/2 is a wide aperture and f/16 is narrow.

Fast (lens) Lens with a wide maximum aperture, e.g. f/1.8. f/4 is relatively fast for long telephotos.

Fill-in flash Flash used in combination with daylight. Used with naturally backlit or harshly side-lit subjects to prevent dark shadows.

Filter A piece of glass or plastic placed in front of, within, or behind the lens to modify light.

Firmware Software which controls the camera: upgrades are issued by Nikon from time to time and can be transferred to the camera via a memory card.

Focal length The distance (in mm) from the optical center of a lens to the point at which light is focused.

Focal length multiplication factor For a DX-format sensor (as with the D3300), the image area is smaller than a 35mm film frame so the effective focal length of all lenses is multiplied by 1.5.

fps (frames per second) The number of exposures (photographs) that can be taken in a second. The D3300's maximum rate is 5fps.

Highlights The brightest areas of the scene and/or the image.

Histogram A graph representing the distribution of tones in an image, ranging from pure black to pure white.

ISO (International Standards Organization) ISO ratings express film speed and the sensitivity of digital sensors is quoted as ISO-equivalent.

JPEG A compressed image file standard. High levels of JPEG compression can reduce files to about 5% of their original size, but there may be some loss of quality (from Joint Photographic Experts Group).

LCD (liquid crystal display) Flat screen like the D3300's rear monitor.

Macro A term used to describe close focusing and close-focusing ability of a lens. A true macro lens has a reproduction ratio of 1:1 or better.

Megapixel *See* Pixel.

Noise Image interference manifested as random variations in pixel brightness and/or color.

Overexposure When too much light reaches the sensor, resulting in a too-bright image, often with clipped highlights.

Pixel (picture element) The individual colored dots (usually square) which make up a digital image. One million pixels = 1 megapixel.

Post-processing Adjustment to images on computer after shooting. Can cover anything from minor tweaks of brightness/color to extensive editing.

ppi (pixels per inch) Should be applied to digital files rather than the commonly used dpi.

Reproduction ratio The ratio between the real size of an object and the size of its image on the sensor.

Resolution The number of pixels for a given dimension, for example 300 pixels per inch. Resolution is often confused with image size. The native size of an image from the D3300 is 4928 x 3280 pixels; this could make a large but coarse print at 100 dpi or a smaller but finer one at 300 dpi.

RGB (red, green, blue) Digital devices, including the D3300, record color in terms of brightness levels of the three primary colors.

Sensor The light-sensitive image-forming chip at the heart of every digital camera.

Shutter The mechanism which controls the amount of light reaching the sensor by opening and closing to expose the sensor when the shutter-release button is pushed.

Speedlight Nikon's range of dedicated external flashguns.

Spot metering A metering method which takes its reading from the light reflected by a small portion of the scene.

Telephoto lens A lens with a large focal length and a narrow angle of view.

TIFF (Tagged Image File Format) A universal file format supported by virtually all image-editing applications.

TTL (through the lens) Like the viewing and metering of SLR cameras such as the D3300.

Underexposure When insufficient light reaches the sensor, resulting in a too-dark image, often with clipped shadows.

USB (Universal Serial Bus) A data transfer standard, used to connect to a computer.

Viewfinder An optical system used for framing the image; on an SLR camera like the D3300 it shows the view as seen through the lens.

White balance A function which compensates for different color temperatures so that images may be recorded with correct color balance.

Wideangle lens A lens with a short focal length and a wide angle of view.

Zoom A lens with variable focal length, giving a range of viewing angles. To zoom in is to change focal length to give a narrower view and zoom out is the converse. Optical zoom refers to the genuine zoom ability of a lens; digital zoom is the cropping of part of an image to produce an illusion of the same effect.

USEFUL WEB SITES

NIKON-RELATED SITES

Nikon Worldwide
Home page for the Nikon Corporation
www.nikon.com

Nikon UK
Home page for Nikon UK
www.nikon.co.uk

Nikon USA
Home page for Nikon USA
www.nikonusa.com

Nikon User Support
European Technical Support Gateway
www.europe-nikon.comsupport

Nikon Info
User forum, gallery, news, and reviews
www.nikoninfo.com

Nikon Historical Society
Worldwide site for study of Nikon products
www.nikonhs.org

Nikon Links
Links to many Nikon-related sites
www.nikonlinks.com

Grays of Westminster
Legendary Nikon-only dealer (London)
www.graysofwestminster.co.uk

GENERAL SITES

Digital Photography Review
Independent news and reviews
www.dpreview.com

Thom Hogan
Real-world reviews and advice
www.dslrbodies.com

Jon Sparks
Landscape and outdoor pursuit
photography
www.jon-sparks.co.uk

EQUIPMENT

Adobe
Photoshop, Photoshop Elements, Lightroom
www.adobe.com

Apple
Aperture and iPhoto
www.apple.com

Aquapac
Waterproof cases
www.aquapac.net

Sigma
Independent lenses and flash units
www.sigma-imaging-uk.com

PHOTOGRAPHY PUBLICATIONS

Ammonite Press
Photography books
www.ammonitepress.com

Black & White Photography magazine, *Outdoor Photography* magazine
www.thegmcgroup.com

» INDEX

NIKON D3300
THE EXPANDED GUIDE

FRONT OF CAMERA

BACK OF CAMERA

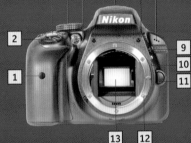

1 Infrared receiver (front)	**17** MENU button
2 Power switch	**18** Playback button
3 Shutter-release button	**19** Infrared receiver (rear)
4 Mode Dial	**20** Eyecup
5 AF-assist illuminator/ Self-timer/ Red-eye reduction lamp	**21** Viewfinder eyepiece
6 Built-in flash	**22** Accessory hotshoe cover
7 Flash/ Flash mode/ Flash compensation button	**23** Diopter adjustment dial
8 Microphone	**24** AE-L/AF-L/Protect button
9 Fn button	**25** Command Dial
10 Mounting mark	**26** Live View/Movie button
11 Lens release button	**27** Multi-selector
12 Lens mount	**28** OK button
13 Mirror	**29** Delete button
14 Information edit button	**30** Memory card access lamp
15 Thumbnail/playback zoom out/ Help button	**31** Release mode/ Self-timer/ Remote control button
16 Playback zoom in button	**32** LCD monitor

TOP OF CAMERA

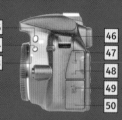

33 34
35
36
37 37
38 39 40 41 42

BOTTOM OF CAMERA

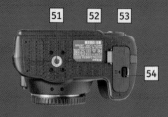

51 52 53
54

LEFT OF CAMERA

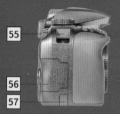

45
44
43
46
47
48
49
50

RIGHT OF CAMERA

55
56
57

33	Movie-record button	46	Connector cover
34	Power switch	47	Accessory terminal
35	Shutter-release button	48	External microphone connector
36	Exposure compensation/ Aperture adjustment/ Flash compensation button	49	USB and AV connector
		50	HDMI mini-pin connector
37	Camera strap mount	51	Tripod socket (¼in)
38	Focal plane mark	52	Camera serial number
39	Accessory hotshoe	53	Battery compartment
40	Mode Dial	54	Battery compartment release lever
41	INFO button	55	Camera strap mount
42	Speaker	56	Memory card slot cover
43	Mounting mark	57	Power connector cover for optional power connector
44	Fn button		
45	Flash/Flash mode/ Flash compensation button		